Praise for *The Artist's* Edition

"What artists don't know—but ...cipate in the amazing, expanding, impactful ...public art could fill a book! This is that book! Just open to any page, and you'll see why."
—**Jack Becker, founder of Forecast Public Art and *Public Art Review***

"Lynn Basa is a practitioner who knows the ins and outs of public art. The second edition of her book offers an additional chapter on how to make the leap into creating art in public places. *The Artist's Guide to Public Art* is a great resource recommended to anyone with an interest or stake in the field."
—**Christina Lanzl, director, Urban Culture Institute**

"Filled with both practical specifics and astute perceptions of the genre, I have found *The Artist's Guide to Public Art* to be an indispensable text for my public art class. This new edition updates changes within the field and makes it even more valuable as a text I can rely upon."
—**Jim Hirschfield, artist and professor of art, University of North Carolina–Chapel Hill**

"After reading this book, I immediately felt inspired and equipped to find and create opportunities for making art in the public realm. Its contents are comprehensive, practical, and highly relevant to current practices. A must-have for anyone interested in public art."
—**Lynn Sondag, professor of art and design, Dominican University of California**

"Artists—read this book! It is full of stories and practical advice on how to navigate the public art world. This second edition keeps pace with the changes in public art processes and gives a rare objective look at the good and the not so good. Lynn's book provides a complete guide to making the leap from a studio artist to a public artist, putting together an application, a behind-the-scenes look at getting selected, and an understanding of contracts and copyright. It will help artists find their voice and even answer the question, 'Should I consider making public artwork in the first place?'"
—**Karen Rudd, manager, NorfolkArts**

"At the intersection of public art and public discourse, Basa paints with the finest of strokes."
—**Jason Vasser-Elong, arts advocate, poet, and author of *Shrimp***

THE
ARTIST'S GUIDE
TO
PUBLIC ART

SECOND EDITION

How to Find and Win Commissions

LYNN BASA

Foreword by Mary Jane Jacob

With a special section by art lawyer Barbara T. Hoffman

ALLWORTH PRESS
NEW YORK

Allworth Press books may be purchased in bulk at special discounts for sales promotion,
corporate gifts, fund-raising, or educational purposes. Special editions can also be created
to specifications. For details, contact the Special Sales Department, Allworth Press, 307
West 36th Street, 11th Floor, New York, NY 10018 or info@skyhorsepublishing.com.

23 22 21 20 19 5 4 3 2 1

Published by Allworth Press, an imprint of Skyhorse Publishing, Inc. 307 West 36th Street,
11th Floor, New York, NY 10018. Allworth Press® is a registered trademark of Skyhorse
Publishing, Inc.®, a Delaware corporation.

www.allworth.com

Cover design by Mary Ann Smith

Library of Congress Cataloging-in-Publication Data

Names: Basa, Lynn, author. | Jacob, Mary Jane, writer of foreword. | Hoffman,
 Barbara T., contributor.
Title: The artist's guide to public art: how to find and win commissions /
 Lynn Basa ; foreword by Mary Jane Jacob ; with a special section by art
 lawyer Barbara T. Hoffman.
Description: Second edition. | New York, New York: Allworth Press, an
 imprint of Skyhorse Publishing, Inc., [2019] | Includes bibliographical
 references and index.
Identifiers: LCCN 2019007390 (print) | LCCN 2019008358 (ebook) | ISBN
 9781621536192 (eBook) | ISBN 9781621536147 (paperback)
Subjects: LCSH: Public art—Economic aspects—United States. | Art
 commissions—United States. | BISAC: ART / Business Aspects. | ART /
 General. | ART / American / General. | ART / Study & Teaching. | ART / Art
 & Politics.
Classification: LCC N8846.U6 (ebook) | LCC N8846.U6 B37 2019 (print) | DDC
 700.973—dc23
LC record available at https://lccn.loc.gov/2019007390

Print ISBN: 978-1-62153-614-7
eBook ISBN: 978-1-62153-619-2

Printed in the United States of America

Contents

Foreword by Mary Jane Jacob vii
Introduction xi

Chapter 1 | Public Art Fundamentals 1
Trend Spotting 4
Why Does the Government Buy Art? 5
Public Art Training 11

Chapter 2 | Start Here: Where to Find Public Art Competitions 15
How Public Art Agencies Find Artists 17
RFQs and RFPs 19
Persistence Pays 21

Chapter 3 | Anatomy of a Call for Artists: The Selection Process 23
Components of a Call 23
Deciding Whether to Apply 27
The Selection Process 27
Backstage at a Selection Meeting 31
Selection Criteria 32

Chapter 4 | Application Readiness 37
Digital Images 40
Resume 41
Annotated Image List 41
References 43
Support Material 44
Letter of Interest 44
Sample Letter of Interest 52
Tricks of the Trade 58

Chapter 5 | Congratulations! You're a Finalist! (Now What?) 61
Questions to Ask Yourself 62
Questions to Ask the Project Manager 63
What Goes into a Finalist Proposal? 67
Presentation 82

Chapter 6 | Budgeting for Public Art Projects and Other Financial Survival Strategies 85
with Nancy Herring, Financial Consultant
Business Practices for the Public Artist 86

Chapter 7 | Insurance: The Lowdown **101**
Interview with Kristin Enzor 101
Performance Bonds 108
Health Insurance 109

Chapter 8 | Ask the Expert—Contracts Q&A **117**
by Barbara T. Hoffman, Esq.
Negotiating the Contract 118
Types of Contracts 123
Specific Contract Clauses 126
Incorporation 133

Chapter 9 | Ask the Expert—A Primer on Copyright and Artists' Rights **135**
by Barbara T. Hoffman, Esq.
Copyright Basics 135
The Battle of US Artists for "Moral Rights" 138
Copyright Q&A 142
Visual Artists Rights Act (VARA), 17 U.S.C. § 106A (1990) Q&A 145

Chapter 10 | Working with Fabricators **149**
Finding Fabricators 150
Working Well with Fabricators 152

Chapter 11 | Making the Leap **159**
Inspirations and Influences 159
Act Locally 159
Show Up 160
Self-Educate 160
Experiment with Material Samples 161
No Experience Required 164
Artists-in-Residence 165
Murals 169
Creative Placemaking 171
Making a Difference 179

Chapter 12 | Voices of Experience **183**

Bibliography 210
Acknowledgments 213
About the Author 213
Index 214

Foreword

by Mary Jane Jacob

Art in situ has been around throughout human history, defining locations to such a degree that this art becomes synonymous with places, cultures, and peoples. Even if much of it now only remains as architectural and sculptural fragments in museums or images in paintings, photographs, and other secondary sources, it is still these artworks and artifacts that tell us who we are.

Our own American tradition of art in public had its vigorous antecedent in the last century as a key part of the social programs in the 1930s, through which emerged some of the greatest American artists of that time. Their creations—murals in schools, post offices, and other government buildings; sculptural projects and photographs; urban park systems and public monuments; and more ephemeral but no less impactful efforts, such as community theater, educational programs, and writing and crafts projects—changed the American social landscape.

An alignment of creative forces brought us to this current chapter in public art when, in the late 1980s, tendencies toward installation, site, and environmental genres, along with theoretical discourses of representation, cultural diversity, and globalism met up with the then twenty-year movement of government-commissioned public art. Public art became hot—a hotbed of artistic activity both intellectually rich and materially experimental, and a volatile field of political and public controversy. Corporate funding and foundation sponsorship kicked in by the nineties to help engender laboratory projects. Foundations then institutionalized these artists' pioneering ways of working, setting standards for the practice of public art as they designed their own program initiatives and revamped guidelines. While the public art field is one, by very definition, outside the world of museums and in contrast and complement to these storehouses and showplaces of art, museums also got

in the act with outreach projects and the capital projects of new or expanded outdoor sculpture gardens.

Yet during these recent decades, another phenomenon occurred as public art exploded on the scene, encapsulating much of the cultural debates of the time: the public joined artists to reaffirm that art mattered. Artworks in our environs enriched our lives and became a part of them, signifying who we are today. Even classic, seemingly tired traditions of public art were renewed, as cultural politics demanded that form be given to others' stories and tragedies in order to provide solace by memorializing gestures and to join in a continuum of human history that even the avant-garde notions could not sever. Thus, the commissioning of art had a mission and platform from which to operate.

These late twentieth-century public projects proved to be critical in defining what art is today and to understating how we engage the world. These works, created by artists in collaboration with fellow artists, architects, tradesman, other professionals, and, yes, sponsors, have made the difference and given us a sense of our culture, that of others, and of how culture and daily life are intrinsically bound.

My own work in the sculpture department at the School of the Art Institute of Chicago reflects this genesis as, in recent years, technical and studio-based directions have erupted into a range of interdisciplinary, environmental, sustainable, and other sculptural and public practices that take students out of the classroom and beyond the city. The School of the Art Institute has also provided a space for creative gestation and a testing ground for Lynn Basa's ideas. Here, she has helped students map out pathways to enter and pursue public art and to negotiate practical terrain through which proposals could be cultivated, resulting in projects that were both well conceived and feasible. In fact, every artist entering the realm of public art has to acquire new language skills—of sales, contracts, and fabricators—and must learn to trust that the business of art can complement, rather than override, the aesthetics of art.

The preparation of young artists for public art commissions fits well with other curricular initiatives at the School of the Art Institute of Chicago, all aimed to better equip students for life after art school and enable them to make a life in art. This was catapulted, too, by our work within a national consortium of the Emily Hall Tremaine Foundation. As one of a few select art schools, we look at the fundamental relationship between the study of art and professional practice. We recognize that public art is an important route—one that by its very nature can bring art and life together.

As to which came first—the existence of commission and government funding or the creative directions of art in the public sphere—the history of public art is much like that of the chicken and the egg. In any event, today the opportunities are numerous, and no one has to wait to be called. The meaning and purpose of public art is wide, and its role evolves as artists take on greater challenges—and many of these challenges come in the form of competitions and commissions that demand creative interpretation and excellent execution. What's more, public art making can be a path to your own interests and ideas through various artistic practices and related fields. It can foster personal and professional development as well as widen your scope to a wider, multifaceted artistic practice.

By working in this field and taking advantage of its opportunities with a greater awareness and skill set, you can contribute to the history of public art. The field of public art can, quite literally, be shaped by you—your work might just affect the places in which it is placed and those living there—and this book can help along the way.

Introduction

Hello, again. In the eleven years since I wrote the first edition of *The Artist's Guide to Public Art*, we've had the Great Recession and, for some, the great recovery; the launch of the iPhone; and the widespread use of social media. We're only two years into the Trump era and not yet sure what will be the fallout. Whether or not the country has become more politically polarized or just more gerrymandered, we're now more aware of "red states" and "blue islands." Feminism has jumped to the next level with #MeToo, and Black Lives Matter has daylighted biases that some of us didn't realize we had. Same-sex marriage has become the law of the land. The alarm bells of global warming have becoming deafening. The US war in Afghanistan is now the longest in American history, and we just started trade wars with China, Canada, and the European Union. Even public art has entered the fray with protests and counterprotests over Confederate monuments, leading to death and violence.

Percent-for-art programs are in transition, too. For one thing, there are more of them, especially in rural and midsized cities. "Creative placemaking" and "human-centered design" are now frequently used terms signaling a shift away from a top-down, outside-in approach to public art and toward community-driven decision making. Artists are increasingly being asked to act as conduits for the stories embedded in a place and as catalysts for community development. There has been a rise in support from private foundations, large nonprofits, and urban planners seeking to fund artist-led projects that have a direct benefit on the quality of life in their communities. Gun violence, police overreach, displacement, safe streets, equitable economic development, affordable housing, access to fresh produce, social justice, and the environment are just a few of the issues artists have been tackling for years at a grassroots level that are now finding more mainstream support. Preference is being given to artists who are already part of a community to build on its inherent resources and potential, rather than focusing on its problems. Calls

for artists emphasize "equity" as much as they once did "site-specific." There's so much talk about giving artists a place at the table where cultural policy is being decided that it seems like it might really lead to more artists actually being at the table.

In many ways, this is the golden age of public art. Artists are becoming more valued than ever for our contributions to the greater good. The answer to "why do we need public art?" is more nuanced and less compartmentalized, if the question is even asked anymore. It's still a challenge to make the leap from a studio practice to doing public art commissions—but the hurdles are lower. In addition to more funding for a broader definition of public art, there are artist residencies that afford artists the opportunity to create temporary projects that are relevant to daily life. Public art today is becoming as much about artists making a difference as it is about making things.

Despite this trend to address social as well as physical space, percent-for-art programs are still a reliable and significant source of funding for artists who make objects that are part of the built environment. Massive light-rail and airport construction projects around the country have been planned out for the next twenty years. Universities are continuing to expand their campuses, and towns of every size have rail-to-trail and park projects. The demand for street murals has only gotten greater, and art is increasingly being incorporated into designs for safer streets. The digital revolution, of course, has affected all aspects of the creation, presentation, and experience of art. Music festivals and concert halls include show-stopping temporary art installations.

As for my own practice, I started a gallery in the storefront of my studio in a predominantly Hispanic and Polish neighborhood on Chicago's northwest side. Called Corner, it hosted residencies and exhibits by artists whose work was experiential and referenced everyday life. After a couple of years, I realized that while what I was doing was interesting to the art community, it wasn't relevant to what actually mattered to the daily life of my neighbors. So, I took a hard look outside the windows of my studio to see what I could do about what needed to be done. I saw a relatively well-preserved 100-year-old main street with many storefront vacancies and a few struggling business owners who didn't know each other and had no one representing their interests. In August 2017, I launched the Corner Project to identify and build on the resources and opportunities inherent in the people and places of our three blocks. It remains to be seen if I'll be able to make a difference, but it's been a helluva learning curve, and one I recommend that every artist try wherever you are.

Public Art Fundamentals

Art is everywhere in our urban landscape. While some of those murals and sculptures, artist-designed floors, windows, benches, railings, lights, and digital installations got there the old-fashioned way—through private patronage—many of them were funded by government "percent-for-art" programs. And their numbers are growing. In 2001, Americans for the Arts estimated that there were 350 public art programs across the United States. By 2017 there were over twice as many: 728. While most public art programs are still public (81 percent in 2001 and 60 percent in 2017), the percentage of public art programs that are registered as nonprofits increased from 19 percent in 2001 to 34 percent in 2017.[1] In 2017, calls for public art totaling $20 million from 222 postings flowed through CaFÉ's application management system, and that's only one of several sources for public art listings.[2] Most of this money comes from federal, state, county, and city governments that set aside between 0.5 percent and 2 percent of their capital building budgets for art. One percent is the most common allowance, but it is inching upward as art becomes a more accepted—and expected—feature of our urban commons. By the time this book is published, barring economic catastrophe, more programs will have been added, and with those, more opportunities for artists of all kinds.

The evolution of public art in both selection and conception has been one of increasing inclusiveness, challenging artists not only to respond to the physical characteristics of sites, but to the communities that inhabit

1 Patricia Walsh, Public Art and Civic Design Program Manager, Americans for the Arts, email message to author, July 31, 2018.
2 Lori Goldstein, Manager, Public Art Archive, Western States Arts Federation, email message to author, September 4, 2018.

them. Selection panels for public art commissions now attempt to include a diversity of voices, instead of being solely that of art experts and patrons. Institutionally sponsored art for public spaces was once an extension of pedestal art, emblematized by large sculptures on plazas. The social intervention, guerrilla art, and community-based practices that grew out of grassroots community organizing have since infused the selection process. There are still plenty of artworks, perhaps most of them, commissioned to "enhance" already-built spaces. The difference now is that artists are also being invited (or are inviting themselves) to engage more with the users and planners of these places in consultation with the community.

Artists in residence in city departments are still very much alive and well. A hybrid descendent of CETA's[3] Neighborhood Arts Program from 1973 to 1981 and the design-team artist approach pioneered by the Seattle Arts Commission in 1976 with the Viewland Hoffman substation project, the idea of the "embedded artist" has firmly taken hold in this century. Calgary, Boston, Pittsburgh, New York, Los Angeles County, Alexandria, Minneapolis, Memphis, Dallas, Austin, Seattle, and more have programs where artists are partnered with city departments such as streets and sanitation, water quality, utilities, and transportation in order to understand their inner workings and interject new ways of relating to the public and public space.

While treating "the citizens of the city as experts on their own space"[4] does not guarantee success or failure by any measure, public art has become less about impassive monuments and more about activation and engagement. Increasingly, artists are bypassing institutional support altogether and initiating projects in response to the needs, resources, and opportunities in their own backyards. As Forecast Public Art founder Jack Becker observes, "There's a growing participatory culture in America. It's not about buying or selling or authorship or star power. We all have an opportunity to co-create the kind of built environment and social realm we want to share."[5]

"Current practice in public art engages with issues of spatial, social and environmental concern: artists, with others, are leading in these fields,

3 Comprehensive Employment and Training Act.
4 Tom Finkelpearl, *Dialogues in Public Art* (Cambridge, MA: MIT Press, 2000), 45.
5 The Community Foundation of Greater Greensboro, "The Public Art Endowment Lecture Series—Jack Becker: The Evolution of Contemporary Public Art in America," *YouTube* video, 44:11, December 3, 2015, https://www.youtube.com /watch?v=RhFM66aZ-oU. (Quote appears at the 23:20 mark.)

precisely because they operate independently, free of hierarchies. They are the first to recognize potential and to act in the transformation of space. Artists characteristically lead the way in urban regeneration. At the same time they open new sites of debate—in ecology, music, choreography, geography or science," according to Vivien Lovell in *Public:Art:Space.*[6]

In the 2008 edition of this book, I made this prediction: a new form of public space created by the internet and mobile media, such as cell phones and PDAs, would be explored by individual artists and collectives. It is no doubt on the verge of being discovered by institutional public art funders as artists begin to propose networked approaches in response to calls for artists for traditional brick-and-mortar projects. Christiane Paul, adjunct curator of New Media Arts at the Whitney Museum and the author of *Digital Art*, writes, "Internet art, which is accessible from the privacy of one's home, introduces a shift from the site-specific to the global, collapses boundaries between the private and public, and exists in a distributed non-local space."[7] The new frontier created by the "networked commons"—public defined by shared interests and issues, not geographical proximity—is tailor-made for the community-contribution aspect of public art.

I retained the previous paragraph for its sheer time-capsule quality. For you younger readers, PDA used to mean "personal digital assistant," the precursor to smartphones, not "public displays of affection." The "networked commons" has taken over our lives in the form of social media. The digital revolution hasn't impacted public art in the narrow way I imagined it would, with the artworks themselves transcending geographic permanence through the miracle of the internet. Instead, digital technology is now a common component of site-specific work in the form of programmable LEDs and fabrication methods.[8] Trompe l'oeil digital video–projection mapping onto buildings has become a minor industry. Virtual reality is the next game changer on the horizon for public art. But the most surprising development (to me, anyway) regarding virtual and real-life interaction with public art

6 Vivien Lovell and Sara Roberts, eds., "Foreword," in *Public:Art:Space: A Decade of Public Art Commissions Agency, 1987–1997* (London: Merrell Holberton, 1998), 11.

7 Christiane Paul, "Digital Art/Public Art: Governance and Agency in the Networked Commons," *First Monday* special issue 7 (2006): 6, doi.org/10.5210/fm .v0i0.1616.

8 As of this writing, virtual reality experiences are beginning to make their way into artwork.

is through the selfie. Everywhere you go, people are experiencing art by immortalizing themselves with it as a marker for a specific place at a specific moment. I'm sure there are excellent scholarly papers with insights to the social psychology of this phenomenon, but the takeaway for the purposes of this book is that artists must now take into account the potential for their work to become a backdrop for photo ops as another dimension of viewer engagement. Oh, and remember to put a hashtag near the work where people can see it. (As I write this, I wonder if in another ten years hashtags will be as anachronistic as PDAs.)

TREND SPOTTING

I took an informal survey of public artists and managers to ask them what new trends they've seen emerge in the last ten years. Here's what I heard, listed in no particular order:

- the dispersion of public art programs from large cities to small and midsized towns and rural areas;
- the rise of extravagant European-style mixed arts festivals in US cities;
- increased demand for spectacle and interactivity as an element of public artworks;
- more opportunities for work that contributes to safer streets and air and water quality;
- increased sensitivity to more equitable racial, economic, geographic, and technical access to opportunities;
- the recognition of public art and social practice as distinct artistic disciplines;
- the proliferation of artist-initiated, community-driven projects and spaces;
- increased support from private foundations, public charities, and nonarts government agencies for artists who are leading change in their communities;
- increased access to public art via the internet;
- more fabricators who specialize in public art; and
- the growing volume of critical writing on the role and effect of art in public.

WHY DOES THE GOVERNMENT BUY ART?

What motivates politicians to support legislation that spends the public's money on a lightning rod for controversy like art? What benefit do they expect from it for their communities, and how does that affect the panel's choice of artist and artwork? These questions are not academic. Just as artists need to understand how their work will relate to the context of a site, they need to understand the social, political, and economic contexts of the selection process. One answer is economics. As manufacturing jobs decline and the US economy depends increasingly on the technology, service, and entertainment industries, urban regions need to make themselves attractive to the sort of people who work in those sectors. And nothing says "welcome" to a creative, educated, and taxpaying workforce like the outward symbol of civic enlightenment embodied by public art. Of course, the crime rate, weather, affordable housing, quality of schools, and availability of jobs may have more tangible weight in the livability equation. According to some social theorists, it's the ability to attract and retain this "creative class"[9] that gives cities a competitive edge. Public art is a sign that innovative thinking is encouraged, diversity is tolerated, and that the city's vital signs are strong. A place that can afford art can surely afford good health care, police protection, schools, and social services. There's another, more altruistic reason besides economic improvement and image that led to the establishment of public art programs: to bring the art experience out of the museums and galleries and into places where everyone can have free access to it. In the early days of public art, advocates relied mainly on this justification despite its "we know what's best for you" subtext. In a capitalist economy that nominally condemns elitism and believes itself to be classless, that argument can hold water for only so long. As examples of public artworks have accrued over the past thirty years, so has the body of evidence about what they can accomplish aesthetically, socially, economically, and environmentally.

"Governments legally cannot spend the public's money on things that do not bring a measurable return back to the public," says Julia Muney Moore, public art administrator for the Indianapolis International Airport. Moore continues:

9 Term coined by Richard Florida in his book *The Rise of the Creative Class: And How It's Transforming Work, Leisure, Community and Everyday Life* (New York: Basic Books, 2002).

They spend money on education because the return is a citizenry qualified to get jobs. They spend money on public services like trash collection, road salting, animal control, food stamps, all with a direct benefit to the public. But public art isn't like that. The benefit to the public is not measurable except in the aggregate, and even then it is indirect. But, if a government can say, 'Hey, we spent half a billion on a new convention center and we will make that up in three years from increased convention tourism and assorted spill-over spending in local businesses, so the rest is pure gravy that we can use to salt your roads more often, and by the way there's some cool art in it that you can stop by and look at any time you like,' it's not only a good way to get public art, it's responsible government. Very, very rarely will you see a government using arguments like 'it helps people understand art better if they see it in their everyday environments.'[10]

In 2018, Americans for the Arts in collaboration with its Public Art Network Advisory Council came up with the following talking points "to provide the field with a tool to help educate community members, local decision makers, and other stakeholders on the value that public art can bring to cities and towns."[11]

Five Reasons Why Public Art Matters

Art in public spaces plays a distinguishing role in our country's history and culture. It reflects and reveals our society, enhances meaning in our civic spaces, and adds uniqueness to our communities. Public art humanizes the built environment. It provides an intersection between past, present, and future; between disciplines and ideas. Public art matters because our communities gain cultural, social, and economic value through public art.

10 Julia Muney Moore, public art administrator, Blackburn Architects Inc., email message to author, January 29, 2007.
11 Patricia Walsh, "Five Reasons Why Public Art Matters," *Americans for the Arts Artsblog*, August 30, 2018, https://blog.americansforthearts.org/2018/08/30/five-reasons-why-public-art-matters.

1. **Economic Growth and Sustainability.** By engaging in public art as a tool for growth and sustainability, communities can thrive economically. Seventy percent of Americans believe that the "arts improve the image and identity" of their community.

2. **Attachment and Cultural Identity.** Public art directly influences how people see and connect with a place, providing access to aesthetics that support its identity and making residents feel appreciated and valued. Aesthetics is one of the top three characteristics why residents attach themselves to a community.

3. **Artists as Contributors.** Providing a public art ecosystem supports artists and other creatives by validating them as important contributors to the community. Artists are highly entrepreneurial. They are 3.5 times more likely than the total U.S. work force to be self-employed.

4. **Social Cohesion and Cultural Understanding.** Public art provides a visual mechanism for understanding other cultures and perspectives, reinforcing social connectivity with others. Seventy-three percent of Americans agree that the arts "helps me understand other cultures better."

5. **Public Health and Belonging.** Public art addresses public health and personal illness by reducing stress, providing a sense of belonging, and addressing stigmas toward those with mental health issues. Public art is noted as slowing pedestrians down to enjoy their space and providing a positive impact on mood.[12]

I asked several managers of established public art programs to go beyond what their official mission statements say and to speak to the underlying motivations that drive their organizations' support of public art. Here are some of their responses:

I used to believe that there was only one reason why governments buy art—to support the cultural life of the community. Now I think it's much more complex. Governments buy art to support the cultural life of a community, to support the regional cultural

12 Walsh, "Five Reasons."

economy, to support the larger business climate (and the tax base) by making a community's quality of life better, to commemorate people and events, to cover up design mistakes, to mitigate the effects of sterile streetscapes and buildings, to support the missions of government, to decorate, and finally (and perhaps surprisingly) because it's not only often mandated, but expected, as part of the development of public spaces.

—Kurt Kiefer, Project Manager,
Sound Transit Art Program, Seattle

Public art programs continue the legacy of government support for the arts that started with the New Deal's Public Works of Art Projects (PWAP) in the 1930s during the Great Depression. This was an early and important civic investment in public culture. These programs, now prolific in the United States and abroad, are evidence of a collective belief and optimism that public artworks contribute to the beautification of a public place, helping to distinguish it with a special identity and provide a lasting cultural legacy that is free and accessible to the public. Artists bring a unique perspective and visual candor to the design of public spaces, often imbuing them with something unexpected, unpredictable, and wonderful. As a member of the public said to me, public art adds dignity to a place.

—Jill Manton, Public Art Program Director,
San Francisco Arts Commission

At the heart of the conversation is: if you want to be a great city, you have to have a great downtown. People are moving back to cities. They need services, grocery stores, and places to live, but they also expect food trucks, coffee shops, craft beer as ingredients of a groovy downtown. Leaders recognize that public art is part of that package. The public already has their own story about the value of art and believes that art makes neighborhoods vibrant and connects people. The art community doesn't have to do all the advocating.

—Karen Rudd, Manager, Norfolk Arts[13]

13 Karen Rudd, Manager, Norfolk Arts, phone call with the author, September 4, 2018.

In 2008 a group of donors created the Public Art Endowment because we didn't have a formal public art program in the community. They felt it was important to make art accessible to everyone, knowing that public art can bring people together and open eyes to new possibilities. It's really a personal way to give back to the city they love—with no other motive than sharing the power of art with Greensboro.

—Cheryl Stewart, Program Coordinator and Consultant, Public Art, the Community Foundation of Greater Greensboro, Inc.

I asked Jill Manton, one of the public art program managers above, if the issue of consciously using art to enhance the tax base ever arises in her discussions with San Francisco's public officials. She replied, "While this is not an explicitly stated objective of our program, it is an inevitable benefit. Successful public art can turn a place into a destination, adding to the prestige of the building or site with which it is associated."[14]

Millennium Park

The spectacular success of Chicago's Millennium Park[15] is Exhibit A in making the case for public art as an economic asset. Completed in 2005, this extravaganza of interactive sculptures, artist-designed gardens, free performance spaces, and restaurants (not to mention an ice skating rink and a building that generates its own electricity) has raised the bar for what can be accomplished with public art. Anchored by Jaume Plensa's *Crown Fountain*, Anish Kapoor's *Cloud Gate*, Frank Gehry's *Pritzker Music Pavilion* and *BP Pedestrian Bridge*, and the art and design team GGN's *Lurie Garden*, it is adjacent to the Art Institute of Chicago and next to Grant Park, which hosts a constant stream of megafestivals, such as Lollapalooza, Taste of Chicago, and the Chicago Marathon.

14 Jill Manton, Public Art Program Director, San Francisco Arts Commission, email message to author, August 17, 2018.
15 Edward K. Uhlir, "The Millennium Park Effect: Creating a Cultural Venue with an Economic Impact," *Greater Philadelphia Regional Review* (2006): 20–25, https://www.americansforthearts.org/sites/default/files/Millennium_0.pdf.

Its success manifests itself most tangibly when one sees the delight, and even wonder, on the faces of the throngs of people that constantly fill the park, interacting with the artworks. People of all ages, races, classes, and nationalities mingle in this public art melting pot.

And it has put wonder and delight in the eyes of local politicians, business owners, and developers. A major justification for building it on public land was the economic benefit that would accrue. A 2005 economic impact study confidently predicted that "the yearly visitation will be in excess of 3 million."[16] They were way off. In 2016 Millennium Park had 12.9 million visitors—and that was only in the last six months of the year.[17] They predicted that total visitor spending would add up to $2.6 billion annually by 2015.[18] But even that was lowballing it. In 2014, "the annual estimated gross sales from visitor spending attributable to Millennium Park" was $1.2 trillion. It has spurred equally prediction-busting growth in new development of residences, hotels, and adaptive reuse of office buildings. Rents have increased 22 percent since the park opened, and it boasts occupancy rates 95 percent higher than the rest of the city.[19] Pretty good for an initial investment of $220 million in private donations and $270 million from the City of Chicago which, it should be noted, was controversially extravagant at the time.

In one way, it's misleading to use Millennium Park as an example of public art because none of the artworks were funded through the percent-for-art model nor did their selection involve public process in the usual way. The art itself was built on public property, but it was funded by private donors. Private art committees selected internationally known artists from a short invitational list. The city's Public Art Committee was offered the courtesy of a review without having an official vote.[20] The artists were given enough money and freedom to do

16 Uhlir, "The Millennium Park Effect," 23.

17 Steve Johnson, "Millennium Park Is New Top Midwest Visitor Destination, High-Tech Count Finds," *Chicago Tribune*, April 6, 2017, http://www.chicagotribune.com /entertainment/ct-millennium-park-visitors-ent-0406-20170406-column.html#.

18 Uhlir, "The Millennium Park Effect," 23.

19 Ed Uhlir, "Millennium Park—Its Creation and Economic Impact," PDF of presentation, accessed August 4, 2018, http://chrgasa.org/wp-content/uploads/2016/01 /Millennium-Park-by-Ed-Uhlir.pdf.

20 Ed Uhlir, email message to author, April 8, 2007.

their best work. It defies the prevailing belief in the selection of public art that there needs to be involvement by the community in order to create a place where public art fosters "democratic interaction."[21] Is there a lesson in there somewhere for how public art should be delivered in the future, or was it a fluke of right time, right place, right mayor, and right economy?

If all this talk about money is making you woozy with disillusionment, just remember that counting dollars and feet are the easiest ways to quantify the success of any particular project in order to justify the expenditure of public funds. What's actually more important to every public art administrator I know is the effect of the artwork on the quality of life of the community they serve and providing opportunities for artists to do their best work. The search is on for other ways to measure the effectiveness of public art; but for now, hard data prevails, and if that's what it takes to make those less measurable benefits happen, then we artists need to understand how that works. It's not as much of an uphill battle as it was in the olden days when the first public art programs were coming into being in the 1960s and '70s, but art still has to justify its existence if it's going to use public funding.

PUBLIC ART TRAINING

The professionalization of the field continues. Dozens of art schools include courses on public art practice and administration, and increasingly more schools offer degrees, such as the University of Cincinnati's certificate in Public Art and Placemaking, and the University of Indianapolis Master of Arts in Social Practice Art. Harvard, USC, and Bauhaus University each have highly evolved, interdisciplinary programs around "spatial practice."[22] In the first edition of this book, I wrote that there's really no such thing as public art as a separate practice, but today it would be difficult to find an art school that doesn't have at least a course or two teaching the intersection of art with

21 Finkelpearl, *Dialogue*, 45.
22 "Art, Design, and the Public Domain," Harvard University Graduate School Master in Design Studies, accessed September 4, 2018, https://www.gsd.harvard .edu/design-studies/art-and-the-public-domain/.

public life. The majority of us are still entering the field through the studio portal as painters, sculptors, ceramicists, muralists, or fiber-, multimedia-, street-, performance-, or installation artists, with a smattering of us coming from architecture and other design professions. Many of us have studied art formally and view making art for public spaces as an expanded aspect of our practices.

While there are still many examples of art in the public realm that were achieved without much collaborative input, the one thing many of us practicing in this field do have in common is the ability to subject our ideas and egos to a process involving disparate opinions, agendas, and art expertise outside the protective shell of the studio. It's not for everyone. The sheer volume of human contact, approvals, and paperwork required to take a public piece from start to finish can be overwhelming to the type of personality that was led in the first place to an art form generally practiced in solitude. And there are different ways to approach public art. Some artists are simply doing a variation of their studio work on a grander scale, while others reinvent themselves for every project. Jack Becker, artistic director of the *Public Art Review*, writes, "I tend to divide artists like doctors: There are specialists and general practitioners. Specialists are typically product makers, focusing on one thing and doing it expertly. GPs are into process and working laterally across many disciplines."[23] Fortunately, there are plenty of opportunities to fit most approaches.

In the Gross Generalization Department, I've attempted to point out the differences between studio art and public art.

23 Jack Becker, "Public Art's Cultural Evolution," *Community Arts Network: Reading Room*, February 2002, http://wayback.archive-it.org/2077/20100906195345/http: //www.communityarts.net/readingroom/archivefiles/2002/02/public_arts_cul .php.

Studio Art	Public Art
Your work consists of whatever your imagination can contrive.	You respond to parameters set by client.
You develop concepts in isolation.	Concepts evolve through idea exchange with people invested in the project.
You are responsible only to yourself.	You are responsible to others.[24]
Discrete objects.	Site-specific and integrated installations.
Existing work purchased.	New work commissioned.
You likely make the work yourself.	You often subcontract with fabricators.
Business is conducted between you and your gallerist, art consultant, or collector.	The public art manager is your main contact to a much larger bureaucracy.
You get paid a commission when the work sells.	You get paid in stages throughout the production process.
You submit your portfolio for review.	You respond to a call-for-artists competition.
Consignment agreement.	Commission contract.
There's an opening.	There's a dedication or ribbon-cutting ceremony.
Work is viewed by a few who are predisposed to look at art.	Work is viewed by many who may not have a particular interest in art.

24 Mary Jane Jacob, from a comment made in a seminar at the School of the Art Institute of Chicago, October 12, 2006.

Start Here

Where to Find Public Art Competitions

Unlike in 2008 when there was no centralized database, unified format, or shared standard procedures, the main sources for finding public art opportunities have consolidated into these few clearinghouses in the United States: CallForEntry.org, PublicArtist.org, and CODAworx. Start by signing up on those websites to receive notifications. Americans for the Arts recently launched the Public Art Resource Center. It's not a mailing list you can sign up for, but it has a searchable database for public art opportunities that is updated by the public art managers of programs looking for artists. Sign up for as many of those agencies' mailing lists as you can, especially all of the ones in your town, county, and state. You'll see many of the same calls for artists overlapping on these lists, but it's worth keeping tabs on each of them anyway.

Public Art Consultants

There are public art consulting firms whose mailing lists you should sign up for to keep track of where new programs are cropping up. Some of these firms help cities develop policies and cultural plans that eventually lead to commission opportunities for artists, while others are retained to run the commission process itself. Keep up with what these firms are doing by getting on their mailing lists: NOW Art LA, Metris Arts Consulting, Lord Cultural Resources, Via Partnership, Forecast Public Art, Gail M. Goldman Associates, WolfBrown, Center for Creative Placemaking, and many . . . many . . . more. Do a search for "cultural planning consultants" and "creative placemaking consultants." If nothing else, it will impress upon you what a hot commodity we artists are in the cultural development biz.

Once you get on a few of these lists, you'll start seeing about a dozen "calls for artists" in any given month. Most of them will not be a good fit for your work, but that's okay. As I'll discuss later, it's as important to know when not to apply as it is to know when to go for it.

Those calls for artists are not only going to you, but to about 12,000 other artists as well.[1] Ten years ago, that number was 2,500. Here's why you shouldn't be discouraged:

1. The majority of those artists will decide not to apply for several reasons:
 - They're not inspired by the project description.
 - Their work doesn't fit the project.
 - They're too busy with other projects.
 - The budget isn't large enough to make it worthwhile (there's a sharp drop-off in the number of applicants for projects with budgets below $100,000).
 - They think that so many other artists will apply that they shouldn't bother.
 - They can't deal with the paperwork and people work.
2. Of those who do apply, the majority won't make the first cut either because their work isn't right for the project or their application will be substandard in some way. Things like submitting incomplete information, lousy images, missing the deadline, or otherwise not following instructions will disqualify them. Over the years I've been taking an informal poll among public art managers, and the consensus is that two-thirds of applications are obviously not fit to go forward for consideration.
3. Public art agencies want and need to find artists they haven't worked with before. A recurring topic among arts administrators is how to cultivate artists who are new to the field. They not only want to commission new work, but they cannot justify giving jobs to the same artists over and over again. It makes their job easier if you find them first. Don't think of yourself as a supplicant asking for favors. You have something they want. If you get rejected, see if you can find out why, and try again

1 PublicArtist.org, email message to author, August 6, 2018.

for another competition at the same agency because there will be a whole new selection committee for each project.[2]

4. For each call that goes out to the multitudes, there are more floating around under the radar—and that doesn't even count all of the commissions generated by the private sector. And, you can make your own opportunities. In chapter 11, I'll go into some of the ways artists do this.

HOW PUBLIC ART AGENCIES FIND ARTISTS

Here are the main ways public art agencies find artists.

Artist Registries

Some agencies maintain a list of prequalified artists from which they draw as commission opportunities arise. There are two kinds of lists:

1. Prequalified: You must compete to get chosen for the juried, prequalified artist pool. For example, the Seattle-area Sound Transit program issued a call for their pool in 2018, received 305 applications, and chose 111 artists who won't need to apply again for three more years.[3] Fort Worth's public art program received 380 responses for their artist registry and chose 207, who will be eligible for the next two years. It's worth mentioning that Fort Worth has two categories, one for regional artists who have no prior experience doing public art commissions and another open to artists nationally who have completed commissions.[4]

2. Open: You simply submit your work by following the agency's application instructions, and you're automatically accepted into its artist registry.

2 I quit asking for feedback years ago when the answer given by one public art manager, Ben Owen, to my question about why my work wasn't chosen was, "I don't know, Lynn. They just liked somebody else's work better." That's when I realized that's always going to be the answer.

3 Ashley Long, Sound Transit Public Art Project Manager, email message to author, March 29, 2018.

4 Sam Brown, Fort Worth Public Art Community Engagement Manager, phone call with author, September 7, 2018.

It is important to get included in as many artist registries as possible because for agencies that mainly choose artists from an existing pool, if you're not in there, you're not eligible. Even well-established artists have to submit their work to the registry in order to be considered.

Open Calls

These are announcements that go out regionally, nationally, or internationally looking for artists for specific projects. These projects could be anything from a mural for a library to a public art master plan for a transit line, paying anywhere from $10,000 to $2 million. Open calls are issued to apply for prequalified artist registries, too.

Invitational

Individual artists are invited to apply because certain attributes found in their past work or relationship to the community are sought for a specific project. Often, these artists are chosen from the prequalified artist registry. Artists who have a track record of interesting projects, have been written about in magazines, were included in the Public Art Network's annual conference Year in Review,[5] or have kept the agency updated about their work have a better chance of being on the radar of the project managers who compile the list of invitees. This is where refreshing your social media pages with new work and sending out an e-newsletter a few times a year could potentially pay off.

Direct Purchase

Sometimes public art agencies will issue a call for existing work to add to their collection. Even though this may seem like the simplest route for them to take because there's no guesswork about what the finished artwork will look like and less of a delay to receive it, there are few calls for completed work for permanent placement. Many cities, however, have calls for individual works to be on loan for up to a year as part of downtown or neighborhood sculpture walk. It's a different story on the private sector side, however, where art advisors buy volumes of prints, paintings, photographs, and sculptures for their corporate, health-care, and hospitality clients.

5 Public Art Network, Americans for the Arts, Year in Review, accessed April 26, 2019, https://www.americansforthearts.org/by-program/networks-and-councils /public-art-network.

RFQs AND RFPs

Calls for artists most often come in the form of a request for qualifications (RFQ) or request for proposals (RFP). An RFQ simply asks you to submit evidence of your qualifications based on past work. From there, a handful of finalists are invited and paid (usually between $500 to $3,000) to create proposals after having the opportunity to research the site. Some agencies only ask to interview each finalist before choosing one to create a final, detailed proposal. Many artists prefer the interview method. First, because it saves the time and expense of putting together a proposal for a competition that they have a 66 to 80 percent chance of losing (if there are three to five finalists). Second, because once they're chosen, if it's early enough in the project, they can get the access they need to the team and the community to research the site in depth.

The RFP is more burdensome. It asks you to submit an idea in the form of a drawing, a concept narrative, and, sometimes, even a preliminary budget *at the open-call stage*, not after having been chosen as a finalist. The problem with this is that an RFP asks artists to come up with an idea that has relevance to a specific site that they may not have had a chance to see, let alone get a feeling for the sort of work that would be meaningful for that place. As Lucy Lippard writes, "Because place-specific (as opposed to drive-by) art begins with looking around, the artist needs to understand far more about a place than what it looks like or the tales told by the local chamber of commerce."[6] Artists who have a chance to understand each location more fully would see the opportunities it presents through different lenses. That unique perspective is the principal benefit of hiring artists, which is, unfortunately, diluted when the RFP process is employed.

The creative concept is the value artists bring to the table for each project. When every artist responding to an RFP is asked to submit a concept we are, in essence, being asked to work for free. And if the artist is asked to develop a budget without seeing a sample of the agency's contract—no matter how "preliminary" the agency says it will be—it is particularly problematic because of all the unanticipated expenses it could contain. Furthermore, the agency is short-changing its constituents by not giving artists a chance to fully understand the site before proposing an idea.

6 Lucy Lippard, *The Lure of the Local: Senses of Place in a Multicentered Society* (New York: New Press, 1997), 181.

The RFP approach was patterned after those of architectural competitions. It's one of those things that probably made sense at the time when public art was a new field and needed a process model to latch onto. The problem is that public art project budgets are in the tens or hundreds of thousands of dollars, not millions as for building design, and we do not get paid for construction administration as architects often do. Artist Mike Mandel spoke for many of us when he wrote to the Public Art Network listserv: "Do not compare artist and architect. Do not compare a $100,000 public art commission with a $100 million architectural commission. The architect has resources by the sheer scale of their financial support that puts them in a completely different sphere."[7] Most artists don't have a staff or several large projects going at once across which to spread the risk of potentially wasting their time and talent. When you think of dozens or hundreds of artists each spending many hours responding to an RFP, that is a huge expenditure of labor relative to each artist's chances of winning.

It's not a great system for architects, either. In fact, architects very rarely respond to an RFP with an actual design proposal. Instead, they create a fee proposal based on the scope and scale of the prospective project. If they make the cut, the next stage is an interview. There, they present thoroughly researched case studies to show their experience with similar projects in the past and how the firm would manage this prospective one. While the average fee awarded to them to develop a finalist proposal is typically $25,000, it is not unusual for a firm to spend over $100,000 and several months of staff time to fully research the site, creating models, PowerPoint presentations, color renderings, and so forth because that's what their competition will spend. Again, however, the potential payout if they win is worth that degree of effort.

There is an upside to RFPs that I should mention despite the fact that I would like them to go away: they're a good avenue for artists new to public art to get a foot in the door. If you don't have a portfolio strong on completed public artworks, it's possible to win over a selection committee on the strength of your vision for a particular project as long as you can also convince them of your ability to follow through with it. Additionally, RFPs are usually issued by smaller, less established agencies that aren't as concerned with getting a big-name artist as they are in minimizing their upfront risk by commissioning work their public can live with and that they can afford. You

7 Mike Mandel, via email (with permission), posted to the PAN listserv, November 14, 2006.

won't have as much competition, either. Experienced artists are less likely to apply because smaller agencies mean smaller project budgets and they don't have the time to come up with an idea on speculation.

I'm happy to report that in the ten years since I wrote the preceding paragraph, RFPs have become almost entirely a thing of the past. On the rare occasions when they are issued its either because they're actually an RFQ in disguise that the agency's purchasing department is making them call an RFP for legal reasons or because it was written by someone who isn't familiar with current best practices in the field. The Americans for the Arts Public Art Network now recommends this policy: "Request for Proposals (RFP) can be an effective way to consider and evaluate the appropriateness of an artist when a limited number of artists are invited to participate in a selection process, the criteria for selection is explicit and uniform, and there is an honorarium paid to each artist for each submission. Proposals should only be requested when the commissioning agency/organization is prepared to consider the proposal as a conceptual approach to the project and not the final design. The commissioning agency upholds that all ideas presented for the project, including copyright, belong to the artist."[8]

PERSISTENCE PAYS

The thing that's going to keep you from winning commissions isn't going to be your artwork—assuming it's reasonably competent, original, and appropriate for public settings—it will be your stamina for sticking with the application process. Too many artists think that the first couple of rejections mean that their work isn't right for public art or that they don't know the secret handshake. They give up just when they should be persisting. By applying for project after project that interests you, you streamline your application materials and process, learn a little more about how the system works, and, most of all, you're repeatedly getting your work and name in front of people who are always looking for art. You increase your chances of winning exponentially the more competitions you enter.

The name of the game is to get some finished projects in your portfolio. Whether they're in Mongolia or Manhattan, temporary or permanent, private

8 Americans for the Arts, "Frequently Asked Questions," accessed August 5, 2018, https://www.americansforthearts.org/by-program/networks-and-councils /public-art-network/frequently-asked-questions.

or public, paid or pro bono, it doesn't matter. Once you get a track record that shows you can complete projects on time and on budget and compile three solid references, preferably from public art managers who have worked with you, you'll no longer be an anonymous part of the herd in these cattle calls.

Anatomy of a Call for Artists

The Selection Process

A well-designed call seeking artists for a specific project, whether an RFQ or RFP, will contain similar basic components.[1] I've listed them here in the order I think makes the most sense in deciding whether to apply.

COMPONENTS OF A CALL

Deadline. Obviously, if you've missed the deadline or don't have enough time to apply, there's nothing you can do. Happily, most applications can now be submitted digitally, so we rarely need to rely on the tender mercies of the US Postal Service. All we have to worry about now is making sure that we hit Send before the application period snaps shut. Deadlines are even less forgiving now than when we had to mail in a packet of slides or a thumb drive. Agencies can't hold the deadline open for one person if they don't do it for everyone, not only because it's a government procurement process but because the ire of one irate applicant could cause a lawsuit or a stink in the press. Besides, it doesn't really work in your favor to make a first impression as the artist who expected special treatment for not being organized enough to get your application in on time.

Artist Eligibility. Read this section of an artist call next to avoid spending time getting excited about the call before you discover you're not eligible due to a technicality such as not living in the targeted geographic region.

1 Section headings taken from Renee Piechocki, *Call for Artists Resource Guide* (Washington, DC: Americans for the Arts Public Art Network, 2003), 1–4, https://files.nc.gov/ncarts/pdf/Call%20For%20Artists%20RG.pdf.

Generally speaking, the larger the budget, the wider the net the agency will cast for artists—unless it's super prestigious, then it'll likely be an invitational. Conversely, small towns or cities with small budgets will tend to stick close to home to find artists. Also, find out if the call is open to students or to artists who have a lot or a little public art experience. The call should specify if the agency is encouraging applications from artist teams, those willing to mentor emerging public artists, or students.

Selection Criteria. This is where you will find out if you have the qualifications to apply. Once you get past "artistic excellence," which they all list as a criterion, you'll find specifics on whether they're looking for artists with X number of years of experience in a certain art form and whether artists new to public art or students should apply. A more subtle request is for examples of completed projects. That means if you were planning on showing images of ideas that weren't executed (such as models for finalist proposals) to beef up your portfolio, you're out of luck.

Project Description. Is the project for a design team, artist residency, or a commission for a new or existing work? Are they looking for a suspended sculpture, landscape design, light installation, portable works, or what? If you only do 2-D work and they want an artist to write a plan for restoring a wetland, think about forming a team, or pass on it.

Call Summary. Some calls will open with a brief summary of the requirements and description of the competition that you can use to decide whether you're qualified or interested enough to read on.

Budget. Read this with a cold eye to make sure that the scope of work they're asking for in the project goals meshes with the amount of money they have to do it with. Writing realistic budgets is a skill that comes only after years of experience, and some of the administrators who write these public art budgets aren't experienced enough to know how much it takes to make a work of art happen. (I know of one where they even forgot to include an artist fee, and another where they thought artists would work for free just for the "opportunity" to create artwork for their city.)

If it looks like the budget is too small but you're still tantalized by the project, it wouldn't be a waste of time to call up the project manager and ask him if he anticipates additional money from fund-raising or from transferring

overlapping costs from the construction budget (called "construction credits"). Before you throw it away and move on to the next opportunity, ask yourself if there would be other benefits of applying, such as gaining experience, exposure or, simply, because you're inspired by the challenge.

For the sake of all working artists, however, I must insert a caveat: when you succumb to agency administrators who assume artists will work for little or nothing, it only perpetuates the practice of not paying artists a living wage and undercuts the rest of us who can't afford to subsidize large bureaucracies with our personal income.

Project Timeline. Like the project budget, this is another section that bears close scrutiny. Timelines, like budgets, take skill and experience to craft realistically. Consider it a red flag when the artist is given very little time for concept development, execution, or installation. It can be a sign that the agency doesn't understand what goes into making a site-specific artwork, or that it is simply unorganized, unprofessional, or inexperienced, or all of the above. That said, you can turn a situation like that to your advantage by how you present yourself. Go into it as someone who can help save the bureaucrats from their bad planning by being organized, professional, and with your eyes open—and cushion your timeline and fee to make up for the inevitable hassle that is to follow.

Artwork Goals. After checking out all of the technicalities you could get snagged on, you still think you've found a project you can apply to, read this section between the lines. It's where the commissioning agency tells you its hopes, dreams, and fears for the project. There could be all manner of good information here, like how much the agency wants the artwork to tie in with the community, or whether it should be about the area's history or the environment. You never know what you're going to find in this section. Then do a gut check. Are you at least a little inspired by this challenge? Are you already starting to see in your mind how your work could look in the site? You don't need to have a fully fleshed-out idea at this point, in fact it's better not to, but feeling some flicker of enthusiasm is a good sign.

The trick is, you don't want to ignore what agencies ask for—after all, it took someone, or several someones, hours to come up with this section—but you also don't need to be slavishly literal in conforming to it and limiting other creative solutions you might envision. As I will emphasize more than once in this book, the value we bring to each project is our unique perspective as artists.

Artwork Location Description. The call will, you hope, go into some detail here about the physical location of the site(s) the agency is thinking about, often including a link to the architect's drawings, if it's a new construction, or photos of the existing site. If it's an RFP, it should go into a lot of detail since you are being asked to come up with an idea for a place you probably won't get to visit at the open-call stage. Even if there's an X-marks-the-spot where the agency wants the art to go, cast about in your imagination for alternate, expanded, or additional sites for your work. (One artist I know responded to an RFP for a library mural with an idea for a text-based installation over all of the fluorescent light fixtures.)[2]

Site History or Description. This will be a short history and general description of how the site is used—something like what you would find on the city's website or in a tourism brochure. It can be valuable information if you combine it with the section on the artwork goals.

Application Requirements. In comparison-chart form, the application materials you typically will be asked for are as follows:

Application Materials	RFQ	RFP
Resume and/or bio*	X	X
Images of work (slides or digital)*	X	X
Annotated slide list*	X	X
Letter of interest	X	X
Application form	X	X
Professional references	X	X
Sketch		X
Preliminary budget		X
Concept narrative		X

You will always be asked for these; the other items will vary from agency to agency. Take note of how they want files and images to be named and the pixel dimensions they require for the images.

2 B. J. Krivanek, http://www.krivanek-breaux.com.

Selection Process. Sometimes the call for artists will let you know who comprises the selection committee (i.e., how many artists, architects, and community representatives will be making the decision). It's a good way to get a quick read on how big of a deal the project is to the agency in the scheme of things. If the mayor, philanthropists, and world-renowned curators are on the panel, that tells you one thing. If it's artists and community representatives, as you will find most often, you'll have a better chance of having your work considered if you're not an art star.

DECIDING WHETHER TO APPLY

There's one more step you can take in deciding whether you should apply. Go to the agency's website and check out what types of other projects it has commissioned. See if it looks like a collection you want to be associated with or that would be amenable to your work. Be sure to ascertain if it has recently had a change in direction. For example, say the agency used to only collect figurative pedestal pieces, but now it has a new program administrator who is looking for work that is more site integrated.

In summary, ask yourself these questions:

- Can I meet the application deadline?
- Do I meet the eligibility requirements?
- Is my work a good fit for the project?
- Is the budget realistic vis-à-vis agency expectations, my income needs, and the cost of production? If not, are there nonmonetary benefits to applying, such as gaining experience or exposure?
- Is the project deadline realistic given what is asked for?
- Can I meet the project deadline given my schedule?
- Am I inspired by the project?
- Is the agency's collection a good fit for my work?

If you can answer yes to all of these, then start filling out the application.

THE SELECTION PROCESS

A typical transaction through a gallery includes the dealer, maybe an art consultant, and the client—the most layers an artist will encounter before his

work reaches its final destination in a collection. But as soon as an artist sets out on the path of accepting the public's money for his work, he encounters a chain of accountability that stretches up into the highest level that particular bureaucracy has to offer, be it the city council or state legislature, mayor or governor. It's these levels of fiscal responsibility that drive the selection process, and all the processes that follow, for government-funded art purchases.

The main thing you need to keep in mind is that the selection process is done by human beings. There's no scientific formula. This works out in your favor two reasons:

1. If you get rejected by one selection panel, you could get a call the next day from another one that you've won. It's not as if you've got "Loser" permanently tattooed on your forehead. It's more like the lottery, but with a much greater chance of winning.
2. Human beings can be influenced. I'm not talking about anything nefarious. I simply mean that by committing to your work and being persistent, professional, and smart about the business of art, it is possible to build up your reputation and get the attention of the people who make decisions about who gets chosen for commissions.

The selection process for public commission competitions is pretty much consistent across agencies no matter which government department the public art program is housed within—be it parks, building, tourism, transit, facilities, planning, or cultural affairs. For each call for artists, the project manager will put together a selection panel, the composition of which will be determined by the enabling legislation for the percent-for-art program. There will usually be two or three arts professionals (artists), one or two community representatives (folks from the population to be served), one or two "client" representatives (for example, if the artwork is to go into the public library, the director of the library or her designees will be there), and sometimes, but not always, the architect will be present if it is a new building.

The project manager will often facilitate the process. Even though the public art agency staff does not usually get to vote, they can have a lot of influence. Because the project manager knows more about the work at hand than anyone else in the room and is considered an art expert in general, he or she will often be asked for an opinion by the committee. I've seen artists'

work torpedoed with as little response from the project manager as a wrinkle of the nose and a hesitant, "Well . . ."

The bigger the budget and visibility of the project, the more high-profile and national in scope the selection panel will be. If it's a small mural, for example, the artists on the panel will be local. If it's a library designed by a famous architect, artists with a track record of major projects may be flown in to serve along with a prominent local artist. The community members and the client representatives will most likely be nonarts professionals. The inevitable dynamics occur where strongly opinionated people or those recognized as art experts will dominate or be deferred to. The same thing may happen when someone with perceived higher status in that particular hierarchy is on the jury—such as doctors if it's a project for a hospital, judges if for a courthouse, and so forth. A skilled project manager or committee chair will know, ideally, how to keep the alpha panelists from overrunning everyone else.

Jill Manton, director of public art for the San Francisco Arts Commission, observed the following about the selection panel process: "Sometimes there is a lack of consensus between the people on the panel with an art or design background and those who do not have this background. Everyone ends up compromising by going with their second choice. Sometimes that results in work that is acceptable, but not spectacular."[3]

A Word about Public Art Program Managers

In the vast bureaucratic hierarchy you'll be dealing with when you work with a government art agency, whether at the federal, state, or local level, your point person will most likely be the public art program manager. In a large agency, there may be four or five such staff members in charge of specific projects who report to the head of the department, the public art program director. In the smaller agencies, the program director could be the only employee and in charge of overseeing each project himself or, perhaps, a consultant on contract. You can't assume this person even has an art background; he could come from urban planning, engineering, or architecture. Nor can you assume that the municipality even has a public art department. You could be dealing with a manager whose main job is to oversee some other area such as planning, parks, or tourism.

3 Jill Manton, Public Art Program Director, San Francisco Arts Commission, interview, January 22, 2007.

The public art manager is your point person for all things related to the agency, from the moment you get the call for artists to the dedication ceremony once you've completed the commission. Your goal is to develop a comfortable rapport with this person, but you must always remember that she is your client first and foremost—not your best friend, mother, teacher, or therapist. The manager doesn't need to hear how overwhelmed you are with obligations, that your marriage is breaking up, that you have a lot of self-doubt about your work, or any bad experiences you're having with other projects or artists. Even if all that is true, the face you show to your point person is always competent and can-do. You'll be glad you've kept a pleasant, yet professional working relationship with her when it comes time to negotiate contracts, navigate conflicts, or get a referral instead of using her as a sounding post for your personal history and problems.

Potential clients, in this case public art managers, begin to form an impression of you from the very first contact you have with them no matter how small, such as the type of questions you ask when you email them for clarification of the RFQ or RFP, whether you respond promptly with a thank-you note, your phone manner, the quality of your presentation materials, and how well you followed the instructions on the application. They will pick up on whether you have an innate desire to work with the public and your level of confidence and competency.

Contrary to what you've been told your whole life, there *is* such a thing as a stupid question. When dealing with the public art manager, it's not the time to play the wide-eyed ingenue. You need to inspire confidence from your first contact.

An artist emailed me as I was in the middle of writing this book to say that she had given up applying for public art commissions because of a bad experience she'd had a couple of years ago. Right out of undergraduate school, she entered an open call, was chosen as a finalist, and was up against several other more experienced artists. She didn't know how to put together a finalist proposal and said that, despite repeated calls to the "committee," she didn't receive any help or guidance. Eventually she withdrew from the competition because she couldn't assemble the materials, saying she "felt hung out to dry by the committee." Assuming she meant that she was calling the public

art manager and not "the committee" (you shouldn't contact anyone on the selection committee unless it has been cleared by the project manager), what she inadvertently did was convey to the client that she didn't even have the experience to complete a proposal let alone a site-specific installation.

There's nothing special about public art managers beyond how any other human being is wired. We make our initial judgments of people from the smallest signals. Most of all, project managers will be watching to see if you are someone they can count on to take a commission through the long journey to completion with minimum grief to them and their agency.

BACKSTAGE AT A SELECTION MEETING

Because the selection panel will be potentially looking at hundreds of artists' work, a three-tiered weeding-out process will most often be used to make things more manageable. After being briefed about the project goals and selection criteria from agency staff, panels typically go through the following stages:

1. **First cut:** All of the images are looked at quickly with committee members giving each artist's work a simple "Yes" or "No." The yeses stay in for the second round. The majority of artists will not make it through this stage, mainly because their work doesn't fit the criteria or their images are substandard. Sometimes all the artists' names are deliberately withheld, called a "blind jury," so that the committee will focus only on the quality of the work. That doesn't always prevent panelists from recognizing artists from their work and asking aloud if they were right about guessing who they were. No matter how objective panelists are trying to be, if they remember your work from having seen it before, they will have probably formed an opinion about it, whether they are aware of it or not. In general, name and work recognition tend to act in the artist's favor.

2. **Second cut:** The images are viewed more slowly this time around. There may be minimal discussion for clarification or to indicate personal preference. Resumes may be consulted. A

scoring sheet will often be used, with one being low and five (or ten) being high. The images may be gone through again. At the end, the scores will be tallied and the highest scorers will move on to the next round. Sometimes panelists will be given a chance to bring one of their favorites forward if the artist didn't score high enough to qualify in order to argue a case for him or her in the third round.

3. **Final cut:** Much discussion will occur at this stage. There may be only a dozen or so artists left to whittle down to three to five finalists. Letters of interest will be consulted. Resumes will be rereviewed. Images will stay up on the screen for a long time while the panelists take turns discussing the merits of past work and its applicability to the current project. Several votes may be taken with more discussion and advocating for certain artists, until the finalists are decided on.

 If the call for artists was an RFP, the deliberations will be even more lengthy as the panel goes over the concepts submitted by each artist and analyzes the preliminary budgets and timelines for completing the work.

 The finalists will be given several weeks or months to put together a more detailed proposal to present to the panel in person. In chapter 5, we'll go over the components of a finalist presentation.

SELECTION CRITERIA

As I mentioned earlier, artistic merit consistently tops the list of criteria agencies cite for choosing artists. While that is vague and subjective, selection panels all over the country manage to arrive at a consensus. Here are the stated criteria from five different calls where you'll see how they range from general to very specific.

Points Criteria

25 Artistic merit of proposed design and quality of materials
25 Meets program goals and criteria; ability to complete the project
20 Degree of benefit to and involvement of the community; design
reflects community characteristics
10 Visibility of location to the public and accessibility for the disabled
5 Feasibility of long-term maintenance to the public art project
5 Inclusion of a public outreach/education component[4]

———————————

- Ability to create art of unique vision and of the highest caliber
- Ability to create art that is sensitive to budgets, schedules, and maintenance issues
- Evidence of successful experience in public art commensurate to the particular commission for which one applies
- Ability to respond to the requirements of this call for artists
- Demonstrated career as a working artist[5]

———————————

- Professional qualifications
- Proven ability to take on the given project
- Artistic quality of the submitted materials
- Demonstrated ability to work with committees and community groups in the creation of a project[6]

———————————

4 Palm Beach County, "Public Art Improves Our Community" [Matching Grant Program Description and Application], accessed February 21, 2007, http://www.pbcgov.com/fdo/art/Downloads/010207%20APR%20extend%20deadline%20GRANT%20APPLICATION.pdf.
5 City of Pasadena, "Call for Artists: Request for Qualifications, Pasadena Center," accessed February 21, 2007, http://www.ci.pasadena.ca.us/planning/arts/Documents/PasCenter/PCRFQ.pdf.
6 City of Laguna Hills, Public Art Program, "Request for Qualifications: Civic Center Early California History Display and Council Chamber Murals," January 23, 2007.

- The artist's professional qualifications
- Proven ability to undertake projects of the described scope
- Artistic merit as evidenced by the slides and other supporting materials
- Appropriateness of submission to project intent and site[7]

Criteria for the Artist and the Resulting Artwork

- Incorporate elements from the surrounding environment into design.
- Only 2-D and 3-D art proposals intended to be permanent will be considered.
- Artwork must require low maintenance and be vandal/weather resistant to the extent feasible.
- Proposals must focus pedestrian activity and/or seating areas toward the eastern end of (location).
- Artwork sited on the sidewalk adjacent to or in front of the (location) will need to comply with the county's building security objectives for emergency access and evacuation.
- Movement of pedestrians should not be obstructed.
- Designs must be in compliance with all city codes regarding safety, accessibility, and other structural and maintenance issues.
- Artists may apply individually or as a team. Professional artists or artist teams with experience in the field will be given preference.
- Artist designs will be presented to the community, the project advisory committee, the (location), city departments, and appropriate city authorities for review and approval.
- Artists will be required to collaborate with and be available for meetings during the design and implementation process

7 New Mexico Arts, Art in Public Places Program, "Prospectus #185, New Mexico School for the Deaf," accessed February 21, 2007, http://www.nmarts.org/pdf /prospectus185.pdf.

with community members, project advisory committee, and city department staff.[8]

A spokesperson for the Metro Nashville Arts Commission said the two winning artists the committee selected from 171 applications "came down to who had best understood and creatively responded to the goals of the project, which were to enliven the space, to create a sense of place, and to add to the good job that the design team had already done with the space."[9]

Sometimes the criteria or parameters of the project changes during the selection process as the panel sees approaches it hadn't considered in the submitted images. Because this is the first chance panelists have had to discuss the project as a group, a completely new direction from that stated in the call for artists could arise out of that synergy. Like I said, it's a process done by human beings.

––––––––––––––––––

In the next chapter, I'll go over how to put together an application that will show your work to its best advantage and how to avoid disqualifying yourself with a bad one.

8 City of Las Vegas, "Lewis Avenue Justice Quarter Enhancement," accessed February 22, 2007, http://www.lasvegasnevada.gov/files/Lewis_Street_Corridor_RFQ.pdf.

9 Jonathan Marx, "Two Art Projects Selected to Grace Public Square," *Tennessean*, September 29, 2006.

Application Readiness

In the end, the quality of your work and its suitability for a particular project are the deciding factors in winning public art competitions. You're not going to blind the committee to inappropriate or incompetent work with a slick presentation, but there are many things you can do to increase your chances—and avoid sabotaging yourself right out of the starting gate.

The object is to apply for as many projects as you're qualified for and interested in, while cutting into your studio time as little as possible. Responding to a basic RFQ can take anywhere from forty-five minutes to several hours depending on how you've organized your application materials. An RFP can take several days. If you have the basic components of an application ready to go, you won't have to start from scratch every time. In other words, strive to streamline the application process. It's the next best thing to money in the bank.

Unlike when I first wrote this book, no one asks for slides anymore, and applications can be submitted digitally. At the very least you'll need to have a comfortable familiarity with these programs or know someone who does.

- **Word-processing programs such as Microsoft Word and Google Docs.** You can also use them to insert pictures, which will come in handy when creating your annotated image lists.
- **Photoshop.** It's the best way to tweak images of your work; create composite pages and two-dimensional mock-ups of your idea; and resize and reformat images to send as PDF, JPEG, and TIFF attachments that your clients and fabricators will need. It's also your gateway software for preparing website images to maximum effect.

 The good news is that while Photoshop is a complex and powerful program, you only need to know how to use a few

of its functions for presentation purposes. Unless you're doing serious photo work or running a print shop, all you have to learn is how to import digital images, resize, reformat, color manage, adjust image quality, and add text.

Photoshop has a good tutorial through its help function, and there are websites and books where you can teach yourself the skills you need in a short time, as long as you don't get intimidated by the program's many bells and whistles.

- **Microsoft PowerPoint, Apple Keynote, or Google Slides.** If you're able to learn a few Photoshop techniques, PowerPoint won't be a challenge. It's simply a way to create a slideshow presentation with digital images. Some agencies are catching on that if they ask artists to submit their portfolios preformatted in PowerPoint, they won't have to pay an office assistant to compile hundreds of images into a PowerPoint presentation. CaFÉ removes this burden because it functions as a platform as well as an application portal.

 In PowerPoint you can add text, special backgrounds, and moving objects, but I suggest you not do that. You don't want selection panels to focus on anything but your work. So no busy backgrounds, swooping text, or sound effects. One great thing about PowerPoint is that you can insert video (with sound) of your work to play as part of your presentation.

- **Website.** You need to have a website that functions as a portfolio because selection panels these days expect to be able to find out more about your work in an instant. There are a ton of plug-and-play website templates you can use that are designed for users who want to emphasize images. Weebly and Squarespace are popular now and work well.

- **Accounting.** Software like QuickBooks allows you to set up and keep your books, track money that's coming in or going out, print profit and loss statements, automate bill payments, and much more.

- **Microsoft Excel or Google Sheets.** Spreadsheets are many-layered, powerful programs that you could use to bestride the world like a Colossus. Or, you could use them to simply add and subtract columns of data. For example, it's a great program for setting up a log of the tasks and hours

worked on a project, getting an overview of your cash flow, or designing your own inventory system.

- **3-D rendering.** My personal favorite is SketchUp because I was able to learn it in an afternoon and it's good enough for what I need to do, which is show how my work would look in a virtual 3-D model. It's available for free from Google and allows you to model geometric shapes, apply textures to them, and zoom and rotate freely throughout. You can create a slideshow of views from different angles, fly throughs, or export freeze frames as JPEGs. You can also place your model in Google Earth. After SketchUp, the complexity and sophistication of 3-D modeling programs goes up from there, some of which can be downloaded for free from the internet. Do a search for 3-D modeling programs and find one you feel comfortable with. Beyond that, there's game development software and virtual reality. That level of realism hasn't made its way into public art application yet, but it's only a matter of time. Realistic renderings, however, are starting to show up in finalist proposals, especially as more trained architects apply for public art commissions.

Architects and engineers use computer aided drafting (CAD). Because I don't know much more about it than that, I'm going to let Michael Hale, an architect with Rowland Design in Indianapolis, explain it:

The predominant software used for this in the industry is AutoCAD produced by a company named Autodesk. The software permits architects and engineers to produce (primarily) two-dimensional construction documents with a high degree of accuracy, and the ability to modify those documents in a much more timely and efficient manner than by producing drawings by hand.

Now the coming thing is something called Building Information Modeling (or BIM). The primary difference in this software and previous configurations of CAD is that this software automatically draws everything in three dimensions. This facilitates much better coordination between architects' and engineers' drawings, primarily enabling discovery of conflicts between architectural,

structural, or mechanical/plumbing system elements in the design process and thus reducing field problems during construction.[1]

Hale says that even as a trained architect, it took him six months of working in CAD every day to learn it. While it is second nature to him now, he can see how artists would find it too technical, cumbersome, and restrictive for more creative uses. Unfortunately, if you win enough site-integrated commissions, you're eventually going to encounter a fabricator, contractor, or architect who won't be able to incorporate your drawings unless they can be opened in CAD. If you do an internet search for "CAD converter" you'll be able to find plug-ins for graphics applications such as Photoshop and Adobe Illustrator and third-party software that will allow you to export your files so that they're readable by AutoCAD and vice versa. Free downloadable versions of CAD are available on the internet.

DIGITAL IMAGES

Start with 300 ppi digital files of all of your work, preferably in Photoshop because it is the best for tweaking image quality and offers many different formatting options for sharing your files. Thanks to the consolidation of application portals like CaFÉ, SlideRoom, and Submittable, it is now easy to meet the Tower-of-Babel range of image format requirements. Out of curiosity I compiled this sampling of the different digital file formats requested in calls for artists that came across my desk while I was writing this.

Public Art Agency	Image Submission Requirement
Cultural Council of Greater Jacksonville (FL)	"1920 pixels on the longest side and no less than 72 dpi, for a range of 2–5 MB each image"
City of Evanston (IL)	CaFÉ
City of Oklahoma City (OK)	"digital images in jpg format, not to exceed 2MB in size (use image resolution not less than 72 ppi and not more than 200 ppi)"
Arts and Science Council, Charlotte (NC)	SlideRoom
City of Columbus (OH)	CODworx "images should be from 70–100 dpi"

1 Michael Hale, graduate architect, Rowland Design, Indianapolis, Indiana, via email, March 12, 2007.

Monroe County (FL) Art in Public Places	"five (5) to ten (10) images on a digital data storage device"
Cambridge Art (MA)	SlideRoom
City of Boynton Beach (FL)	"dimensions minimum 4 inch, maximum 10 inch with common aspect ratio sizes preferred. JPEG or PNG 150 DPI min, 300 DPI maximum"
City of Durham (NC)	CaFÉ

RESUME

Resume formats for artists have consolidated into those recommended by the College Art Association (CAA). Go to the CAA website and look for "Artist Resume" and "Visual Artist Curriculum Vitae." Their outline is so detailed that there's no need for me to reproduce it here and so thorough they even show you the correct pronunciation and punctuation for "curriculum vitae."

ANNOTATED IMAGE LIST

Using Photoshop, Word, or another program that allows you to easily manipulate text and images, create a master list consisting of thumbnail images of all your completed work accompanied by text that lists title of the work, date, dimensions, materials, location, client, fabricator(s), total budget,[2] firms of design team members involved (if any), and any other collaborators. You can cut and paste from your master copy when you're tailoring your images to specific applications.

Remember that the selection panel will be reading this in semidarkness, so be sure to use 12- or 14-point type and plenty of space between each section. While they may ask that resumes be kept to one or two pages, they rarely ever ask that there be a page limit on image lists. Err on the side of readability. And don't forget to put your contact information on the first page with your name on every subsequent page. You want them to remember whose work they're looking at.

2 Budget: If the project was self-financed, such as for a student assignment or done on speculation, include the amount it would cost if you were to factor in your artist fee, profit, labor, insurance, travel, and other expenses. If it's an object for sale, put "price" instead of "budget."

As far as image order, there's nothing magic about it that's going to make the difference between winning or losing, but one rule of thumb is to start and end with your strongest images. The first one makes the initial impression, while the last one is usually what's left up on the screen if there is discussion about your work. In between, try not to jump around. There needs to be some logic to the order. Group by commonalities, such as style or medium rather than chronologically. If you haven't done very many public art commissions, use details and images of people interacting with the work.

The more complex and dimensional each piece is, the more details will be needed to show it to its best advantage. For two-dimensional work, a site shot and a close-up of the surface material should be enough. Sculpture, interactive, and time-based work will need more details. If you're not allowed to submit a video as part of your application, a sequence of photos can create an effective visual narrative that will give the selection panel a feel for the work.

Some artists put all of their thumbnail images at the top of the page with corresponding numbers; others place them along the side. It's up to you if not specified in the application instructions. Here's one possible format for a single image:

01. Title Date
 Medium Budget*
 Client (or commissioning agency)
 Collaborators/Fabricators (if any)
 Description (one to three sentences)

If the project was self-financed, such as for a student assignment or done on speculation, include the amount it would cost if you were to factor in your artist fee, profit, labor, insurance, travel, and other expenses. If it's an object for sale, put "price" instead of "budget."

With the ability to manipulate images digitally, it's easy to do a convincing virtual mock-up so that it looks like the work exists in real life. It's perfectly legitimate to include finalist proposals in your portfolio, even if they were not realized. After all, they're still a product of your creativity. If you do submit this hypothetical work, however, be sure it is clearly labeled as "unrealized," "concept drawing," "unfunded," "mock-up," or words to that effect. Independent public art consultant Joel Straus says inexperienced selection panels don't get it when these composite images are mixed in with finished projects. "They feel like they've been swindled" once they sort out what's real

and what's not.[3] And if the agency specifically requests that only *completed* projects be submitted in your application, then positively do not include these speculative ones. It will backfire on you because your credibility will be called into question.

Also, I've seen artists who go text crazy on their composites with blocks full of tiny type everywhere, their unreadability compounded by light fonts on black backgrounds. No one can read that when it's projected at 72 dpi, and it's so distracting that by the time viewers figure out where to rest their eyes, the screen has switched to another image. Take pity on the committee. Keep your images clear and simple.

REFERENCES

Current references who will vouch for your work, professionalism, and integrity are important to have on hand. They're not often asked for in the initial call but will be required when you become a finalist. The below are in order of strength:

- Public art program managers and other clients who have commissioned your work
- Prominent public artists
- Curators and critics
- Former art professors
- Art advisors and dealers who have a stake in selling your work

Be sure you get permission from everyone whose name you use (and be sure to thank them). While you're at it, ask them if they want to be notified every time you use them as a reference or if they give you blanket permission. One of my references likes to be told every time so that she can tailor a rap in my favor for each specific project. Another said I don't need to ask him every time, that he's prepared to be there for me. Don't let your references get stale. Keep them up to date with your work so that you're not calling them out of the blue every few years to ask for the favor of a reference.

3 Joel Straus, telephone interview, February 2, 2007.

SUPPORT MATERIAL

Tear sheets, catalogs, postcards, exhibit announcements, and copies of any articles written about your work should be scanned and saved as PDFs. Once in a while, an agency will ask for "support material," and that's what they're referring to.

LETTER OF INTEREST

The letter of interest, sometimes also called the statement of qualifications, is important. It is not an artist's statement, although you can incorporate parts of it. The letter of interest is specific to the project you're applying for. It's a chance for you to sell yourself to the selection committee, giving them a glimpse into your personality, professionalism, qualifications, and enthusiasm for a particular project. It will not make up for lousy images or work that is not a good fit for the project, but it can tip the decision in your favor when it's a close call between you and a handful of other artists. In some cases, if it's beguiling enough, it can even make up for lack of experience evidenced in your portfolio.

Cath Brunner, 4Culture's director of public art, says when writing a letter of interest:

> Artists without previous public art projects need to pay attention to the prospectus that describes the project—what will be the artist's job assignment ultimately if he or she is selected? If the prospectus says the project will require working with a community group—think about it. Have you ever led a neighborhood action committee? Have you ever organized a rally or served as a scout troop leader? Do you actually live in the neighborhood where the artwork will be located, and therefore have firsthand, in-depth knowledge of the site and the neighbors? Those are "qualifications" related directly to the job. If the public art project is in a hospital, I have seen first-time artists selected because they had worked as summer interns in a hospital or they had undergone extensive treatments as a patient and could understand the environment and the challenges that patients might face. The cover letter illustrates to the panel how well you communicate with others—use it to talk about why the panel should take a risk on you and your art and why you are interested in doing art for this particular project.[4]

4 Cath Brunner, via email exchange with author, June 22, 2007.

Anatomy of a Letter of Interest

Most calls for artists ask that the letter of interest be kept to one page, so you need to make the most of it. While certain sections, such as your previous experience, can be more or less boilerplate, a letter of interest needs to be a custom-made response to each RFQ.

First Paragraph

Your first paragraph, starting with the very first sentence, should reflect the affinity you feel for the project that led you to apply in the first place. This is where you make your initial impression, so it needs to have some energy behind it. You want the panelists to keep reading. By the time it gets to the point where they're reviewing the letters of interest, it's been a long day of looking at images in the dark. It's most likely after a lunch of carbs and everyone is a little logy. Your first sentence needs to be peppy enough to snap them out of it. If you're not the perky type, that's okay. Just be the version of your best self that lets your personal style and enthusiasm show through. If you don't feel that way about a particular application, then consider not applying for it. Calls for artists are like buses; another one will be along in no time. Save your effort for the ones that spark you, unless you want to do it for the practice.

The first paragraph is where a careful reading of all of the narrative sections of the call for artists is crucial. Dig deep and try to understand what is important to them. Highlight adjectives in sections that go over the site's history, goals, and physical description. Pretty soon you'll start getting a feel for the project. Here are key words I found in some recent calls for artists.

- Public Art for Black Wall Street Gardens, Durham, NC (Budget $50,000)[5]:
 "signature, permanent piece of public art"
 "to commemorate and illuminate"
 "legacy of Durham's African-American business community"
 "Black Wall Street"
 "Capital of the Black Middle Class"
 "Themes: Inclusivity, Diversity, Community, Activism, Creativity, Entrepreneurial Spirit, and

5 City of Durham, "Public Art for Black Wall Street Gardens" Request for Qualifications, July 19, 2018.

Progress"

"Aesthetic excellence"

"Community engagement"

"Materiality"

- Health Education Outreach Center, Colorado State University, Fort Collins, CO (Budget $130,000)[6]:

 "state-of-the-art laboratories"

 "subjects central to human medicine'

 "bring science to life"

 "activate the exterior"

 "operate on campus scale"

 "engaging"

 "assist with wayfinding"

 "enhance sense of arrival"

 "single, large scale artwork for one of the locations or multiple artworks in a series"

As you can see, there is a treasure trove of information distinct to each project. You need to directly address the particular wishes and concerns of the committee in your letter of interest. Show that you carefully read the call and that you understand what it requires by directly responding to the description they gave of the site, whether it's the history, environment, function, whatever. The main thing is to build off of what they say, not to repeat back to them the words in the RFQ. Another good source of background information is to look at the agency's website. You'll find useful information such as minutes from commission meetings pertaining to this project and the agency's public art master plan with its philosophy and mission statement, and you may get a chance to see what other kinds of projects have most recently been funded.

Second Paragraph

What you focus on in the second paragraph depends on whether it's an RFQ or an RFP. If it's an RFP, which means the agency is looking for specific proposals, you'll need to go into preliminary ideas for the project. If you only know the site from the description given in the call, it'll be a little like playing darts blindfolded. You never know though—you might hit a bull's-eye.

6 Colorado Creative Industries, "Health Education Outreach Center, Colorado State University" Request for Qualifications, August 2018.

Any agency that has issued an RFP doesn't have a firm idea of what it wants. Because the committee members are shopping, you might as well let your imagination loose. Again, drawing on your careful reading of the narrative (and a call to the project manager for more information wouldn't be out of line at this stage), brainstorm a few options for them. Let them know you're flexible and interested in their input by saying something like, "Of course, I'm open to revisiting these initial ideas once I've had the opportunity to learn more about the project."

In an RFQ, where they're more interested in qualifications than specific proposals, use the second paragraph to refer to projects you've done that have some relevance. If, in your word hunt, you saw that they were emphasizing "community" and "equity," for example, highlight that aspect of prior projects. If "education" is their focus, then show that side of your work. There are many facets to your practice. You can shine a light on whichever angles you want them to see. You might even discover a few yourself that you didn't realize were there before. (Note: If you're responding to an RFP, this will be your third paragraph.)

Third Paragraph

This is a summing up in narrative form of your resume. It's where, in a matter of fact way, you describe your credentials such as your education, professional organizations to which you belong, work and teaching experience, and awards. Even if your prior experience wasn't particularly relevant, you can use what I taught you for the second paragraph to find relevance in it. Say you paid your way through college working in a frame shop. Well, there you honed your attention to detail, your listening skills, your ability to interpret each client's vision, and you learned the importance of art to people from all walks of life.

Conclusion

This where you say in your own words that you are excited about the project, think it's a great opportunity, and want to be chosen to do it. In business, it's called "asking for the sale." And don't forget to thank the selection committee for considering your application. If they've read this far, they deserve to be thanked.

The best way to illustrate these points is to show you an example of a call for artists[7] and the letter of interest from the artist who ultimately won the commission.

7 Reprinted with permission by the Public Art Program, Arlington Cultural Affairs.

EXAMPLE OF AN RFQ

Creative Waco[8]
Request for Proposals for "Sculpture Zoo"
Riverside Sculpture Project

Stretching from Baylor University to McLennan Community College, the Brazos River corridor runs through the heart of Waco, incorporating natural and cultural resources that include Cameron Park and the recently designated Downtown Cultural District. Located next door to historic downtown and at the convergence of two rivers, Cameron Park is an oasis with dramatic cliffs and ancient trees; a network of hike and mountain bike trails; and a delightful, natural habitat zoo. The Brazos River corridor is already home to an outstanding collection of public art that includes approximately forty sculptures, the most recent being *Waco Chisholm Trail Heritage*, created by renowned sculptor Robert Summers. The purpose of this project is to build on an ongoing effort to provide quality public art in the river corridor through the issuing of a Request for Proposals (RFP) for sculptures to be placed near the vehicular and pedestrian entrances to Cameron Park Zoo from the park. The proposed subject matter of the sculptures is animals found in the zoo and their symbolic or cultural meaning.

PROJECT DESCRIPTION

This RFP is extended to individual artists, art students, and design teams with no geographic limitations as to place of work or residence. Submissions may be in the form of new work or existing art available for purchase. The subject matter of the RFP is limited to sculptures of animals found in the Cameron Park Zoo. These pieces may vary in style and form from figurative to abstract but must be recognizable by the average person as representing the animal depicted. In order to be visible in an outdoor setting, the scale of the sculptures should be 1.5 times life size, with the exception of large animals (e.g., elephants), which may be depicted at less than life size or somewhat smaller.

Since the sculptures will be displayed outdoors and in the public realm, construction should be from durable and easy-to-maintain materials.

8 Reprinted with permission from Creative Waco.

Sculptures must withstand climbing and touching and not pose sharp edges or other safety threats. It is recommended that Public Playground Safety Guidelines are consulted. Plans must include structural drawings and specifications for production and placement of bases to which the sculptures will be anchored.

This project is being sponsored by a local philanthropist. Upon completion, the sculpture will be dedicated to the City of Waco as part of Cameron Park Zoo's twenty-fifth anniversary celebration. Creative Waco, Waco's Local Arts Agency, is assisting the City of Waco in the implementation of this project from the issuing of the RFP through the selection process and installation of the sculptures.

PROJECT GOALS

The goals of the project include the following:

- Place new, high quality works of public art that complement existing pieces in the Brazos River Corridor.
- Grow Waco's reputation as a community that values and supports the arts and as one of the State's newly designated Cultural Districts.
- Contribute to the celebration of the twenty-fifth Anniversary of the Cameron Park Zoo in 2018.
- Serve as a visual cue to guide people to Cameron Park Zoo.

SITE DESCRIPTION

The potential site zone encompasses a strip of land along the east side of University Parks Drive, beginning at the intersection of University Parks Drive with Colcord Avenue and ending at the entrance to the Cameron Park Zoo. Portions of the potential site are visible from the street, the riverwalk and/or the river. Priority will be given to those areas closest to the entrances to the zoo.

The site includes the following potential areas for installation of the sculptures:

- A relatively narrow grassy area along University Parks Drive as you approach the entrance to Cameron Park from Downtown Waco.
- A portion of the more open area known as Pecan Bottom as you enter the park that includes a pedestrian connection from

a boat landing on the river to the pedestrian entrance to the
Cameron Park Zoo.

- The grassy area across Cameron Park Drive from Pecan
Bottom adjacent to the gateway to the Cameron Park Zoo for
motorist and pedestrians.

BUDGET

The total amount budgeted for the project is $150,000 to result in four
or five sculptures. Artists may submit proposals for one to five sculptures,
with the cost per sculpture expressed as a portion of the total budget.
Submitted budgets should include artist's fee, travel, engineering, mate-
rials, fabrication, transportation, documentation, and installation exclusive
of the production and placement of bases/foundations, which will be pro-
vided by the City of Waco.

ARTIST ELIGIBILITY

- There are no restrictions regarding where artists live or work.
- This call is open to professional artists and/or students.
- Artist teams are eligible to submit proposals.
- Artists need not have completed a project of similar budget,
scale, and/or scope, but do need to show their capability of
doing so.

PROPOSAL REQUIREMENTS

Proposals should include the following information:

- Statement of concept and approach.
- Visual Support Materials—a maximum of twenty images of
proposed designs and examples of past work. Images should
be in JPEG or PDF format.
- Annotated lists describing the visual support material including
a description, material, location, budget, client and any other
relevant information.
- A Budget listing the anticipated costs.

SELECTION PROCESS

- Proposals will be reviewed by Creative Waco and City of Waco staff for compliance with minimum technical/safety requirements as stated in the RFP.
- Technically eligible proposals will be submitted to a jury consisting of professionals from the fields of art, design, engineering, and representatives from Creative Waco and the City of Waco.
- The Jury & Donor will select the finalists. *(Finalists may be invited to make a presentation to the jury.)*
- Final recommendations will be submitted to City of Waco Parks and Recreation Advisory Commission and Waco City Council for review and approval.

SELECTION CRITERIA
Artistic Merit

- Level of originality and creativity.
- How the artist's choice of material, presentation and display affect the visitor experience. .
- How the art relates to Waco and the Cameron Park environment.
- Visual impact.

Technical Merit

- Level of technical skill, artistry and/or craftsmanship exhibited.
- Sustainability/durability.
- Safety.

Supports Project Goals

- Complements existing public art in the Brazos River Corridor.
- Demonstrates the importance of creativity in art and/or technology.
- Overall impression.

Other

- Demonstrated ability of the artist or team to complete a project on schedule and within budget.

TIMELINE

2017

DECEMBER 1: Deadline for Artist Submissions

DECEMBER 2–8: Technical Review Panel

2018

JANUARY: Artistic Review Panel & Selection of Finalists

LATE JANUARY/EARLY FEBRUARY: Interviews & Final Selection

FEBRUARY 20: Presentation to Parks & Recreation Commission

MARCH 1: Presentation to City Council

MARCH–APRIL: Finalize Contracts with Artists

APRIL–AUGUST: Build/Make Period

SEPTEMBER–OCTOBER: Installation

NOVEMBER: Dedication of Sculptures

SAMPLE LETTER OF INTEREST

Fiona J. M. Bond, the executive director of Creative Waco, said that Dallas artist Andrew F. Scott's letter of interest stood out as one of the best. I am reprinting it here with Professor Scott's permission. Keep in mind this was written in response to an RFP, so it contains more detail about the final concept and fabrication than would be in a letter of interest for an RFQ.

Statement of Concept and Approach

The "Sculpture Zoo" Riverside Sculpture Project presents another opportunity for me to apply and expand the conceptual methodologies employed in my studio practice. Unlike the work I create in my studio where I have total control over the form, materials, and content of the work, public art projects are by their nature a collaborative process. Within this context, I view myself as a member of a team whose goal is the completion of a project that reflects values that enrich the lives of the community. My approach to public art projects takes the vision established by the client as the starting point of a creative problem-solving process that yields tangible solutions within the defined budget.

Each public art project presents a unique challenge defined by site, scale, and cultural context. As a result, my approach to these projects starts from a firm conceptual basis that considers each of these factors. In this case, both the subject and the site context are identified. Using animals found in the Cameron Zoo, I seek to create a series of four to five abstracted sculptures in steel that activate one or two of the designated sites along University Park Drive and the Pecan Bottom. As an artist and sculptor, I am aware and sensitive to the power and context of space. The best aesthetic solutions arrive through a thorough and thoughtful consideration of these factors. In the end, every space and site come with their own sets of attributes that influence the formal qualities of the artwork that engages them. As a result, I feel strongly that a site visit will be necessary before the final sculptural design can begin. The existing artwork along the project corridor makes this even more critical.

Zoological Tessellations
Concept

For thirty years my artistic practice has explored the relationship between computer graphic technologies and traditional sculptural practice. While initially attracted to these technologies as tools of design my current practice has expanded to employ them as a tool for manufacture. My familiarity with traditional studio practices combined with my skills in rendering, animation and digital fabrication allow me to conceive designs in a variety of materials at different scales. I will apply this approach to this project. For this project, I will create a series of sculptures based on planar abstractions of animals found in the Cameron Zoo Collection. The animals that will be utilized for the sculptures will be identified through consultation with stakeholders associated with the project. The site visit and interactions with the stakeholders will help to determine the location and appropriate scale of each work. The works will be unified in style while unique in their expression based on the variety and level of abstraction in each sculpture. The sculptures will be constructed using stainless steel or powder-coated steel.

Approach

A computer model of the animal will be created and posed to define each sculptural composition. The level of abstraction of each subject will be

determined through a process of polygonal reduction to determine the appropriate stylistic expression of the work. This model will then be used to create patterns expressed as either planar volume or linear forms. The stainless steel forms will be welded and attached to bases at the appropriate sites. I have both used and taught this fabrication process. I have also created several large-scale indoor and outdoor cardboard sculpture installations using this technique. The cardboard made using this approach provides templates for sculptures that will be fabricated permanently in steel.

As an artist and professor working at the intersection of digital fabrication technologies, traditional fine-arts practices, and collective cultural ideals, I use laser cutters, CNC mills, 3-D printers and scanning technologies as tools to fabricate sculptures and create installations and immersive visual experiences by bringing static objects to life using projection mapping. My creative practice spans more than three decades working in a variety of scales and in a variety of materials and digital platforms that have been exhibited worldwide in galleries, museums, and other venues. I have also created several permanent public art projects and participated on design teams with architects and engineers on major civic projects.

In 2014 I completed a memorial to fallen police officers for the city of Gainesville, Florida. In 2012 I was invited as the featured artist for the Cartasia Sculpture Biennial in Lucca, Italy. The work, *Black Man Grove Resilience*, graced the historic Piazza San Michele. During the same year my sculpture *Follow the Drinking Gourd* was presented at the PULSE festival and remained suspended in the atrium of the Jepson Museum throughout the year. In 2008 the world's largest gavel was installed in the south reflecting pool of the Ohio supreme court.

I am confident that I can create a series of sculptures that will complement the existing pieces along the Brazos River Corridor. The proposed solution to the project call will yield works that enhance the newly designated Cultural District and serve as a visual cue that guides people to the Cameron Park Zoo as it celebrates its twenty-fifth anniversary in 2018.

Tips from a Pro: Application Packets

Porter Arneill, Director of Communications and Creative Resources for the City of Lawrence, KS

After sitting on both sides of the community-based public art selection panel process, I've seen how artists can sharpen their competitiveness. Here are a few of my tips:

Make original, excellent art. Artists should make every effort to imbue their art with the highest aesthetic quality. The art should relate uniquely and authentically both with the artist and to the site. When a panel is struggling to pick between handfuls of artists, the quality of the work sways them most.

Volunteer to serve on a selection panel in your community, or, if appropriate, sit in on a panel. I remember the first panel I sat on as a young artist. I was amazed at the lack of knowledge of several of the panelists. One woman was hell-bent in believing that the colors of the art we selected had to match everything else. An older man was convinced that only figurative bronzes qualify as "art." Experiencing the process from a panelist's perspective is perhaps the most enlightening (and humbling) experience an artist will have.

Present the best possible photographic images. Competition is escalating in this field and decisions often come down to a razor's edge. After a panel views many strong images by a range of qualified artists, one or two poor photos might eliminate someone from the competition. Your photos are the primary example of your work, and a variety of people with a variety of experiences will be interpreting what they see.

Since this is public art, it's okay to include people in your photos, particularly for a sense of scale and to show human interaction. On the other hand, including cameo appearances by the artist (or his or her children, dog, cat, parrot, etc.) or staging photos with ballerinas or models is disadvantageous. Panels tend to see it as silly and amateurish. Also, make sure your annotated image list is accurate and that

it matches the photos the panel is viewing. I'm amazed at how often image lists submitted are out of order.

Be specific and demonstrate confidence in your letter of interest. The artists who are creating unique, innovative work *and* who articulate their ideas earnestly and effectively are the most successful. Personally, I'm impressed by artists who show a developed body of work and who confidently explain how they will use their experience within the context (and challenges) of the public realm.

Regularly refine and improve your qualification packets. I encourage artists to host a gathering of their art and nonart friends (heck, grab a complete stranger) and run their materials past them. Seeking this type of honest critique is extremely helpful in gaining an outside perspective of how your work is perceived by others.

Be patient. Be smart. Keep trying. It's a marathon, not a sprint.

Porter Arneill holds an MFA in sculpture from the Massachusetts College of Art. He became an "accidental arts administrator" in 1993 and has worked as a city public art administrator since 1997.

Tips from a Pro: Letters of Interest

Joel T. Straus, Principal, Straus Art Group, Chicago, IL

Assembling an application is fairly simple. If you can't assemble an organized and aesthetic portfolio, then I'd have trouble considering your work because it represents your working practices. Submit an organized application. Don't make the administrator organize it for you.

Artists need to do their own market research. Don't apply for projects that you can't do or ones for which your work isn't appropriate. The inverse is even more important: make certain your concept is actually buildable. Research your materials for conservation issues and document construction techniques. Compare your idea to the work of other artists who have completed similar projects. It'll be a great learning experience and give you more credibility. Given that your design is the best and that you can demonstrate professionalism and facility with technique and materials, I would definitely take the chance and commission the inexperienced artist.

The first questions asked of finalists are always "How much do you think this would cost to build? Are there conservation issues with the materials? What will be needed to maintain the piece?" If you don't have reasonable answers to these questions, it makes me and the committee insecure. Inexperience is just one of the factors in the final selection process. A demonstrated lack of understanding of these issues will probably lead to your elimination. Often, when it comes to the final selection, a committee is looking for reasons to reduce the final group. Don't give them an easy one.[9]

9 Joel Straus, via email, April 9, 2007.

Tips from a Pro: Letters of Interest

Lee Modica, Arts Administrator, Art in State Buildings Program, Florida Division of Cultural Affairs

I can say that what our selection committees appreciate are letters in which the artist restates the project parameters (the committee's desires) and proceeds to tell them exactly why he or she is the one they are looking for, giving good examples of how they have previously solved similar projects or describing how they might address this one.

It is also good to include concrete references instead of generalities. Don't say, "I'm a team player" or "I complete projects on time" but "I worked with such-and-such a group on such-and-such a project to address these anomalies and resolve those unforeseen problems to bring their project in on time and within budget."

Artists may certainly speak to their own aesthetic philosophy and personal reasons for being in public art but should do so in layman's language rather than foggy, esoteric jargon.

TRICKS OF THE TRADE

Never have to say you're sorry. If there's anything in your portfolio you find yourself apologizing for, fix it before you show it again. You don't ever want to have to say, "Sorry I couldn't get a detail of this piece," "Sorry it's so blurry," "Sorry there are fingerprints on this," "Sorry, I don't know how that goat got in the picture. . . ."

Make sure you have all the information you need. If there's information missing on the RFQ or RFP, as there almost always is, do not be shy about emailing the public art manager to ask him or her for clarification. Keep in mind that this is your chance to make a first impression. Your questions should be brief, intelligent, and pleasant.

Make it easy for them to get in touch with you. Have your name, address, and contact information on the front of every section of your application—resume, image list, and letter of interest.

Make it easy for them to remember whose work they're looking at. Have your name, the name of the project, and the page number on every secondary page of your resume, annotated slide list, and letter of interest (if more than one page). Example:

> Artist name
> San Francisco—artist registry
> Page 2 of 4

(Don't forget to update if you recycle this information for another application! You don't want Kansas City to think you spaced out and sent them San Francisco's entry by mistake.)

Follow instructions. If they didn't ask you for references, don't include references. If they ask you to fill out a form and get it notarized for their purchasing department, do it. Likewise, follow all requirements concerning image formats, image labeling, and page length of letter of interest.

There are exceptions to the "follow instructions" advice. Every once in a while you'll encounter an application that will ask you to sign away your copyright if you get the commission or, incredibly, that requires you to agree to abide by the contract even before you've seen it! Those are impossible requests that you'd have to be pretty desperate to agree to, not to mention that accepting those terms is a detriment to fellow artists as well as yourself. You'll need to ask the public art manager if the agency has any flexibility on that, and, if not, you've got a decision to make. Later in the book, art lawyer Barbara Hoffman goes into detail about copyright.

If you think the application was a lot of work, it ain't nothin' compared to what you're in for once you become a finalist.

Congratulations! You're a Finalist! (Now What?)

You've just been notified that you're one of three (or perhaps four, five, or more) artists selected to be pitted against each other for a commission. You now need to make an all-out effort to win the confidence and imagination of the selection panel. While a few public art agencies simply invite finalists for an interview before choosing one to put through the hoops of coming up with a detailed plan for artwork, the majority ask for specific proposals before meeting each artist. In the first approach, they're putting the emphasis on finding an artist they think they can work with to develop a concept; in the second, it's more about the concept itself.

You will be given a proposal fee of $500–$2,500 or more, depending on the size of the project budget. Like the odious RFP, this is another bit of procedural cognitive dissonance in the way public art is chosen. Because your art ideas comprise the bulk of the value of your work, that means you're essentially getting paid a few hundred bucks for your most important effort—sometimes without the benefit of having full access to the decision makers and end users as you will once you are under contract. And that money isn't going into your pocket to compensate for all of that brainwork. It'll be spent on hard costs such as printouts, models, material samples, and perhaps a site visit and consults with architects or engineers as you pull out all the stops to win the thing. I have a colleague who was short-listed for a half-million-dollar project for which he was given a $10,000 proposal fee. He spent every dime of it on models and 3-D renderings, and he still lost. He doesn't regret it because he knows he gave it his best shot. And definitely don't do what I did. I was given $5,000 to put together a finalist presentation and spent $10,000—for a project that the client, an airport, never intended to build at all, as I later found out.

The finalist proposal needs to be as complete and accurate as you can make it, even though you have not yet been selected and put under contract. All agencies are different, but, in general, if you win, you'll have some flexibility with your concept because they'll understand that your response to the site will change once you get more of a chance to investigate it. Don't expect a lot of flexibility though. After the selection panel makes its decision and goes home, after the full commission, city or county council, or other governing body puts its official stamp on it, it's not that simple to decide that you want the work to go in another direction. In addition, your initial numbers and schedule may end up as an attachment to the legally binding commission contract, so don't assume there's anything preliminary about your finalist proposal.

QUESTIONS TO ASK YOURSELF

Ask yourself these questions as you lay out your finalist proposal:

1. **Is your idea buildable?** Can you, given where you are in your experience, actually make (or find others to make) what you are proposing?
2. **Is it feasible given the timeline?** Can you deliver what you're promising within the allotted time frame?
3. **Is it worth it?** This is a more complicated question than weighing whether you will make money because there are intangible benefits to take into consideration, especially when you're first starting out. Financial advisor Nancy Herring recommends asking yourself these questions to decide if there are other reasons besides income to invest your efforts:
 - Will it build my career by raising my profile and adding to my portfolio?
 - Will it give me the opportunity to make work I'm excited about?
 - Will it help me gain real-life experience and lay groundwork for me to be more competitive the next time around?

QUESTIONS TO ASK THE PROJECT MANAGER[1]

- **Budget.** Find out exactly what the budget will cover and the proposed payment schedule. Ask if there are any other sources of funds that could help with "leveraging" the construction budget. This is where there might be an overlap in construction and art funds allocated for the same site. For example, if your site is a sidewalk and your idea is to create an artwork using pigmented concrete, ask if your budget will only need to cover the cost of the pigment and design, while the construction budget pays for cement and installation.

 Ask if the budget you submit with your finalist proposal is going to be the one attached to your contract, or ask if you can refine it after your attorney has a chance to go over the contract, you find out more about the details of the site, and you get the final estimates from your subcontractors.

- **Contract.** Be sure to get a copy of the contract you would be expected to sign if you win. Go through it with a fine-toothed comb to look for any requirements that will cost you time or money, such as special insurance, storage, meetings, travel, site prep—or attorney's fees that you'll incur to help you decipher the contract.

- **Timeline and schedule.** When does the agency expect certain work to take place? Are there any hard deadlines, such as a dedication, which must happen on a specific date? What is the schedule for the entire project for all contractors, design, construction, and installation included? At what point is the artist expected to be involved and what work will you be expected to accomplish?

- **Proof of approval.** The book *Going Public* recommends that you get legal evidence that the site has been officially sanctioned for the proposed public art project. I would go further than that and be sure to ask if the project itself has been approved and that the planned funds are available.

1 Adapted from Jeffrey L. Cruikshank and Pam Korza, *Going Public: A Field Guide to Developments in Art in Public Places*. (Amherst, MA: Arts Extension Service, University of Massachusetts, 1988).

Legal documents or something in writing, such as an email from the program administrator, could come in handy if the deal starts going sideways. Many an artist can tell you a tale of woe about a year's worth of work that went down the drain because the agency couldn't raise matching funds, the mayor changed her mind, or the economy took a dive.

- **Site plans and photographs.** Get every kind of visual that the project manager has available to give you about the site, especially if the project site does not yet exist or if you can't afford to visit it in person. Not only will you need these to develop your idea, but you can use elevations, photos, and architectural renderings to mock up what your work would look like as a virtual in-situ without having to duplicate the efforts of others. Look at the site on Google Earth to get a feel for what's going on around it. Is it bordered by parks, buildings, vacant lots, or freeways?

- **Building and zoning permits or other relevant regulations.** Are you or your fabricator going to be responsible for navigating the bureaucratic maze to get these approvals or will the agency have done all or some of that for you?

- **Statement of the site's substructure, if known.** In other words, has the agency done its due diligence and made sure it isn't asking you to install your mosaic over a painted wall that you need to sandblast to make it usable, or that the parking garage lid where your landscape installation is going is engineered to hold it?

- **Environmental regulations.** Increasingly, as municipalities become more sensitive to preserving or reversing damage to the natural environment, they're doing "environmental impact statements" (EISs) before undertaking improvements of any kind. Ask for the EIS or a summary of it to make sure there's nothing that will affect your concept or costs.

- **Preliminary preferences regarding the proposal's format and content.** This is the time for you to diplomatically find out if there is any flexibility on the budget, timeline, payment schedule, or anything else you discovered wasn't realistic about the initial proposal. Remember, whoever wrote the proposal and instructions for the finalists was

seeing the project from a hypothetical perspective, not from the perspective of the artist who examines every practical detail with a magnifying glass. Most project managers will welcome any input from the finalists about gaps or inconsistencies you found in their process or budget—as long as you're not negative and accusing about it.

21 Tips for Writing a Proposal (for a public art commission, grant, or anything else)[2]

1. Read the prospectus and any related material carefully.
2. Reread, underlining or highlighting the important parts.
3. If there is any element of this prospectus that you cannot fulfill, discard the prospectus before wasting any more time on it.
4. Consider the goals of this organization and decide whether you are willing to be associated with them.
5. Make a list of what is being requested; e.g., budget, drawings, photos, slides of previous work, one-page proposal, etc.
6. Note which of the above you have on hand, which you have yet to obtain, and which you have to create.
7. If a budget is involved, double-check it for accuracy, using a method different from that which you used to draw it up in the first place. Experts say that things often take two to three times as long and cost twice as much as you had planned.
8. Decide who your audience is (for the project and the proposal): that is, are they artists, tech people, architects, or a mix?
9. Decide what you are going to do.
10. Decide how you are going to do it.
11. List who else will be involved, if anyone.
12. List your materials and methods.
13. Make an outline of your proposal.
14. Following the outline, do the actual writing. Use clear, simple language. Don't worry too much about grammar and spelling at this point.

2 Reprinted with permission from *The Art Opportunities Book* by Benny Shaboy, 2004.

15. Separate its sections with appropriate headings and subheadings.

16. End with a paragraph that summarizes the proposal succinctly.

17. After you have finished the first draft, set it aside for a day, then reread and correct it. Make deletions and additions as necessary.

18. If using a word-processing program, run the proposal through spellcheck, being careful with homonyms such as "their" and "there" and "its" and "it's." Unless you have an above-average grasp of grammar, don't use a grammar-checking program, as it will do more harm than good. *The Chicago Manual of Style* is available as a book, CD, or online through subscription. There is also free useful information from its staff at www.chicagomanua- lofstyle.org.

19. Read it aloud, preferably to a willing partner. This will help you (and your listener) to catch grammar and logic mistakes that might slip by otherwise.

20. Rewrite as many times as necessary to ensure that it is clear to even the most harried reader.

21. Have someone new proofread it.

Tips from the Pros

I asked the project directors of six leading public art agencies what questions they advise artists ask when notified that they've been chosen as finalists.

- Because the artist is usually brought in at the end of a long planning dialogue, ask what issues and expectations have been discussed regarding the art.

- What is the physical-cultural-political history of the project? What does the project manager perceive to be the physical, intellectual, and aesthetic/sensory goals of the project?

- How did this project come to be? What other projects have been accepted? Try to get a sense of their "personality."

- How open and flexible is the community to new ideas? Are there any sensitive political issues or a history of controversy surrounding a past art project?

- Is the budget firm, or is it just a number to make all proposals more or less equal?
- Will the agency have any funding for regular maintenance of the artwork?
- Are the architects flexible and willing to embrace an artist as part of the team? Or do they represent a more traditional approach in terms of the relationship of the art to the architecture?
- What did the committee like about the artist's work in particular? Which previous work did they respond to? Get the contact information to call each committee member and architect to ask him or her these questions individually to incorporate into the finalist proposal.
- When is the finalist proposal due? If awarded the commission, how soon after that can the artist expect a signed contract?
- What happens to any contingency fee budgeted that the artist doesn't spend? Does he or she get to keep it, or does it revert to the agency?
- Who is/are the intended or expected audience(s) who will have significant and/or primary interaction with the work(s)?
- Does the agency have the sort of technology you need for your presentation? (For example, a DVD player, a digital projector that will connect with your laptop, etc.)
- The most intelligent thing artists can do is create the opportunity for a fairly regular dialogue with the public art administrator and then *listen carefully,* as opposed to asking leading questions based on their presumptions that might limit their opportunities.

(Questions contributed by Lee Modica, Janet Kagan, Jill Manton, Porter Arneill, Julia Muney Moore, and Kurt Kiefer.)

WHAT GOES INTO A FINALIST PROPOSAL?

There are three main components to a finalist proposal: concept, budget, and schedule. There's also an underlying subtext: credibility. You need to convince the selection committee members you can pull off what you're proposing by giving them a thoroughly researched idea and a realistic, detailed

budget and schedule. The more you look like you've got a handle on the entire process the more confidence they will have that you can successfully execute your proposed artwork.

Concept

If your idea captures the hearts and minds of the selection committee, they may be willing to overlook some inexperience and inconsistencies in your budget and timeline—but don't count on it.

As for how many ideas to submit, public art advisor Joel Straus recommends, "Give 'em two." One of them should adhere to the preconceived vision provided by the agency through its RFQ or RFP project description plus what you can glean from your conversations with your agency contact and others associated with the project. The second should be what you think would be right for the site after all the information you gather has been put through your artist filter. You'll probably have many more ideas, but stop at three. I've gotten feedback from several public art managers that presenting too many ideas muddies the waters for the selection committee and forces them to do the editing that you should have done before submitting your proposal. You can indicate in your cover letter that you have more ideas and that the ones shown can be considered as starting points should the committee want you to explore further possibilities.

With as much access as you're able to get as a finalist, investigate the site through a variety of lenses:

- historical
- cultural
- social
- natural environment
- economic
- ethnic
- aesthetic
- political
- built environment
- function

It may not always be possible to get much access. For every agency that will give you a mandate to get out there and engage the community, there will be others where the closest you'll get to the people who will live with your artwork is whatever you're able to research yourself on the internet, through interviews, and in person. Mine more deeply for meaning than what you can find on Wikipedia or the chamber of commerce's website. Look to see what is beyond the immediate clichés even though you may end up coming back to them to use as themes in your work.

This is the time to call the project manager for all the facts, insights, and contacts you need to put together a complete proposal. Unless you were given an unusually detailed packet of information as a finalist, you'll need to know the answers to these questions if you are doing a site-specific artwork. Even if you're proposing a relatively straightforward piece—such as painting a mural on panel in your studio and then installing it yourself—you'll still need to be informed about payments, sequencing with other construction, site preparation, storage, and security.

From the project manager, get the names and contact information for the key representatives of the communities that engage with the site where your work will be. Think critically about the power structures. Who has the official voice and what are the messages it is trying to convey? Whose voices were left out of the process? What is their experience of the place, and what are their stories?

The artist Jack Mackie and the team of designers he worked with in Chattanooga created a riverfront park where landscape, water features, historical markers, benches, and other features were united to tell the stories of Chattanooga using the metaphorical power of art. Named Ross's Landing after the Cherokee tribal chief John Ross, a portion of the park is paved with quotes marking the Trail of Tears, the name given to the forced removal of the Cherokee People from eastern Tennessee and northern Georgia to Oklahoma in 1838. Along this journey, nearly a third of the fifteen thousand people died. It's the sort of history that the chamber of commerce usually wants to keep out of the tourist brochures but found the courage to include as the true stories of Chattanooga when creatively led by the design team.

Artist B. J. Krivanek developed his own set of "mandates" to guide him in addressing the many facets of a public art proposal.[3]

- **Translate:** Narratives and aesthetics
- **Accommodate:** Various constituencies
- **Incorporate:** Urban histories and centers
- **Negotiate:** Public review and permits
- **Manage:** Budget fabrication and installation
- **Anticipate:** Public experience and interpretation

3 B. J. Krivanek in a presentation to the author's Public Art Professional Practices course at the School of the Art Institute of Chicago, March 7, 2006.

Place Ethic

Lucy Lippard observes that the most successful public art seems to be governed by a "place ethic" that embodies some of these criteria:

SPECIFIC enough to engage people on the level of their own lived experiences, to say something about the place as it is or was or could be.

GENEROUS and OPEN-ENDED enough to be accessible to a wide variety of people from different classes and cultures, and to different interpretations and tastes. (Titles and captions help a lot here; it seems like pure snobbery—even if unintended—to withhold from the general public the kind of vital information that might be accessible to the cognoscenti.)

APPEALING enough either visually or emotionally to catch the eye and be memorable.

SIMPLE and FAMILIAR enough, at least on the surface, not to confuse or repel potential viewer-participants.

LAYERED, COMPLEX, and UNFAMILIAR enough to hold people's attention once they've been attracted, to make them wonder, and to offer ever deeper experiences and references to those who hang in.

EVOCATIVE enough to make people recall related moments, places, and emotions in their own lives.

PROVOCATIVE and CRITICAL enough to make people think about issues beyond the scope of the work, to call into question superficial assumptions about the place, its history, and its use.[4]

Budget

Chapter 6, "Budgeting for Public Art Projects and Other Financial Survival Strategies," will go into excruciating detail to help you figure out how much you need to charge in order to make a living wage and the budget items you'll encounter when putting together your finalist proposal. Here are a few general tips.

Start with how much you need to pay yourself. Take your fee off the top, and whatever is left over is what you have for hard project costs. It's like what

4 Lippard, *The Lure of the Local*, 286–87. Reprinted with permission from New Press, New York.

flight attendants say in the safety demonstration: secure your own oxygen mask first before assisting others.

You've heard that old adage that everything takes twice as long and costs twice as much as you thought. Don't take it literally, but keep it in mind and put in extra cushioning in every category for unforeseen circumstances. Ten percent is a commonly estimated figure.

Many project managers consider it part of their job to help artists make their numbers work. Keep in mind, though, that you'll be up against other artists who have a great concept *and* a competent grasp of the numbers, so don't go to the project manager as a first resort. Figure out as much as you can on your own, with the help of your fabricator and within your own support group of other artists. If you find something that doesn't add up in the numbers the agency gave you, then call the project manager. On a terrazzo floor I was commissioned to design, my flooring contractor discovered that the budget the agency had allocated only covered the base costs of a simple, two-color design. They hadn't calculated putting in the art. When we pointed that out to the manager, the committee found the extra money I needed to do something fabulous.

One of the most complete lists of budget items that I've come across is this one prepared by Jeffrey J. York, of the North Carolina Arts Council.[5] I've added my comments after the italics.

1. Artist's fee—a value assigned to the idea and design

A key calculation to make is for artist's time. Start with 15 percent of the total contract. So, a $20,000 contract is $3,000. If you need to earn $50,000 a year ($25.00 an hour), then you can spend a *total* of eighty hours, about two full-time work weeks, on this project. This includes all brainstorming, sketches, and preliminary plans—essentially, the creative process is covered here. These numbers show how important quick, easy facility with a project is. It stands to reason that a beginner will take much longer to accomplish these tasks, while a seasoned artist can probably manage this part of the project in less than eighty hours.

Use table 6.1 in chapter 6 to figure out the base hourly wage you need to make a living.

2. Labor—artist's physical time (including research, travel, meetings, community involvement, fabrication, installation, educational programming, documentation, etc.)

5 North Carolina Arts Council, "Public Art Commissions: An Artist Handbook," Office of Public Art and Community Design, 2005. Addenda IV.

This is where your profit can get eaten alive. It's the answer to the question, "Why are artists poor?" It's because we don't anticipate how much time it actually takes to make art. Estimate as closely as possible from the stated scope of the project, your discussions with the project manager, and the process you need to make the kind of work you want.

Using the base hourly wage calculator in table 6.1, even if you come up with $25 an hour as what you need to bill, remember that not every hour in a forty-hour workweek will be billed to a specific project's budget because many work days are spent cleaning up your studio, running errands, applying for other projects, and so forth. If your contract asks you to specify an amount that you will track and bill for labor (meetings, supervising, travel, design, hands-on art making, etc.), start at $100 an hour. That's comparable to what other artists write in on their budgets for an hourly labor fee.

Assistants and other labor for research, model making, fabrication, and so forth. If the project is fairly small, you can probably handle making all of the presentation materials yourself, including models, mock-ups in Photoshop, and printouts. To be competitive in the larger commissions, however, where the stakes are as high as the budget, you may want to consider outsourcing the fabrication of presentation materials, such as 3-D or animated renderings (unless you know how to do those yourself), professional-grade models, printed and bound packets, full-color presentation boards, and material samples.

Finding pricing for outside help is, mercifully, much more straightforward than figuring out your own labor. An architectural model maker will have a set fee depending on the complexity of the design, as will a CAD technician and a service center such as FedEx Office. Those are all a phone call away.

3. Consultants/other people-related costs
You will rarely need all of the help listed below. Remember in your dealings with these professionals to seek long-term relationships with the best people you can find. Haggling doesn't always pay off in the long run.

- **Structural engineers or specialists like electrical engineers, lighting designers, or plumbers.**
- **Architects/landscape architects.** Your need for these professionals will increase proportionately with the complexity of your concept and installation. For insurance purposes,

your contract may require you to have your design redrawn and stamped by a licensed architect or engineer no matter how detailed your own drawings are. That's because artists are not in a licensed profession and are not able to get professional liability insurance to protect the client from being sued if anyone gets hurt as a result of bad design. This could cost you in the range of $1,200 to $3,500 and beyond for a particularly technically complex job.

- **Historians, sociologists, urban anthropologists, and so forth.** Each community usually has one or two history buffs who would be thrilled to help you research the site without charge. Local libraries and universities would be the place to start looking for other social scientists and archives. However, if any of these experts—amateur or pro—is going to add so much content to the work that they amount to being co-creators or collaborators, they deserve to be paid and credited.

- **Lawyer.** Until you're proficient in understanding a public art commission contract—some of which can be over sixty pages long—you should have an attorney look it over for you. Ask to see the contract before you submit your finalist proposal. You'd be surprised what sorts of hidden expenses you can find lurking in there. Expect to pay around $350 an hour. Also check to see if there's a Volunteer Lawyers for the Arts chapter in your area by going to www.vlany.org. This is the New York chapter's website, but if you look in its "Resources" section under "National Directory," it has an up-to-date list of counterparts in other states.

 I used to think I could skip hiring an attorney in order to save money, but, after losing thousands of dollars because I didn't catch everything I should have in contracts, I've converted.

- **Photographer.** It's an essential investment to document the process as well as the finished work, for your website, portfolio, speaking engagements, press, and publications.

- **Fabricator.** Hiring an outside firm to realize your concept if it is in a material you are not tooled up to work with—terrazzo, plate glass, mosaic, water, or light for example—will

be the largest line item in your budget. Chapter 10, "Working with Fabricators," will go into more detail.

4. Travel
- Airfare or automobile mileage
- Car rental
- Hotels
- Meals

Travel expenses can mount. Use all the resources available to cut costs. Websites for Travelocity, Orbitz, and Priceline will give you enough information to estimate the cost of your travel. When it comes time to make your reservations, packages that bundle airfare, car rental, and hotel can save you hundreds of dollars. One well-traveled artist I know names his own price on Priceline for hotels and routinely stays in nice rooms for $75 a night that would normally cost $120 or more.

The Couch Surfing Project (www.couchsurfing.com) is a worldwide social network whose goal it is to spread peace, love, and understanding through the exchange of free lodging at the homes of like-minded people. The Hospitality Club (www.hospitalityclub.org) is a similar free organization. One of my students, Sam Reicks, speaks highly of having spent a summer traveling throughout Europe this way.

(Note: In case you're thinking that you can put the cost of a hotel in your budget and then stay someplace for free while pocketing the difference, you'll have to think again. Some agencies will ask that you turn in an invoice backed up with receipts for all of your expenses before they'll reimburse you.)

If you worked for a large company, you wouldn't have to collect all your meal receipts for a refund, you'd simply get paid what's called a per diem. Each city all over the world has an allowance calculated for meals and incidental expenses (M&IE). The US General Services Administration website makes it easy to find this information to use when estimating your travel costs. Go to www.gsa.gov and navigate to "Travel Resources" > "Per Diem Rates."

5. Transportation
- Shipping materials to fabrication site
- Shipping work to installation site

If you're working with fabricators, these expenses will be included in what they're charging you. If not, you'll need to find out how much a shipper would charge to pack, send, and unload your work. Get several bids. Haggling may work better here than with professional consultants. Look into if it would be cheaper to rent a truck and drive the work out yourself. Be sure to include a charge for your time, lodging, and meals if you do this.

6. Materials

Again, if you've hired a fabricator, materials will be included in his or her costs. If you're doing the work yourself, base the materials cost on previous projects. Some artists add a margin of 10 percent so they won't get caught short.

The cost of materials can vary greatly. Search far and wide for the best possible prices if you are using expensive materials like metals whose prices fluctuate with market rates. Work closely with your fabricator to avoid mistakes and miscommunication. Look into reusing material from the project site that the project manager might have been planning to pay the contractor to cart off, or use recycled materials. An increasing number of artists are working this way to lower cost, make a stronger connection between their work and the site, and go easier on the environment.

7. Site preparation

- Cleanup/removal
- Irrigation and plumbing preparation
- Testing
- Grading/landscaping
- Surface preparation

It's rare that the artist would be asked to do any of this sort of raw site prep. What's not so rare is that you'll arrive ready to go to work and discover that there's a bunch of debris on the site or that the wall has something on it that needs to be removed before you can start. In any case, it needs to be absolutely clear in your contract who is responsible for site prep. If it's going to be you, spell out what you're responsible for and how much of your budget you will spend on it. Don't forget that above the cost of hiring someone to do this work for you, you need to charge for the time you'll spend on coordination and supervision.

Electrical and lighting. The artist's budget will often be expected to cover the cost of lighting the artwork and any other electrical work or fixtures that were special requirements of the artwork—that is, not part of the basic construction bid.

8. Installation needs and equipment

- Rental of lifts, scaffolding, special equipment/materials, and so forth
- Truck rental
- Work lighting

Your fabricator will take care of all of this as part of his or her subcontract with you. If you're doing it yourself, just as with site prep, be sure to charge for your labor, coordination, and supervision.

- **Storage rental.** This is an expense that can sneak up on you if you're not careful. If the client does not have the site ready by the time your work is ready, your contract will most likely say that you need to pay for storage even if you've kept your end of the bargain by getting the work done on time. I once did a project for a client that was two years behind in construction. I had to pay for the storage of my work for that entire time.
- **Traffic barriers/off-duty police.** Believe it or not, the artist is often expected to provide her own security and site control by hiring government and/or union workers. It's not realistic for reasons having to do with access, liability, and logistics. Try to change this requirement in your contract if at all possible.
- **Permits.** Unless it's a permit specific to work in your studio or that your fabricator needs, try to get the commissioning agency to get any government permits related to the site. It's already part of the bureaucracy. It'll be easier for the agency.

9. Office/studio expenses (a.k.a., "overhead")

- Rental, phone/fax, utilities, supplies

Here's another place where you could leak money by not knowing how much overhead to write into your budget. Figure out how much it costs you per month to keep your place of business up and running, and allocate a portion of these expenses to the project. If your studio is in your home, measure what proportion of space it takes up versus your living space and apportion your rent and utility expenses accordingly. It would be worth hiring an accountant to help you with this.

Overhead is deductible on your taxes and fairly easy to log. Your automobile mileage and gas for business-related use is also tax deductible. You can buy little notebooks at office supply stores specially designed to keep in your car for tracking car-related expenses.

10. Insurance

- Loss/theft/damage coverage to protect the supplies and fabricated parts prior to shipping
- Loss/theft/damage coverage during shipping
- General liability for self and assistants
- Workers' compensation for assistants
- Any special insurance riders
- Performance bond

See chapter 7, "Insurance: The Lowdown," to learn how to deal with the myriad of insurance coverage required of public artists.

11. Taxes

It hurts, but ya gotta do it. The commissioning entity will almost certainly require you to sign a document that says you understand that you are responsible for any and all taxes. It probably will require a tax reporting number and will submit these documents to the IRS. This means you are on the hook. You cannot say, "Gosh, I just didn't understand." The documents make you swear that you understand.

Good record keeping and proper allocation of expenses will help reduce your tax bill. Many of the expenses in the sample budget are tax deductible or used to reduce your gross income for FICA purposes. See above for a fuller discussion of taxes but a good rule of thumb is 25 percent of your profit, not

the gross contract revenue. Many artists do their own taxes and are good at it. If you're not, bite the bullet and hire an accountant.

12. Contingency

A contingency is a buffer of usually 10 percent of the total budget for unintended problems and cost increases. The way most contracts are written, it will revert back to the city or state if you don't use it. Not all contracts will require that you have a contingency. If they don't, don't put one in. Instead, put the 10 percent buffer in each of your other expense categories for your own protection. If the contract does require a contingency, make sure you don't have anything left over at the end of the project by charging enough for your labor, supervision, and overhead when you submit your invoices to the agency.

In summary, budgeting for public artwork is a lot like the hot potato game. The agency will try to make as many expenses as possible the responsibility of the artist. It's your job to root them out and try to toss them back.

Schedule

There are two important things to remember about scheduling:

1. **Don't feel like you're stuck with the payment and work schedules in the initial contract.** No one knows better what it takes to make your work than you do. What is written in the contract is a one-size-fits-all best guess that a bureaucrat came up with. Yes, it may be tied to a very real construction schedule, but those are subject to change too. You need to design in flexibility so that you're not put in the position of having to front large amounts of your own money for materials or fabricators. If you need 50 percent up front to buy materials and get a fabricator started but the contract is written to pay out in percentages of 5-20-20-20-20-15, make your case for why that won't work for this project.

2. **Tie your schedule to benchmarks, not dates.** This is discussed elsewhere in the book, but it bears repeating: don't agree to have a specific phase of work done by a specific date. Make it contingent on whatever you need the client to do first. For example, rewrite the contract to say, "Materials will be ordered, contingent on receipt of second payment of $X," or "Fabrication will commence contingent on receipt of third payment of $X."

It doesn't have to be about money. You could stipulate that "installation will commence upon preparation of site by client as specified in attachment C." Try to think of every possible hitch you could encounter along the way and make a contingency plan for it.

To illustrate this point, here's a teaching moment courtesy of Ken von Roenn, an artist who has had ample opportunities to learn things the hard way after more than thirty-seven years and five hundred projects as an artist:

> **Lesson:** Get the majority of payment from a client before a work is installed.

> **Story:** Early in my career I designed a large project for a church and conceded to their demand that they would pay 90 percent of the cost only after the windows were installed. After installation, they kept finding small changes they wanted made, even though the window was exactly like the design. We made innumerable changes over six months in hopes we would be paid. Ultimately after we made all the changes they requested, they offered to pay us only 50 percent of what was owed because they had "run out of money." I learned that all the requests for changes were just a ploy to delay paying us and our only option was to sue, which would have meant we would not have received any money for at least a year, which would have been far less than the partial payment they offered.

> **Net result:** I lost more than $50,000, but I now include a clause that provides for 90 percent of payment before a work is installed. I have not had a problem with this since.

Anatomy of a Finalist Proposal

Glenn Weiss of glennweiss.com developed this outline to help artists organize their final proposals:

1. **General Description of Artwork:** Text with attached drawings, images, and/or samples (include important dimensions, materials, colors, fabrication method, etc.).
2. **General Description of How the Artwork Satisfies the Project Criteria and Scope of Work.** (Please note any issues that have arisen during your research.)
3. **Budget** *(For a complete list of expenses, see the section on "Budget" starting on page 70 of this chapter.)*
4. **Design Coordination Requirements** (Concepts, designs, materials, lighting, and utilities recommended or required in the design of the facility.)
5. **Construction Coordination Requirements** (Sequencing and requirements of artist regarding on-site construction or installation. If there are subcontractors, please name them.)
6. **Maintenance Plan**
 a. Ongoing maintenance of artwork. (Activity and frequency.)
 b. If applicable, cost of anticipated replacement parts and average lifetime.
 c. Date and type of anticipated major maintenance such as repainting.
7. **Maintenance Plan for the Site** (How is the artwork or artwork base designed for typical site maintenance such as lawn mowers, weed whackers, window washers, or vacuum cleaners? Do the site maintenance crews need to use any special methods—or avoid any typical methods—in order to not damage the artwork?)
8. **Requirements Regarding the Site** (Examples include how much clear space is needed around the work and what kind of landscaping, lighting, furniture placement, tree trimming, openness, air movement for mobiles, etc. is required. Include drawings if helpful. What things should *not* happen at the site?)
9. **Extent of Site That Is Part of the Artwork** (Some artwork has elements of the building or site that are part of the artwork

concept. In other words, if this aspect of the building or site is changed, then the artwork would be damaged. At this stage, the artist would require the removal of his or her name from the work. If a future change in the site attribute would not require the removal of your name from the artwork, please include in "requirements of site" in 8 above.)

The Five Work Phases of a Public Art Commission[6]

Contributed by Janet Kagan, Principal, Percent for Art Collaborative

As a public artist, you will be expected to develop and refine ideas and content for the work of art through interaction with your client and the site, in public meetings, and from your perceptions of project goals and desires. The following phases of work frequently define the payment schedule of a public art contract although it is important to draft a scope of work that reflects your public art process.

1. Background Research and Conceptual Design
 a. Meet with project representatives; tour the site(s) and the community; learn about the project's goals, and listen to multiple constituencies; review all relevant drawings.
 b. Development of preliminary ideas for the work(s).
2. Preliminary Design, Budget, and Proposed Schedule
 a. Identification of any necessary consultants to the project.
 b. Presentation of initial ideas concerning form, material, location, response to climate, and written project description.
 c. Proposed budget for each element.
 d. Schedule that reflects the integration of the project with the overall construction site.

6 Janet Kagan, Principal, Percent for Art Collaborative, 2005.

3. Final Design
 a. Detailed drawings showing material selections and specifications for the artwork(s) and interface of the work(s) with building architecture, landscape, mechanical/electrical/plumbing, or other construction elements.
 b. Final cost estimate (design, fabrication/construction, transportation to the site, installation, and postinstallation maintenance).
4. Fabrication and Construction
 a. Inform the client of any changes to the work (materials, color, form, size, design, texture, finish, location, etc.).
 b. Presentation of work in progress at approximately 50 percent and 75 percent completion.
5. Delivery, Installation, and Dedication
 a. Identification of all equipment and site preparation necessary to deliver and install the work(s).
 b. Arrange for off-site storage should that be necessary.
 c. Prepare remarks for dedication ceremony and celebrate!

An important dimension to the process of design, fabrication/construction, and installation is to keep in contact with your client. These communications may be written and formal, or informal telephone conversations that are followed up in writing. Public clients cannot afford any surprises because there are financial and political repercussions to misunderstandings that will extend beyond the reach of your specific project. As your client helps advance your artistic career, you and your work will forever change their program and the community.

PRESENTATION

Your aim is twofold: to make them see your work in the site so clearly that panelists feel like it was always meant to be there and to assure them that you can get the job done. Help the panel place your idea in a context that goes beyond this project. Tie it into other work you've done and show how it relates to larger themes you've been exploring. You can also cite outside influences,

whether they are other artists, microbiology, the cosmos, or political and social concerns.

1. **Visuals.** Show as clearly as possible what your work will look like in the site: be visually literal. Even though you can see in your head what the project is going to look like when it's finished, any extra trouble you go to on your visual aids will not be wasted. Remember that there will be nonartists on the selection committee who won't have the same capacity to extrapolate from a rough sketch and description that a trained artist or design professional will. Your visual materials must spell out every little thing for them. They won't buy it if they can't visualize it. Keep in mind that the bar is raised higher all the time as more artists come in with realistic looking 3-D renderings and animations.

 Some artists still use presentation boards, but PowerPoints have become the norm. Either way, your renderings or composite images should show how the completed work will look, including where it fits on the elevation, the material and color samples, traffic flow, and any other pertinent graphics that can help the selection panel visualize how your idea would work in that place.

2. **Handouts.** Put together a small booklet for each panelist to leave behind that contains a summary of your concept, images of your proposal, and the budget.

3. **Samples.** Material samples are vital in helping the selection committee visualize your proposed artwork. If possible, they should be in the materials you would actually be using, in the form it would appear in the finished work. For example, if you're proposing bronze inlays in a terrazzo floor, bring a one-foot-square section of the actual inlay in the exact mixture of terrazzo you're proposing.

4. **Attire.** You're an artist. Wear whatever you want.

Budgeting for Public Art Projects and Other Financial Survival Strategies

with Nancy Herring, Financial Consultant

We live in a time of unprecedented wealth—for some people. The money is out there but we artists have to be smart about getting it by overcoming a poverty mentality; we can stop selling ourselves short and learn a few timeworn business skills. The starving artist brainwashing is so intense that many of us believe we can't be serious artists if we earn any more than a subsistence-level income from our work. We can tell ourselves that our work isn't valued, or we can put on different goggles and look around to see that many artists are making a living without being superstars.

None of us went into this for the money. With the same investment in our educations that most of us made, we could have picked more lucrative professions. Instead, artists seem to be motivated by a strong drive to leave our mark on the world by making visible our internal creative dialogues. But that doesn't mean we need to work for free.

According to Hans Abbing in *Why Are Artists Poor?*,[1] a large portion of the art economy has been built on the assumption that artists will work for substandard wages in exchange for being free to pursue our muses. Society's subtext, often swallowed hook, line, and sinker by artists themselves, is, "Hey, we'd all like to be artists, but we have to put aside those childish dreams and work for a living." The expectation that artists should work for less than other highly trained professionals is so pervasive that those of us who can least afford it end up in the ironic position of subsidizing the gigantic budgets of

1 Hans Abbing, *Why Are Artists Poor? The Exceptional Economy of the Arts* (Amsterdam: Amsterdam University Press, 2002).

our government and corporate clients by undervaluing our labor and creative output or by agreeing to contracts that don't factor in a living wage.

It's up to you whether or not you give yourself away, but remember that when you do, you're not just undercutting the worth of your fellow artists, you're ultimately devaluing art.

The first place to stop this cycle is to know how to budget for projects so that you don't shortchange yourself. I've invited financial advisor Nancy Herring to answer some basic questions. Because our personal finances are so closely tied to our business success, she addresses them jointly and puts public art into the larger context of commerce.

BUSINESS PRACTICES FOR THE PUBLIC ARTIST

By Nancy Herring, MBA

What Should Artists Charge for Their Work?

In business, the art market is known as a highly fragmented industry—no one entity has a competitive advantage or accounts for much of the revenue. There are numerous buyers and sellers; it is relatively easy to enter the business and to exit. (Other fragmented industries are real estate and landscaping. By contrast, the light bulb industry is extremely concentrated with only three companies controlling over 80 percent of $250 billion of *global* revenue.) The challenge for artists is to find a strategy for success in the face of what can seem chaotic, impenetrable, and overwhelming.

In dealing with a highly fragmented industry, it makes sense to focus narrowly on the do-able and the incremental. A necessary first step is to build a solid financial foundation, which will enable you to achieve a sustainable living as an artist. These are skills you need to succeed whether in public art or other artistic endeavors. This section will give you some tools in personal finance, budgeting, and troubleshooting.

Money = Freedom

An artist is self-employed—there's a lot of freedom in that but also many challenges. You are responsible for paying taxes, organizing time effectively, making enough money, saving money, obtaining insurance, and so on. You can manage your life so that if you want to spend six months in Europe, you don't have to ask a boss for the time or quit your job. If you do your best work between midnight and 6 a.m. then you are free to do it. You have the

wonderful and rare opportunity to do what you love for as long as you can. Picasso worked as an artist for over seventy years! Louise Bourgeois made her last artwork in 2010, the same year she died at ninety-nine.

This section will try to give you tools so that you can plan your career on the basis of your needs and goals, and in terms of what you can target and control. If you have a firm idea of what your goals are, what you need to do, and your time frame, then projects that add to your goals become easier to identify and those that detract become easier to reject.

Plugging away at what you can control helps maintain sanity and keeps the self-doubt at bay. Public art commissions can and should play a role in establishing your reputation as an artist as well as helping achieve your income goals. It won't really matter if you are as famous as Maya Lin. Go for it if you want it, but an artist's career isn't an either/or proposition. Art is a multibillion dollar business in this country, and there are multiple gradients and entry points of opportunity.

Here are three easy-to-remember (but harder to do) maxims for achieving your financial goals, which will enable you to work as an artist, not a hobbyist.

Earn Enough Money

Never give your work away, don't undervalue your efforts. Remember that they need you. You may trade work, but be sure you get a good value. Sometimes it's useful to barter—just don't use your cash. Know what you're worth. Know how much you need. When someone asks you to do it for free, walk away. By and large, commissioners of public art are professionals; they work with contracts and budgets all the time. Their proposals may not be perfect, but they can be flexible and practical; in short, they are able to understand that an artist must be paid too. But you won't get paid unless you ask for what you're worth.

Step One: Know What You Need to Live On. You need to earn enough to pay your bills and save. The amount needs to grow over time in order to keep up with inflation. To get a handle on what you need, get three to six months of bank statements. Find out what your monthly expenses are that you've got to pay no matter what. These should include housing, transportation, health insurance, utilities (communications, electricity, gas, water, garbage), and food. Some expenses are quarterly or semiannual—this is often the case with auto insurance. Don't underestimate these expenses. Recognize that you're unlikely to succeed at saving on heat by keeping the temperature in your home at

fifty degrees. Also, you probably need a fast internet connection and a cell phone.

Step Two: Figure Out What You Need to Make a Living Wage. Table 6.1 breaks down how much you need per hour to achieve your income goals. This should be your benchmark for allocating your time and efforts. Ask yourself if you're achieving your target income. If your target is $50,000 a year, then a forty-hour workweek at fifty weeks a year comes out to $25.00 an hour. That may sound like a lot but architects bill at between $100 and $125 an hour, and attorneys from $350 to well over $1,000 an hour. It's difficult to keep body and soul together for much less than $30,000 living in a city—and that's with a roommate.

Table 6.1

Annual Target Income (before taxes)	Hourly Wage* (before taxes)
$30,000	$15.00
$50,000	$25.00
$75,000	$37.50
*Assumes a forty-hour workweek, fifty weeks to the year (i.e., two weeks of vacation).	

Taxes. Don't forget to estimate taxes in your living expenses. You must pay federal, state, and local income taxes as well as FICA, also known as Social Security. An easy rule of thumb is to estimate a total tax rate of 25 percent. The IRS requires that the self-employed estimate and pay quarterly income taxes.

A benefit of self-employment is the opportunity to deduct business expenses from your taxes. Such expenses include art supplies, studio occupancy costs, and travel to and from your public art commission or fabricators. If your income consists of more than two sources and has high costs, it might be time to consider a professional to help with your taxes. And don't forget to give yourself a raise every now and then.

Staying on Budget. Artists generally are notably thrifty and make dollars stretch far. Even so, it's useful to keep an eye on spending and take opportunities to go beyond mere subsistence. It can be helpful in maintaining a budget to review once a quarter or so, using your bank statement or online services like Mint.com, to correct course when needed.

Strategies That Can Help You Remain an Artist. A major change in recent years is the rise of work-sharing and more extensive opportunities to earn income between projects or in anticipation of a major opportunity that may stress your budget. There are many internet services that can connect you to some very short-term jobs. The obvious ones are driving for one of the ride-share services, but there are also opportunities that stay a little closer to the art world, such as short-term preparator work, handy-person gigs, small-scale design projects, and so on. Such options can be valuable when you are building your cash cushion (see below), restoring cash you've had to draw on, or saving for an unusual expense.

Never Spend More than You Need To

While there are many variations between lifestyles, there are some crossover areas where we can each save money.

Banking Services. You might think that the Great Recession would have ushered in big changes in banking, but it's rather shocking how little things have changed. Fees are a little higher, as well as penalties for things like bounced checks, and credit card interest remains high.

- Use the internet aggressively to find the best rates on all your banking needs, including checking accounts, savings rates, discount brokers, mortgage rates, and credit card interest.
- Banks favor customers with more, rather than less, money, so you will get fee reductions the more business you do with a bank. (This may seem unfair, but big accounts are more profitable than small accounts.)
- Deposit checks the day you get them. Apps are available that will allow you to make a deposit essentially with a photo of a check.
- Try to use automatic deposit and automatic payments as much as possible; this will greatly ease your record keeping burden. You should know that there is no advantage to using paper checks. In fact, some banks now charge extra for their use. There is no float left for checks versus debit cards; that is, checks clear at your bank the same day, just like your debit card.

Credit Cards. You need one, and only one, credit card. This will help earn you a good credit score. No credit history at all is only one step up from a bad credit history. You need to keep a credit line open, if only for this reason.

- Credit cards can also be useful for tracking expenses.
- Pay off the balance every month.
- Watch your interest rate like a hawk. If your credit card company won't keep the interest rate they charge competitive with others, change providers. Demand to be rewarded for being a good customer; banking is a highly competitive industry; you'll get results.
- You should look for a credit card that doesn't have an annual membership fee, but if you have one that does, ask them to waive it for you.

Communications. Watch communications costs—services proliferate, and costs rise inexorably. The internet is revolutionizing how artists do business, and it is a necessary (and tax-deductible) expense. Still, it's easy to spend $200 a month before you realize what's happened. Communications are looking for every way possible to add on fees and subscriptions; buy what you must, scrutinize your usage, and pester for lower costs.

Credit Score. Your credit score should be 720 or higher. When you're chronically late on payments, you'll get dinged; if you default, you'll get hammered. Automatic payment on your regular bills will really help, but don't do it if you can't keep a cash cushion of one month's expenses in your checking account, because bounced checks will cost you, too. Instead, ferret out where you can cut expenses so you can live within your means. There are three credit score companies through which you can check your rating for free once a year. Otherwise, it costs around fifteen dollars.

- Experian: www.experian.com
- Equifax: www.equifax.com
- TransUnion: www.transunion.com

Transportation. Transportation has become a fairly big money drain, and the opportunities to lower costs are few. Obviously walking and biking are pretty cheap, but mass transit isn't as cheap as it used to be: monthly passes

in major metropolitan systems are between $116 and $85, while the rest of the country barely even has mass transit. Cars are ridiculously expensive. If you do have a car, consider defraying some of the costs by earning a few extra dollars with a ride-share service.

Housing. Housing will almost always be your biggest single expense, outpaced only by raising children. A fine goal for artists is home ownership. You can establish your studio there as well as insulate yourself from the inexorable rise in rent. Plenty of tax deductions are available. You will need a good credit rating, income you can prove with tax returns, and a down payment of as little as 10 percent, though 20 percent is more likely. This may seem an impossible mountain to climb, but consider that artists are great at discovering undervalued neighborhoods, and often their very presence improves values. A home that costs $200,000 requires a down payment of approximately $40,000, but careful financial stewardship will get you there. Saving for a house is separate from your cash cushion.

Health Care. Health-care costs are destroying America, but that doesn't mean you can get by without health insurance. Your income may qualify you for a subsidy under the Affordable Care Act. I cannot overemphasize how dangerous it is to have no health-care coverage at all. You can think of it as bankruptcy insurance, but being hit with both illness and its cost without insurance could leave you in dire financial and health straits for a long time. For budgeting, you should figure about $300 per month without a subsidy, and add about $1,000 to your cash cushion to cover co-pays, some drugs, and deductibles. My estimates are on the low side.

Save and Never Stop Saving

Build a Cash Cushion. This is as important as earning enough money and sticking to your budget. Aim to save 10 percent of your income year in and year out. Your first goal is to build a cash cushion. Let's dwell for a bit on how useful this cash cushion can be. Target at least three months of living expenses for your cash cushion. If you need $50,000 a year, then $12,000 should do it. This won't happen overnight, but you will get there. You will be able to bridge periods between public art commissions or any other interruptions in your monthly earnings. Your cash cushion needs to stay available to you in a savings account. When you take money out of it, you should have a

plan for replacing that cash. For instance, part of your profit from a public art project could be used to replenish your cash cushion.

The Magic of Compounding. Once you have your liquid savings, you should turn to long-term savings, which will allow you to enjoy the benefits of compounding. Conceptually, it is quite simple—it means that savings earn a return on the original amount and on all the profits thereafter as well. Compounding is also extremely flexible; money can be invested in lump sums, contributions can be made over the years, or the rate of return can change. Over many decades the stock market has returned nearly 12 percent compounded annually. Continuous contributions and refraining from panic will help you achieve financial goals that may include home ownership and retirement. Bear in mind though that the Great Recession sorely tested those assumptions. The market fell nearly 40 percent in 2008 and did not fully recover until 2012. By 2016, the market returned to its historical growth rate of 12 percent annual return.

Earn a Return on Your Cash Cushion. Your cash cushion can go to work for you. Certificates of deposit, commonly abbreviated to CDs, are a safe way to earn some money on your money, or, as it's described more formally, to earn a return on your investment. Interest rates have been extremely low since 2008, and only since 2018 have CD rates become more appealing.

Future Goals. Don't stop saving; always target saving 10 percent of your income. Your savings will help you achieve additional goals you may have as an artist, such as better studio space or living overseas. After you've built up that cash cushion, you will need longer-term investments for your savings. While establishing such a portfolio really isn't that hard, the financial industry seems to have done everything it can to make investing highly fraught, maybe even panic inducing. There are many sources of free introductory financial advice, though the fundamental idea of compounding described above is the foundation.

There is an alphabet soup of tax-deferred investment programs that will help you achieve longer-term financial goals. As an artist, you can take advantage of individual retirement accounts, known as IRAs—either the traditional IRA or a Roth IRA and SEP 401(k) plans. As off-putting as these appear, they are actually highly effective, valuable savings vehicles. A web search of these terms will return an abundance of information. Start with the most basic information you can and build from there.

Debt. A main goal of all this saving is to keep you out of debt. It is easy to come by but becomes a monkey on your back that can force you to leave the art world. Don't imagine that bankruptcy will help. It is virtually impossible to eliminate your debts in this manner. The best that will happen is that the debt will stretch out for years, even decades.

Not all debt is bad. In general, you want to pay down the highest interest rate debt first and as fast as you can. Low interest rate debt—often at least part of student loan debt is low interest rate—comes last. If you have debt that is lower than the inflation rate or what you are earning on your savings, you can pay this debt off more slowly. Credit card debt is the likeliest to carry a high interest rate. Often these rates are in excess of 20 percent. You should use your cash cushion to help you get this under control. A 20 percent interest rate on $1,000 costs you $200 for basically nothing. Remember this is mostly profit to the bank that gave you that credit card, often with those sweet teaser rates.

Maximizing the Value of Public Art Commissions

From the standpoint of an individual artist seeking to make $50,000 a year, the public art market, at $150 million in contracts annually, is large. One-half percent of that market is $750,000, which could keep about fifteen artists in clover each year. Perhaps public art will be your only venue, but more likely it will be one of several income streams. Additional sources of income may include galleries, private commissions, teaching, or fellowships, as well as work that earns a royalty, like printed materials.

There are many appealing characteristics of public art, not the least of which is a substantial number of opportunities to submit proposals. In most cases, the tastes and expertise of the selection panelists is varied and ever changing. Typically, public art proposals are open to anyone, thus helping to level the playing field among new artists and more experienced artists. Remember Maya Lin who beat out thousands of proposals for the Vietnam Veterans Memorial in Washington, DC, while still an undergraduate. Under these conditions, the sensible strategy is to apply for as many public art commissions as possible.

Turn this into a numbers game, not a beauty contest: the more proposals you submit, the likelier you are to win at least one. Try to have several proposals out at any one time; inevitably you will lose some, but there will always be one or two more to come. It will ease the hurt of rejection.

An early focus on public art with a strategy that maximizes the chances of winning commissions will help build your artist's resume. Although a direct

connection between a public art commission and gallery representation cannot be assumed, a robust resume available to gallerists, consultants, curators, and collectors will help build your reputation. Multiple income streams from your art practice can bring you closer to achieving your financial goals and, much more importantly, your objectives as an artist.

Table 6.2 Annual Gross Revenue

	Jan	Feb	Mar	Apr	May	Jun	Jul	Aug	Sep	Oct	Nov	Dec	TOTAL
Public art finalist fee	300	250	400	950									
Contract payment	4,000	8,000	12,000										
Gallery	8,000	500	500	500	500	500	500	500	11,500				
Multiples	300	200	1,000	1,500									
Freelance	5,000	5,000											
Part-time	1,200	1,200	1,200	1,200	1,200	1,200	1,200	8,400					
Full-time													
Monthly Total	$300	$300	$0	$4,200	$8,000	$2,950	$1,700	$1,700	$1,700	$7,100	$1,700	$9,700	$39,350

The time between submitting a proposal and money in the bank can be very long; therefore, one needs to plan carefully. It is important to explicitly identify additional sources of income while managing the public art commission from beginning to end. It would be useful to produce a spreadsheet that estimates these revenues, like the one above. This will help schedule your time, reveal gaps in your income, and point out opportunities to pick up more income.

Will the commission require out-of-pocket expenses for things like maquettes, photography, and travel? If so, it may be necessary to have other sources of income to fund these. If you dip into savings, do you have a replacement plan? It is dangerous and expensive to use credit cards to fund these up-front expenses because commissions frequently meet lengthy delays, requiring the artist to pay interest on any credit card debt.

Budgeting

Below is a spreadsheet for working up a project budget. This should be used as a negotiating tool, a planning tool, as well as the nexus of your record keeping for the project. There are numerous spreadsheet programs available,

including Microsoft Excel, Quicken, and QuickBooks, and others mentioned in this book. You will have to decide which is best for you.

A major goal of applying for many public art commissions is to become adept at reading and understanding calls for artists and contracts. You should be able to read a call and decide whether it's a good fit for your capacity and goals. You should be able to estimate a budget and determine whether it is profitable for you. A budget can also give you the tools you need to negotiate a better contract with the commissioning agency. The first proposal will be very difficult; by the fifth proposal, you will be surprised at how skilled you've become. By keeping track of how much your budgeted amount varied from your actual amount (budget - actual = variance), you'll have a much better idea how to calculate expenses the next time.

Refer to the detailed list of budget items in chapter 5 and the spreadsheet on calculating an hourly fee in table 6.1 to develop as detailed a budget as possible for the project. Keep track of your budget in the following spreadsheet format:

Table 6.3

Income/Expense	Budget	Minus	Actual	Equals	Variance
Gross Revenue:	Total value of contract	–	Actual proceeds	=	Budget—Actual
Costs:	Cost *estimates*	–	Final costs	=	Budget—Actual

Gross Revenue. Gross revenue is simply the total amount of the contract. If the call for artists says there is $50,000 available for the artwork in a public parking structure, then that's the gross revenue. After carefully estimating a budget, refer back to the gross revenue amount. Of course, the gross revenue should be sufficient to cover all the costs, especially your payment, of the project. Don't hesitate to speak with the project manager on these questions and to ask if he anticipates any future monies from fund-raising or leveraging the construction budget. Armed with a detailed budget that clearly specifies costs will make negotiating easier and more productive. Be prepared to back up various estimates like insurance fees or art transportation costs with solid data. Remember everyone can use the internet to check what you tell them, so be accurate and fair. It is highly unlikely, however, that any project manager will question your right to earn a living. A detailed budget will help expose any possible inadequacies in the agency's proposal.

Costs. The core of the budgeting process is accurately estimating costs. Ideally, you should use various research tools to pinpoint costs and avoid the temptation to pad every line item, instead of doing the work of finding out the true cost. Over time, experience will accrue, and you will develop a network of vendors, be they fabricators or insurance agents, whom you trust and who work efficiently with you. Fill in the line items and determine if there is sufficient profit for you to pursue the contract. *Remember that you want enough money left over after all the expenses to earn the rate indicated by your target income.*

Poorly estimated contracts are the bane of many and have destroyed the profitability of extremely sophisticated corporations. Typically, individuals overestimate their own efficiency at coming up with a design and addressing the number of redos the commissioning agent may want. Whenever possible, seek control of the latter; too many do-overs and all your profit/income will evaporate. Charge for repeated design changes; this will be easier done if you can get it written into the contract. Home renovation contractors charge for such changes, as do architects, interior designers, sound engineers, and wedding video editors. It is common and professional to do so.

Variance. As shown earlier, variance is the difference between the budgeted amount and the actual amount spent. This number will show you whether you stayed within budget or not. Variance is a useful planning tool. By identifying variance, you can more effectively plan your next budget.

To the extent that a project comes in under budget, those sums can be added back into the artist's fee, which, at the project's conclusion, is the same as profit. For instance, if you underspend for your travel budget, then add that amount back into your artist's fees. Don't worry if that puts you over the 15 percent mark for your artist's fee. Fifteen percent is the minimum you should charge. As you'll read in the "Voices of Experience" section at the end of the book, artists charge fees anywhere from 15 percent on up.

Productivity Is Key. Undertake enough of these proposals to get good at them. Being able to complete a request for proposal quickly and to accurately estimate your budget will boost productivity. This is one of the surest paths to achieving your income goals. Any economist will tell you that real wealth comes from increasing productivity. Be brave enough to decline projects that turn out to be suboptimal. Don't be afraid to recycle ideas if appropriate. Try to reuse as much of your written material as possible. You want to focus as much as possible on the actual artwork.

Keep a Project Diary. Keep diaries or logs and analyze them after each project so you can see where you spent the most time and money, and what you should cut or concentrate on more in the future. Think in terms of strengths, weaknesses, opportunities, and threats.

Strengths: What works really well?
- Is your application process streamlined?
- Did you get the information you needed for your proposal from the project manager, the community, and other stakeholders?
- Did you have a smooth working relationship with the project manager and others involved with the project?
- Was your budgeting and timeline on target?
- Did you find all the hidden costs in the contract in time to budget for them?
- Are you happy with the finished work? Are your clients?

Weaknesses: What could you improve?
- Was your application as good as it could be?
- Did you unnecessarily spend too much time or money on certain tasks?
- Are there things you don't like doing or aren't good at that you could delegate or avoid without harming your prospects?
- Did your fabricator come through for you on time and on budget?

Opportunities: Can you leverage this project for more work?
- Are there any other projects this client may know about for you?
- Did you meet anyone through the project (architect, fabricator, contractor, selection panel member) who seemed to be impressed enough with your work to refer jobs to you?
- To whom can you send an announcement about this project that may lead to more work?
- Will a press release be sent out about the project?
- Will the project manager submit it to the Public Art Network's Year in Review and the *Public Art Review* commissions section?
- What improvements will have the biggest impact on income, costs, or artistic development?
- Be certain to return favors done for you.

Threats: Is there danger on the horizon?

- Is there a mismatch between the media or style in which you work and what current calls for artists are seeking?
- Is the competition increasing or the budgets of the work you're qualified for decreasing?
- Is the work you're doing starting to feel like a grind?

When to Hire Help. The short answer is only hire help when it will increase your income stream. Help could come in the form of an intern, a bookkeeper, studio assistants, personal assistant, housecleaner, or outsourcing production to a fabricator. It's time to hire help when doing so will allow you to increase your profit past the amount you pay them.

Here are some tasks artists commonly delegate:

- Find and apply for calls for artists
- Track and follow up on applications
- Coordinate meetings
- Book travel arrangements
- Keep the account book
- Maintain and update website
- Mail marketing material to art consultants, gallerists, commissioners, architects, designers, and landscape architects
- Maintain and update portfolio
- Research fabricators
- Answer phone, respond to business emails
- Fill out forms as required by contractor
- Update resume
- Organize photo documentation

How much should you pay? Start by asking artists who are already using assistants what they pay. Look at the job listings in the classifieds and on Craigslist, and go to the Salary section at www.monster.com and use their wizard to see what these jobs pay in your area. For example, an entry-level administrative assistant is worth on average $40,000 in Chicago and about $30,000 in Charleston. Divide that by the average number of work hours in a year (two thousand) and you'll get hourly wages, respectively, of $19.50 and $15.50. Remember that $19.50 an hour for a great person is a far better way

to spend money than $10 for the wrong person whom you'll probably have to replace.

Knowing When It's Time to Get a Day Job. The way you'll know it's time to dust off the resume and look for outside work is when your savings are dwindling to the point where you have less than three months of living expenses. This is even more dangerous if you have no new projects in sight. It takes some serious time to land a job, and it costs money, so you need to evaluate your financial position in time to remedy the problem. You should be able to avoid a really big crisis like eviction or repossession if you act before your cash cushion gets lower than three months of expenses. It is crucially important to avoid using debt (i.e., living off of your credit card) to finance living expenses.

You might want to look for part-time or freelance work if you have some project payments due to you but they've been delayed and your savings are getting dangerously low. Look for jobs that use and improve your skills. You can draw upon your network to help you here. Perhaps some really awful event, like a fire in your studio, has caused a setback that you're having difficulty recovering from. These things happen: panic for a day or two, then make a plan to get back on the horse. Remember that the more savings you have, the more time there is to reverse a bad financial situation without having to leave your field.

Nancy Herring earned her MBA from Columbia Graduate School of Business and has worked in financial services throughout her career. She has worked as a portfolio manager for Dean Witter Asset Management (now Morgan Stanley). While living in Moscow, Russia, she ran the asset management division of Troika Dialog Bank and later was director of research at Regent Securities. She currently consults with a variety of clients on portfolio construction. Nancy is the treasurer at Chicago Artists Coalition, where she has been a board member since 2009.

Insurance
The Lowdown

When you win a public art commission, you will enter a world of insurance requirements heretofore unimaginable as a simple studio artist: professional liability, workers' compensation, commercial general liability, business auto, performance bonds. . . . And as long as we're on the subject of insurance, we may as well cover what you need and don't need as far as personal insurance because, as with finances, the fortunes of small business owners are intertwined with our private lives.

Insurance agents are salespeople. They may seem like they have only the best intentions for you and your interests, but their prime directive is to sell you insurance whether you need it or not. Like Diogenes with his torch looking for an honest man, I found an insurance agent who was willing to go on the record and talk straight to artists about which insurance we absolutely must have and which we can go without.

INTERVIEW WITH KRISTIN ENZOR[1]

I interviewed Kristin Enzor, an account executive for Pillar Group Risk Management, which advised the Indianapolis Airport Authority on the insurance aspects of its contracts with artists.

How should one go about finding a reputable agent?
There is no consumer report for insurance agents. You need to find them by word of mouth or letting your fingers do the walking. It's true, insurance agents are

1 Kristin Enzor has been a commercial insurance agent for eight years and in the insurance industry off and on for twenty years. She has a BFA in painting and in photography from Indiana University at Bloomington.

salespeople; however, they are held under professional obligation to recommend coverages that they deem to be necessary. Otherwise, if you had a claim and it wasn't covered, you could sue them for not pointing that coverage out. Each state has an insurance department that regulates agencies and insurance companies. The state will also cover claims if the insurance company goes belly up.

Look for a "full-service agency" because it can provide coverage for all your needs: personal lines of insurance (personal auto, homeowners, renters, and personal liability), life and health insurance (medical insurance and disability), and commercial insurance (workers' compensation, business auto, commercial property, commercial general liability, professional liability/ errors and omissions, and performance bonds).

Every agency can obtain out-of-state licenses. However, this is only necessary when the named insured is domiciled in or operating out of state. Most commercial coverages provide coverage for anywhere in the country, as well as US possessions and territories, and Canada. Commercial property is tied to the location listed on the policy; however, for property that goes off premises (welding equipment, tools) there is coverage called inland marine insurance that can be purchased.

What kind of personal insurance is essential?

Auto. If the vehicle title is in your name, you must have personal auto insurance. All states let you get away with just liability insurance. So if you drive a junker, don't worry about getting comprehensive and collision coverage.

Any Homeowners Product—whether you own a house, a condo, or rent. It's not just for people who pay a mortgage every month. That policy includes personal liability and personal property combined in the "package." Homeowners insurance is important not just because it covers your home and personal belongings but also because if someone trips and hurts himself in your home studio or your dog bites him, he won't be able to sue you for every asset you own. Your insurance will cover it.

Fine art would typically be covered within your personal property limit. The problem is that a claim would be settled on a replacement cost basis. This is great for replacing a television, but an antique chair would be replaced by a new chair, a painting could be replaced—technically—with new blank canvas stretched on stretcher boards. Also, a mysterious disappearance would not be covered. So, the best way of insuring fine art is scheduling (i.e., separately

listing) each piece on the policy. There should be a list of items. Each item would have a brief description and a value, which would be a market value or an appraised value. That scheduled property would then be covered for the value shown on the list. Also, scheduled items are covered for mysterious disappearance. This is also true of jewelry.

Commercial Policy. I'll go into this more in the section on business insurance, but you should know that if you have a home studio/office and the work you do there is your principal source of income, it needs to be insured under a commercial policy. If you're just starting out or you are right out of school, don't get commercial insurance unless you've established a market value for your work. It also depends on what you're doing with your taxes. When you begin deducting your studio space and art supplies on your tax forms, it's a good time to get commercial insurance.

If you rent a studio space, you'll need to have renters insurance, even if you're just starting out. Again, if you run your studio as a business, then your commercial insurance will cover it.

Health. Everyone absolutely needs medical insurance. Generally, the higher the deductible, the lower the monthly premium, which is true on all kinds of insurance policies. If you're young and healthy, get a policy with a very high deductible and pay for the occasional doctor visit out of pocket. Your policy will cover emergency care.

Health Savings Accounts (HSAs). A new option for coverage is a health savings account. This is a way to fund your health insurance. You put pretax dollars into a qualified bank account that is used specifically for the payment of the health-care plan. They require more effort (shopping physicians to get the best price) and a different mindset, in that you expect to pay more when visiting the doctor for a routine visit (no more co-pays).

Disability Insurance. People between the ages of twenty-five and fifty-four are three times more likely to be disabled than to die. For artists, being physically disabled could have an enormous impact on their livelihoods. For this reason, disability insurance is really more important than life insurance.

Life Insurance. You don't need to buy it unless you have children, a spouse, or have a fair amount of debt. There are two kinds of life insurance: permanent

and term. When buying term, you're buying life insurance for a specified number of years. If you don't die in that time, then the policy expires. If you know you're near the end of your life, you might consider this option. Term insurance is less expensive. It is a good option if you need to buy life insurance but do not have money out of the gate.

Permanent insurance renews until endowment age (usually 100 years old) or until you die. The premium can be guaranteed or flexible. There are different permanent options, including whole life, universal life, and variable life. Permanent life can be an investment vehicle.

When it comes to working on public art commissions, what insurance do artists need, which plans do they not need at all, and which can be bought per project?
Workers' compensation coverage. Each state has different requirements. For instance, in Indiana if you are a sole proprietor with no employees, you can waive your right to purchase workers' comp by submitting a form to the state industrial board. If you're a corporation, you have to have it even if you're the only person employed by your company. If you have employees, you must have it. This protects you from being sued by your employee if they get hurt while working for you. In fact, whichever state your project is in will come down on you hard if this happens and you don't have workers' comp. An employee is anyone for whom you're turning in a W-2 form to the IRS. A 1099—the form the IRS requires for subcontractors—does not count.

The moral of the story is, if you have employees, you want them to be subcontractors. If you hire subcontractors (i.e., fabricators), you should be sure to ask them for a current certificate of insurance, which outlines the coverage they have in place. Because if they don't have coverage for a particular incident (for example, workers' comp), then if one of *their* employees got hurt, he could sue *you*. Your homeowners or commercial liability would not cover that.

On public art contracts, you will be asked for proof of insurance that your subcontractor has added as an "endorsement" on his or her policy, which just means they are naming you as an additional insured. You will be asked to name the client agency in an endorsement on all of your commercial insurance. Endorsements are simply amendments to the policy—any insurance policy. They can restrict coverage or they can broaden coverage. They are used to tailor the coverage.

By the way, limited liability companies (LLCs) are not considered corporations in some states. You'll need to rely on your agent to find out what the

rules are in your particular state. If you live in one state and your project is in a different state, you may or may not need to comply with that state's laws. Again, because each state has its own regulatory board, the requirements vary. In general, on short-term projects, say, under sixty days, you do not need to abide by that state's requirements.

What should you expect to pay for workers' comp? It's based on payroll.

Commercial general liability insurance (formerly called "comprehensive general liability") protects you from third-party suits that are attributed to your work. Within this coverage, there are premises/operations liability and products/completed operations liability. The difference is premises/operations is for when the work is being done. Products/completed operations is for after you're done with the job, like if someone slips and falls. Most of the risk exposure is while it's being created on site, if someone hurts himself during construction.

Commercial liability is divided into two different categories—bodily injury and property damage—and only protects if there has been physical injury or damage to property. Third-party loss of income is not covered. (It also includes other coverage thrown in, like personal and advertising injury liability, which protects you from claims of misrepresentation. For example, if you did a caricature of someone and they were offended and sued you, you'd be covered.)

Say you hired a big terrazzo company to install a floor you designed, and someone slipped on the shiny surface of the terrazzo and sued everyone— the client agency, the city, the contractor, your fabricator, you. What would happen is the terrazzo fabricator's insurance company would probably claim that its client installed the floor correctly—assuming the installation was per spec. *That means if it's not a design or installation issue, then it becomes one of negligence.* Attorneys will always go after as many pockets as possible. Your commercial general liability will protect you. The other part of that is how your contract is written with the owner and the one you have with your subcontractor. Everyone is pushing off the liability to the next level (see "endorsements"). Long story short, you need to have your own attorney look at the contract you get from the client, write one specific to your needs, and have your subcontractor sign it in order to protect you.

There is a standard subcontractor agreement. The American Institute of Architects has one because their members run into this sort of thing all the time. All attorneys with clients in the building industry have access to them.

You can buy commercial general liability in a package policy that combines property and general liability. It's cheaper when you buy it that way. If necessary, you can also customize it.

Expect to pay. Property premium is based on value while commercial liability is based on payroll under the "sales and service organization" classification.

Business auto. You really don't need this, and you should try to avoid it because it is more expensive than personal auto. The only time you absolutely have to have it is when you have the title of your car in your business name. Sometimes the client agency will require it. You can use your personal vehicle for business purposes as long as you aren't using your car in the course of your daily business operation. For example, if you have a courier service company, you would need a business auto policy. If you use your car to drive to the art supply store or even if you haul tile to the job site, you don't need it. So tell your client that you don't need business auto if it is requested in the contract. If the client forces you to get it anyway, then get it and cancel it as soon as the job is done.

There's a big difference between personal auto and business auto. With personal, the basic intent is to cover the *driver*, no matter what vehicle you're driving. Business auto is designed to cover the *vehicle*. That means you have no coverage for any other vehicle you drive if you carry business auto. So when renting a car, be sure to check the box for liability coverage if you only have a business auto policy, and be sure not to drive your friends' cars. You can get "drive other car" coverage for around $100 extra to get covered for driving other cars. If your partner or spouse routinely drives the car that's insured on a business auto policy, then the insurance company will want to run a motor vehicle records (MVR) check on them.

It will cost about 25 percent more than personal auto partially because of the increased liability limits.

Inland marine insurance is for property that moves. Property insurance only covers so many feet in and around a given location; anything taken off of your property isn't covered. For example, if the site isn't ready and your artwork has to sit in storage or it's being trucked to the site, then you need to get inland marine insurance. The good thing is you only need to buy this case by case.

The price of this coverage depends on value and how the work, object, or material is being shipped. You can expect to pay somewhere between $0.75 and $2.00 per $100.00 in value.

Professional liability insurance (PLI). PLI covers losses for claims arising from errors or omissions in the course of business activities for specific licensed professions.[2] Always try to negotiate this requirement out of your contract. Artists are not professionally licensed, like architects, engineers, doctors, and certified public accountants (CPAs). Professional liability is not necessary unless required by contract. If required, miscellaneous professional liability policies can be purchased. There will be a minimum premium of $1,000 to $2,500. The policy should be canceled as soon as the job requiring the coverage is complete. Request an occurrence form, not a claims-made form.

Once again, artist Ken von Roenn has a cautionary tale to share:

Lesson: Always read the insurance policy.

Story: I had a very large project that took a year to produce, and I asked my insurance agent to add an endorsement to my policy to cover the value of the project for this period of time. Two months before installation, with 90 percent of the project complete and crated in my studio, my studio and the project were destroyed in a fire. When I called the insurance agent the day after the fire, he said there was no endorsement for the project. When I asked him why he didn't add it after our phone conversation he said he "didn't remember" my requests. Soon after my attorney called the insurance company, I received a notice that my entire claim was denied and that I was being sued for filing a falsified claim. To honor my contract, I had to redesign the whole project (the designs were also destroyed) and pay to have it reproduced (I couldn't get another year off from grad school). Moreover, the legal fight with the insurance company continued for two years, after which they offered 25 percent of my claim the day of the trial, which I ultimately accepted because my attorney advised me they would tie up the settlement for at least another three years with appeals.

Net result: I lost more than $250,000.

2 For more information on how the definition of a "professional" has been expanded to include a number of other occupations when it comes to PLI, read Lewis-Chester Associates' blog post, "Miscellaneous Professional Liability Insurance": http://coverageglossary.com/miscellaneous-professional-liability-insurance/.

PERFORMANCE BONDS

David Santarossa, the owner of the terrazzo company installing a floor I designed at the Indianapolis International Airport, asked me for a performance bond. Because of the way my contract with the airport is written, all the money goes through me before it gets to him, even though he's the one taking all the risk with labor and materials. This is not an unusual arrangement (even though it would make more sense for the client agency to have a separate contract with the fabricator on large projects like this). He was worried about asking me because he thought it might sound like he didn't trust me, but I agreed with him. What if something happens to me and I'm out of commission for a long time? Or what if the client can't pay me for ninety days, meaning Santarossa can't make his payroll? Or if the client decides to reject my artwork after it is installed? The way these uncertainties are handled in the construction world is through performance bonds. It's a way of creating a buffer or putting some elasticity into the flow of payments.

A performance bond is issued by an insurance company to cover one party against loss if the terms of a contract are not fulfilled by another party it's doing business with. It's usually part of a construction contract or supply agreement.

According to Fred Eickoff,[3] bond manager for JW Flynn, it's difficult for artists to get a performance bond because to get one, you need:

1. A CPA statement that lists all of your liabilities and assets
2. Financial references
3. $150,000 in cash or liquid assets that they can attach if worst comes to worst
4. A high credit rating for your business

Another reason bond companies are reluctant to do business with small businesses is that their "bread and butter" is large contractors. They make money from the premiums of contractors who are required by law to put up performance bonds and who might buy several a year. A public art contract, even if it seems to us like we've hit pay dirt with one for half a mil, is small potatoes to the Fred Eickoffs of the world.

What Eickoff suggests instead is a kind of poor man's performance bond in the form of an "irrevocable letter of credit." Using your home or other equity, you establish a line of credit that your subcontractor has permission

3 Fred Eickoff, via telephone interview, March 27, 2007.

to draw on if your client is late in paying you or if anything happens to you to cause you to default on the job. You can specify the terms, such as the draw date and amount.

The happy ending in my case is that the public art project manager for the airport intervened and convinced Santarossa that they would get paid no matter what.

HEALTH INSURANCE

Since the first edition, the Affordable Care Act has come and, mostly, gone. As of this writing there are still remnants of it that benefit artists and other self- or underemployed people. More workers support themselves as freelancers, or in what is now called the "gig economy," as artists have always done, which means that there is less access to employer-provided medical insurance.

Health Care for Artists by Daniel Grant[4]

No news to anyone, obtaining adequate and affordable health care and health insurance has become a major problem for a sizeable portion of the population. And artists of all media and disciplines are among the most likely groups not to have any health insurance coverage. According to a survey sponsored by the National Endowment for the Arts, less than 75 percent of the composers, filmmakers, photographers, and video artists questioned have any form of coverage. Of all artists in larger cities, the survey found that 30 percent lacked health insurance. One of the reasons for this is the fact that most artists earn too little money to afford insurance; 68 percent of the artists in the survey had household incomes of $30,000 or less.

Perhaps the ongoing debate in the United States on how to provide coverage for the millions of people without health insurance will result in significant improvements. Perhaps the increasing prevalence of health maintenance organizations (or HMOs) may put out of business many of the arts service organizations that currently offer group-rate plans to their members, as artists may believe that they have less of a need to join such

4 Daniel Grant, "Web Special," *Sculpture*, April 2007.

organizations. In this latter scenario, a lot of the career services that only certain organizations provide will be lost to artists as well.

Until the health care situation is improved to include all citizens of the United States, regardless of their ability to pay, artists will continue to rely on their own sources of help and coverage. A number of literary, media, performing, visual arts, and crafts organizations provide group-rate health insurance plans for their members. Membership in the health insurance plan of some of these organizations is confined to artists residing permanently within the particular city or state, while extending nationwide in others. For example, the Chicago Artists' Coalition's health insurance program is available throughout Illinois and in some of the peripheral states, such as Michigan and Wisconsin. Iowa, however, is not eligible unless there are enough Coalition members seeking health insurance to warrant creating a group-rate program there. On the other hand, seven organizations—Artists Talk on Art, Editorial Freelancers Association, National Association of Teachers of Singing, National Sculpture Society, New York Artists Equity, New York Circle of Translators, and the Organization of Independent Artists—all use the same health maintenance organization, limited to the states of Florida, New Jersey, and New York. [. . .]

The insurance industry is regulated by each state, and rates are higher in some states than in others. Massachusetts and New York, for instance, are "guaranteed insured" states, meaning that those wanting insurance coverage cannot be denied policies because of their health (preexisting condition), age, or sex. Some insurance carriers refuse to provide policies in these states because of their inability to weed out potentially higher-cost customers; insurance programs are likely to be more costly in these states than in others as a result of the presumed pool of expensive-to-care-for group members. Medical care and services in New York are also more expensive than in most other states. Those higher costs and mandated coverage are factored into the prices of policies; as a result, New York policy holders are likely to pay more than their counterparts in Illinois or California. The states themselves make analyses of the medical costs in their counties, determining rate areas (by zip code) that are used by insurance carriers when establishing premiums.

Other factors that drive up or down the cost of health insurance are:

- **Age:** Health insurance becomes more expensive as one becomes older.
- **Sex:** Men are generally less expensive to insure, because they do not have babies (prenatal and maternity costs are high), nor do they require mammograms and pap smears. As a group, men also use medical services more sparingly than women. Even after their child-bearing years, women remain more expensive to insure. In life insurance, on the other hand, the policies for women are less expensive because they live longer.
- **Group or individual policies:** "Group-rate" sometimes means less expensive, but many group policies include families and offer extensive prenatal and maternity benefits, which increases the costs. A single male may get a better rate with an individual plan but, if he plans to marry and have children, the group plan is likely to offer the types of coverage that are more expensive to purchase individually.
- **City or suburb:** Cities tend to have more elaborate medical care facilities and equipment, raising the costs for insurance carriers, and their policies to urban-dwelling individuals, couples, and families reflect that increase. To a lesser extent, the degree to which there is a higher incidence of crime in a city may also be factored in.
- **Deductible:** The deductible, or the amount that the policyholder agrees to pay before the insurance carrier steps in, ranges widely from $0 to $5,000 and sometimes more. Lower deductibles increase the annual, monthly, or quarterly costs of a policy.
- **Number of dependents:** The more children one has, the higher the premiums. Insurance carriers generally cut off coverage for children over the age of nineteen, although some will continue coverage up to age twenty-three (finishing college) and even twenty-five (graduate school); however, lengthened terms of coverage increase the costs.

- **Add-ons:** The more options one attaches to a policy, the more expensive it becomes. Insurance coverage for experimental treatments, cosmetic surgery, optometry, dentistry, foot care, organ transplants, drugs not included in the insurance carrier's formulary, assistance with daily living, ambulance service, mental health, and a variety of other concerns is frequently not included in basic and group plans.

Many of the larger performing arts unions offer insurance packages for their members, but the coverage plans tend to differ widely from one local chapter to the next, and local chapters are spread around the country geographically. Here and there, a local chapter may have no health insurance program to offer. On the other hand, the Denver Musicians Association, Local 20-623 of the American Federation of Musicians, offers members insurance on their instruments—coverage that musicians frequently claim is next to impossible to find and exclusive to this union chapter—along with dental, health, and life insurance. Many of the organizations offering health insurance programs rarely ask detailed questions about what prospective members do in the arts or otherwise, and it is unlikely that, say, a musician would be denied a medical insurance claim for belonging to a primarily visual artist group. The American Craft Association, an arm of the American Crafts Council, wants its members to be involved in "the crafts or some related profession," and the Maine Writers and Publishers Alliance requires members to be self-employed.

Membership itself is usually not free, as annual dues range from $25 to $50, sometimes more. The costs of individual or group insurance coverage range widely, depending upon the particular plan and its benefits, the insurance carrier, state laws, and the number of people enrolled in the plan. Artists generally have been a more difficult group to insure because of industry concerns that they do not earn enough money to pay their premiums as well as that they do not generally take adequate preventive care—a result of their poverty—and require more expensive treatments. A number of insurance carriers also believe that artists as a whole are more likely to contract acquired immunodeficiency syndrome, or AIDS, than other occupational groups, which has led to companies greatly raising premiums for, or completely dropping, plans that cover artists of all media

and disciplines. There is no factual basis for this belief, but the subject of AIDS and negative ideas about artists in our society generally tend to exist well outside rational discussion.

Becoming a member does not immediately enroll an artist in an organization's health-care program, and insurance carriers are permitted to deny coverage to any individual. Insurance carriers usually require new members to complete a questionnaire or take a physical, and enrollment on a health plan sometimes takes months. The reason for this is that, over the years, insurance companies have seen people join a group's insurance program so that someone else pays for a needed operation and then drop the health plan after they have recovered. Artists need to look at health insurance as a long-term commitment, and they also should shop around for the most suitable membership groups that they are eligible to join.

A reason to buy insurance through an arts organization is that the coverage plans may be tailored to a particular group. Lenore Janacek, an insurance agent who has crafted insurance plans for artists' groups, noted that she looks for "companies that are sympathetic to artists. Artists, for instance, are users of mental health care, so that should be part of the area of coverage. Artists are also interested in alternative forms of health care, so I look for companies that provide coverage in that area." Because artists may not have a lot of money, she noted that some are offered the choice of a basic Blue Cross plan, with premiums as low as $35 per month.

Various types of health insurance plans are available, all with their own rules and enrollment requirements and procedures. Beyond the fee-for-service and HMO possibilities are hospitalization (base plan, medical, surgical) and major medical insurance plans. Hospitalization insurance generally pays for bed and board (usually in semiprivate rooms), nursing care, and hospital staff physicians' services for a period of between one month and one year. Some hospitalization plans also cover the following:

- The use of operating and recovery rooms and equipment
- Intensive care rooms and equipment
- X-rays, laboratory tests, and pathological examinations

- Drugs, medicines, and dressings
- Blood, blood transfusion equipment, and the cost of a hospital employee administering the transfusion
- Oxygen, vaccines, sera, and intravenous fluids
- Cardiographic and endoscopic equipment and supplies
- Anesthesia supplies and equipment
- Physical and occupational therapy
- Radiation and nuclear therapy
- Any additional medical services customarily provided by the hospital

Most hospitalization plans, however, tend to be limited in terms of the services covered, requiring individuals to purchase major medical or "catastrophic" insurance. This type of plan picks up 80 percent of the costs that the basic hospitalization does not cover, less a deductible (the first $500, for instance), up to $1 million or more.

Among the questions to keep in mind when shopping for insurance coverage are: Who in your family is covered (someone with a preexisting condition, dependents at what age)? What services are covered? Is there a waiting period (and, if so, what is it?) before coverage begins for someone with (or without) a preexisting condition?[5] Are there limitations on the choice of health-care providers or where health care may be obtained? Is the policy renewable (guaranteed renewable: the company cannot cancel a policy as long as premiums are paid on time; optionally renewable: the company may terminate the policy on specified dates; or conditionally renewable: the company may refuse to renew a policy for specified reasons)? What are the family and individual deductibles or co-payments? What is the average annual premium increase for the plan, and how high and under what conditions will premiums increase?

A valuable source of information on health care options for the arts community is the Artists Health Insurance Resource Center (www

5 Daniel Grant wrote this article in 2007. Since then, laws have been passed that prohibit insurance companies from denying coverage or raising rates due to preexisting conditions. This applies to policies after January 1, 2014, except some grandfathered policies that started before 2010. For more information, see: https://www.hhs.gov/healthcare/about-the-aca/pre-existing-conditions/index.html.

.actorsfund.org), which was established by the Actors Fund of America with support from the National Endowment for the Arts. Among the databases are individual and group insurance plans available by state, how to select an appropriate plan, and links to other sources of information.

———————

Daniel Grant is the author of *The Business of Being an Artist*, *The Fine Artist's Career Guide*, and *Selling Art without Galleries*, among other books published by Allworth Press.

Ask the Expert—
Contracts Q&A

By Barbara T. Hoffman, Esq.[1]

Barbara Hoffman is a preeminent art lawyer who has represented many of the most well-known public artists for more than twenty-five years. The questions posed in this interview are representative of concerns compiled by artists experienced in working in the public arena as well as those just starting out.

—LB

As a preliminary matter and to facilitate discussion, let me define the scope of this chapter on public art contracts and some basic concepts. The goal of this chapter is to give the artist confidence in negotiating a public art contract by giving him or her an awareness of rights and to help the artist know when it is necessary or advisable to seek legal counsel. By public art, I refer to original art commissioned by a private corporation or individual, a foundation, or a governmental entity for exhibition or installation in a space accessible to the general public. Although the author of this book tends to favor the term "agency," I prefer to use the term "client" or "commissioning entity."

A contract has been defined in many ways. Perhaps the simplest is "a promise or set of promises enforceable by law," or "a statement of agreement creating legally enforceable obligations between two or more competent, consenting parties." Generally, every contract must have an offer, acceptance, and consideration, which is usually money but sometimes something else of value.

1 © Barbara T. Hoffman, 2007. This chapter and the following are dedicated to my clients who work in the public realm. I am grateful for their teachings in commitment, courage, and vision.

A contract does not have to be in writing under most state laws unless it is (1) a contract for the sale of goods over $500 or (2) a contract for services which cannot be completed in one year. Any assignment of copyright as a matter of federal law must also be in writing.

W. C. Fields once said, however, that "an oral contract is not worth the paper it's written on." That is primarily because, even between those dealing in good faith, memories fail or the parties negotiating may not have interpreted their discussion in the same manner. Then, too, in the event of a dispute, proving an oral agreement may be quite difficult.

Most commission agreements will take the form of a formal written agreement. While there are certain clauses, which we attorneys refer to as "boilerplates" (one of my clients calls them "pot boilers") in every contract, each contract should be tailored to the particular project. As a lawyer, my first question to a client who consults me about a public art project is, "What are you going to be doing?"

NEGOTIATING THE CONTRACT

Can I negotiate the contract the agency gives me? Could that jeopardize my getting the commission?

In an article entitled "The Art of Negotiation," St. Louis Volunteer Lawyers and Accountants for the Arts describes negotiation as "the give-and-take process of bargaining to reach a mutually acceptable agreement."[2] It is an act that combines communication skills, psychology, sociology, and conflict management. It is an important tool in a lawyer's arsenal; however, others should not be intimidated by the process. Negotiation is a part of daily life. Roger Fischer, coauthor of *Getting to Yes*, offers the following suggestions for enhancing negotiating power:

- **The power of skill.** A skilled negotiator is better able to exert influence than an unskilled negotiator. Skills, which can be acquired, include the ability to listen, to become aware of emotions, to empathize, and to become fully integrated so your words and nonverbal behavior reinforce each other.

2 Sue Greenberg, *Anatomy of a Contract* (St. Louis, MO: St. Louis Volunteer Lawyers and Accountants for the Arts, 2004). A free download can be found at https://vlaa.org/wp-content/uploads/2015/05/Anatomy-of-a-Contract.pdf.

- **The power of knowledge.** The more information negotiators gather about their counterparts and the issues at hand, the more powerful they'll be at the table. Preparation is crucial—a repertoire of examples and precedents enhances a negotiator's persuasive abilities.
- **The power of a good relationship.** Generally, negotiations are not one-time events. Instead, they establish or foster ongoing relationships. Trust and the ability to communicate are the two most critical elements in a working relationship. If, over time, you have established a well-deserved reputation for candor, honesty, integrity, and commitment to promises made, your ability to exert influence will be greatly enhanced.

Perhaps the most important point in negotiating a contract is to know what you want. What points are negotiable and what points are deal breakers? If you have a lawyer, it is important that he or she understand what you are doing and your objectives.

Lawyers frequently say, "There is no harm in asking." Some things, of course, are difficult to negotiate. For example, a request for proposals, which is sent out to a select list of competitors, normally cannot be easily negotiated. The artist must carefully consider whether the terms, the project, and the initial monetary offering make it worthwhile to submit his or her work. Notwithstanding, several artists recently invited to submit to a municipal RFP declined because of the anti-artist boilerplate requirement of surrender of artist's rights and a low proposal fee. Faced with an empty slate, the administrator, belatedly, offered to change the contract terms. Even if a government body presents a printed form which appears to be set in stone, more likely than not, certain clauses can be negotiated. Most obvious are those clauses that deal with the particular scope of service to be provided by the artist and the benchmarks and amount of payment at each of those benchmarks. More difficult to negotiate, particularly with governmental bodies, will be those clauses that have been preapproved by a local governing body. Such clauses may include indemnification, insurance, and often sections of artist's rights. Most importantly, negotiating a contract often gives you a preview of what the rest of the project will be like. If it is very rough going during the negotiations, it is only likely to get harder, not easier, if the same people are involved.

What if the agency doesn't give me a contract? Should I work without one? Should I provide one of my own? If so, where can I find a model agreement to use?

It is very unusual that an agency or a client with enough money to hire an artist to do a commission does not have a written contract. The usual scenario is that there is a contract ready, but that the artist must perform before negotiating and signing the contract. The more the artist invests time and possibly money in a project without a contract, the harder it becomes to negotiate a contract and to leave the project if he or she is not able to secure favorable terms. My advice is that, all things being equal, do not begin to work without a contract, and if time pressure prevents entering into a full contract, a letter of intent and a phase-one payment should be negotiated.

With respect to the other questions, there may be situations where an agency or client does not have an appropriate contract. Often, too, lawyers representing the client will be real estate lawyers or city attorneys unfamiliar with art law or copyright. The "Model Agreement for Commissioning a Work of Public Art" developed by the Association of the Bar of the City of New York in 1983 is a good starting place in that situation. The model agreement can be obtained by contacting Lynn Basa at lynnbasa@lynnbasa.com or me at artlaw@hoffmanlaw.org.

Should I hire an attorney to negotiate my contract from the beginning? How much will it cost for an attorney to review my contract? What should I do if I can't afford one?

It is always better to have an attorney involved in negotiating a contract for several reasons, including the fact that it enables the artist to keep out of the negotiation process if it is not going well. Often, an attorney is involved once the preliminary concept or invitation has been extended to the artist and the artist has discussed the basic artistic features of the project. This is an appropriate time.

Attorneys have different rates, but experienced attorneys in this area will charge from $300 to $500 an hour. However, for artists who meet the income requirements and are unable to afford an attorney, most states have a branch of the organization called Volunteer Lawyers for the Arts, which provides free legal assistance to artists without sufficient resources. I founded the Washington Lawyers for the Arts, which is still active throughout the state of Washington and recently celebrated its thirtieth anniversary.

As a finalist, is there a way I can keep the agency from asking me for more and more work? (Here's a common example of this unfortunate situation as told to me by an artist: First the agency asks for a drawing, then a material sample, then more drawings, then a model, and all the while, the artist is traveling back and forth for meetings. In the end, after a year of this, the mayor decides she doesn't like the artwork, overrides the commission, and rejects the selected artist. All this for a $1,000 design fee.)

The artist should know at the time she enters into a competition exactly what is required and not get involved in providing more. Also, unless artists collectively object to this practice by refusing to undertake all of this work for a $1,000 fee, the situation will not change or improve.

In the case mentioned, certainly there should have been reimbursement for travel expenses and required attendance at no more than one meeting. To my knowledge, a model is rarely requested as part of an initial proposal, if at all. Again, artists are prone to accept a certain amount of risk in investing their time and money in submitting a proposal. The question is, is the reward worth it and can the artist afford to say no? Of course, not knowing all the facts, it is difficult to render an opinion, but the artist in your example may have a legal claim for damages.

It seems like a good idea to have a budget estimate before I sign a commission contract, but how do I protect myself from unanticipated demands from the client or agency? (This is a classic catch-22 for inexperienced artists: they're asked to commit contractually to a budget and then asked to do extra work and/or commit more time as the project progresses to such things as engineering stamps, shop drawings, material samples, extra meetings, etc.)

You are right. This is a situation in which many inexperienced artists find themselves. More experienced artists with greater knowledge and/or bargaining power do not commit contractually to these kinds of activities. For artists with less bargaining power, it is sometimes a question of making sure that only preliminary estimates are required at the outset and that there are adequate progress payments for design development and structural review.

If I'm handed a sixty-page contract full of irrelevant or anti-artist "boilerplate," instead of trying to negotiate it point by point, can I simply add an addendum to the contract that addresses my real concerns and protections

for such things as a workable payment schedule, insurance, and realistic time schedules?

This is not a bad suggestion if the client's lawyer agrees, but you had better have a lawyer assist you in the negotiations. You had better know what is in the contract and make sure that the addendum deals with the issues that are important to you and modifies the clauses that don't work for you in the main contract.

Can I simply draw big Xs across sections of the contract that I don't agree with, sign it, and send it in like that?

A physical contract is not an artwork and its form is not inviolate. You can, of course, draw an X or some other mark to indicate clauses or provisions with which you don't agree. Each of those changes should be initialed in addition to signing the contract on the signature page. Of course, a contract is based on mutual understanding and agreement. If the client or agency does not agree with your Xs, there may be no deal. On the other hand, if the client does not object, and sends you a check so that you can begin performance, you have entered into a valid contract.

Is it legal to ask artists applying for RFQs (in other words at the open-call, competition stage) to sign an "assurance of acceptance" of the forthcoming contract should they be selected? (Guy Kemper says this is becoming more commonplace, and "of course it is impossible to say that whatever they put in the contract about your specific contract you'll accept. They want you to agree to the 'boilerplate'—which usually includes signing away rights typically covered by the Visual Artists Rights Act (VARA)[3]—in advance of considering you for the RFQ.")

It may be unfair, but I can't think on what grounds it would be illegal. The reality is that, despite such clauses, negotiation of the contract once an artist is selected may occur, particularly if the artist has "bargaining power." However, technically, and certainly it has happened, the artist may be required to accept the contract that was proposed to her. The artist, however, is unlikely to be forced to do the project. I am not aware of any specific case where an artist refused to accept a contract after being selected and then was sued for walking away from it. The unfortunate part of all this is that artists with bargaining power who enter into competitions where the restrictions are

3 See page 145 for further discussion of VARA.

not so onerous will not enter competitions that pay little money and require surrender of artist's rights. In the end, it is the public that loses. Clients must recognize that it is the artist who creates the work, and without respect for the artist and his or her artistic vision, we will end up with mediocre monuments in public spaces.

When do you go from being a compliant team player to being a doormat? How do you keep from crossing that line while also making sure you get what you deserve? When is it time to walk away or get an attorney? If you feel like you are being unfairly burdened with an expense or work that is outside of your agreed upon scope of service, what are steps you can take before you pound your fist on the table and threaten to walk away from the project?
Questions like these are very difficult to answer without a frame of reference or context. Basically, every contract, particularly those with an agency or with a corporate client, should have one contact person named in the contract to act as an interface between the artist and the agency/client. Hopefully, the initial problems referred to in this question can first be discussed with that person. If the project is a collaboration, there is also usually one person who will be designated as the team coordinator or point person. It is also quite typical now to have alternative dispute resolution mechanisms such as informal discussion, mediation, or arbitration built into public art contracts with any complexity or of a significant monetary amount. Particularly recommended would be a clause requiring mediation in the event of any dispute. This means that any disagreement arising during the course of the project would be brought before a neutral party who will help them resolve their differences. Mediation is consensual and is nonbinding unless all parties agree to be bound by the mediator's recommendations. Mediation can be used for disputes between a client and an artist or between an artist and other team members.

TYPES OF CONTRACTS

What are the different contractual arrangements an artist may encounter? Have public arts contracts changed over the years?
Most of the federal, state, and local public art commissions of the late sixties and early seventies involved the making of objects "plopped" in public plazas. Such commissions reflected the past government philosophy of creating

outdoor museums filled with objects. This paradigm in most instances is based on the artists receiving a fixed fee to "design, fabricate, transport, and install the artwork" at a designated site. The artist must then hire fabricators and other subcontractors. This type of contract, which has multiple variations, is still fairly typical for government art programs. Nevertheless, beginning at least in the 1980s and continuing through the present, the notion of sculpture has gone through a radical redefinition. Sculpture has come off its pedestal and has become linked to the environment, context, and site.

Today there is an increasing recognition of a greater role for artists and their contribution to the public sphere. Artists are now engaged as designers of site-specific landscape installations and environmental works, parks, urban master plans, museums, and housing projects. The artist may be the sole designer, the leader of a design team, a member of a collaborative team, or a partner in a joint venture with architects or landscape architects. The artist functions in a similar fashion to architects: the contract is primarily one for services for the organization, and the artist provides drawings, models, and technical information. In this paradigm, a general contractor produces the final product, subject to the artist's oversight and approval. Such contracts may become complex, for the contract is a roadmap to how these various entities will interact. Issues not only of aesthetic control but also of sharing liability, copyright, and coordination become more complicated.

Is there a typical artist fee for the public art commission? Is the fee included as part of a lump sum, fixed amount, or is there an artist fee which is identified separate and apart from the total project cost which has its own payment schedule?
It should come as no surprise that fees vary with the nature and scope of a project. Another factor of a contract is whether the artist is functioning as an "artist," "designer," or "pseudoarchitect." Usually an artist should charge 20 percent of the project cost for a fixed-fee contract, although in the public art arena, every rule has an exception.

I've been given a purchase order by the client agency instead of a contract. What is a purchase order? Does having a purchase order instead of a contract increase my risks for liability, not getting paid, or . . . ?
No. A purchase order can be seen as an offer to enter into a contract. The problem is not that it is not a binding contract but that the purchase order may not have the negotiated terms and provisions necessary to decrease risks.

Often a purchase order is the basis for a contract between an artist and a subcontractor or fabricator. The purchase order usually will have several amendments added to it by the artist, which cover the benchmarks for payment, issues of liability, an assumption of risk, warranties, and other provisions that protect the artist and ensure that there is a parallel structure between the artist subcontract and prime contract. It is very unusual that the commissioning body itself will issue a purchase order. In the event that it does, the same issues apply: the purchase order does not usually include sufficient terms to define the artist's rights and rewards.

My contract is written so that I am a sub to the general contractor. I fabricate the artwork myself. What risks should I be aware of and how can I protect myself in the event that the general contractor does not finish the work on time or absconds with my money?

The General Services Administration has, in many instances, tried to adopt a policy of having the architect as the prime contractor and the artist as the sub. The same issues arose in these projects as in those described in your question. It is always better for the artist to try to contract directly with the client for two reasons: (1) When the artist is the sub, particularly to the architect, it sets up a negative hierarchical relationship. (2) The risks that the question anticipates are always present. As in any contract situation, the artist can try to protect himself or herself with contract language providing for prompt payment and a payment schedule which reflects compensation for work already performed. However, at the end of the day, there is no better protection than knowing who you are dealing with and (hopefully) working with reliable people. Moreover, the particular risk you speak of is not an insurable risk. This example is the mirror image of the general contractor–artist subcontractor question discussed in the first paragraph. The message again is to know the people with whom you are dealing, check references, and talk to other artists. One artist provided the following comment on this subject:

> I made the mistake once of giving a job to a fairly young subcontractor who sounded like he would do a great job, but he didn't have an established business with a staff, office, et cetera, *and* I gave him up-front money! What a huge mistake that was. He performed a small part of the work, asked for more money, and when I wouldn't give it to him, he left town. And my $30,000 went down the drain. I eventually hired a lawyer, found the guy, got a

judgment against him, and only recently am I receiving a small portion of my judgment in small monthly payments (five years later). Never pay a subcontractor anything until the job is complete and accepted. If they're too small to handle that, then they're too small to take on the job.

SPECIFIC CONTRACT CLAUSES

In 1985, as noted above, the Association of the Bar of the City of New York adopted a model agreement. Although the contract was based on a fixed-fee commission agreement with the work fabricated off-site, almost all of the provisions remain timely and represent a fair and balanced approach to the resolution of many difficult and complex issues. The model agreement answers, in much greater depth, many of the questions posed by the artists who contributed to this chapter, and my answers can be seen as supplementing the annotations to the model agreement. The philosophy that supports the model agreement is still appropriate: client and artist are on the same side. A balanced contract that addresses the reasonable needs and concerns of all parties fosters the greatest creativity and quality.

Scope of Services/Scope of Work

What is the difference between "scope of services" and "scope of work?" Are they the same thing?
For all practical purposes, it is a question of semantics. I personally prefer to use "scope of services," but there is no important legal difference. Often "work" is a defined contract term.

What are the components of a "scope of work" or "scope of services?"
This is the most unique aspect of the contract. The "scope of work" or "scope of services" describes in detail the work to be performed by the artist and his or her responsibilities. For example, it covers whether the artist is responsible for providing designs only or for providing designs, materials, fabrication, and transporting and installing the work at the site. It is very important that the artist clearly states his or her responsibility and defines rough points, such as whether or not he or she is responsible for site preparation, installation, and other transportation—all of which may not be clearly expressed by the client or agency.

Storage

I've noticed that contracts will have a penalty for artists if we don't have the artwork ready by the installation date, but if the site isn't ready when it's supposed to be, the artist gets stuck with the storage costs. How can I protect myself against asymmetrical contract provisions like this?

This is a clause that is often negotiated and it is one for which it is not difficult to achieve symmetry. The artist who ends up getting stuck with storage costs has improperly negotiated the contract.

Quality Control

As an artist and member of a design team, my role in inspecting the work in progress during construction is minimized as the client hires on-site inspectors. How can I get my rights of approval respected in reviewing the work during construction on large infrastructure projects?

Again, this is a negotiating issue. I always try to insert a clause which gives the artist the right to inform the client of any unfair action taken by a contractor and has the client agree that he or she will reject any work not approved by the artist. The client must understand that an artist's vision is in the subtle details and that payment of an artist's fee is wasted if the artist does not have the opportunity to reject work that does not conform to his or her aesthetic vision as expressed in the artist's plans and drawings.

Payment Schedule

Often the payments in schedules set by agencies are weighted toward the end of the project. Because I need to pay for materials and subcontractors up front, I need the preponderance of my payment at the beginning. Can I specify my own benchmarks and payment schedules in a contract that are favorable to me? If so, what payment schedule do you suggest?

Payment schedules are often easily negotiable, particularly if the artist can present evidence to support a front-loaded payment schedule. It really all depends on the nature of the artist's work and what the artist is doing. Some artists will require a lot of time up front, whereas others doing large-scale site installations will do most of the work at the end. On the other hand, if the artist is acting as designer only, preparing documents and then supervising, then the payment schedule should be front-loaded.

What is a change order? How can I make sure that I get paid for extra work that is asked of me beyond the scope of work specified in the contract? What and how should I charge for extra work? By the hour?

A change order is nothing more than a contract modification agreed to by the involved parties. It should be in writing. Usually the contract provides adjustments, which require additional work. It really depends on each individual case and what the main contract provides to answer whether one should be paid by the hour or paid based on a percentage of the increased costs of materials or the increased scope of work. Architects usually specify that for work exceeding basic services, they will charge an hourly fee. But again, this varies. Whatever the adjustment and method of compensation, it should be provided for in the contract.

I signed a contract where the final size of the artwork wasn't determined because construction was not yet complete. There was a clause in the contract that said my wage would go down if the dimensions of the site decreased. They did, but the cost deducted was based on the cost per square foot of all expenses (labor, travel, artist fee, etc.) not just the cost of the materials that would have been used. How can I prevent this from happening on future projects?

Don't sign a contract with a similar provision. Very often, reducing the size of a project entails more work than if the project were built as originally specified. In this particular case, and in future cases, the artist should negotiate for an additional fee to reduce the scope of work. Of course, if there is no additional design work required, then simply reduce the fee based on the cost of materials.

I submit my invoices on time, but the agency is taking longer than the sixty days specified in the contract to pay me. This makes me unable to pay for materials and fabrication, which is putting me behind schedule. Will I be in default of my contract if I slow the project down to match the agency's payments, or should I go into debt to keep the project moving forward? And can I charge them interest for late payments?

This is not an uncommon situation unfortunately. There is a limit to what one can do, but certainly try to have a clause in the contract, which specifically provides for an interest of 1.5 percent on payments not made within the time period specified. This question also suggests that the original payment schedule agreed to did not adequately take into account how the payments should be allocated to prevent the artist from having to subsidize the project

with his or her own money. There are also clauses that one can write into a contract, which, in the event of failure to pay in a timely manner, allows the artist to stop work. The problem is that often there will be other people involved who are working for the artist, so slowing down the project is really not a viable alternative. I am afraid the only solution is to anticipate this problem in future contracts with front-loaded payment schedules and a hefty interest charge if payments are not made in a timely fashion.

Contingency

What is a budget contingency? How much should it be? Can the artist set it? What if the artist comes in under budget? Does he or she get to keep that money? What if the budget is so small that there's no room for a contingency?

A budget contingency is based on the fact that, over time, the cost of labor and materials may vary, usually upward. When the artist is asked to prepare a budget and there is some leeway, I recommend a 10–15 percent contingency. There is no one answer to whether or not the artist gets to keep the contingency; it depends on so many different factors and practices.

Timelines

What can I do to cover myself in the case that I fall behind the contracted schedule waiting for an agency that continually misses deadlines?

This is a fairly easy question. First, the contract should always provide for the readjustment of timelines in the event that one party is prevented from meeting his or her deadlines by the delay of another party. As a matter of law, one party cannot be held in breach of a contract obligation if his or her performance was held up by another party. The contract should always provide that all parties can in good faith mutually adjust the time schedule, which is certainly a legitimate request in many situations. Timelines and performance benchmarks should be very carefully thought out and the provisions governing them negotiated with careful attention to the variety of contingencies that may arise.

Documentation

The contract stipulates that the artist should pay for a plaque and photography included in the project. Shouldn't the agency pay for these things?

This is simply a matter of bargaining power and the agency's budget. No magic answer to this one. Another important aspect of this to consider is

the artist's ability to select the photographs used to represent his or her work because many people will learn of the work exclusively through photographic documentation.

Insurance

Insurance can be both easy and complex. The easy part is calling your lawyer or broker. The hard part is not having insurance if something goes wrong. Insurance is negotiable and there are many ways to skin the cat. Chapter 7 of this book, "Insurance: The Lowdown," goes into depth on the types of insurance coverage artists need.

What are "performance," "labor and materials," "maintenance," and "bid" bonds for? On what types of projects are they required? Are they the same as professional liability insurance?
Various bonds are provided by guarantors to guarantee payment in the event of a contractor default. It is a type of insurance with a premium paid whereby the guarantor guarantees to pay for or complete the performance in the event that the contractor defaults. In the late seventies, I wrote a position paper for the Kings County Arts Commission advising them to remove performance bonds from artists' contracts because the premium, which was high, could be better applied to the artist's fee. In most instances, public art contracts now do not include the requirement that artists obtain performance bonds. They may occur from time to time in large-scale projects involving large payments to the artist and where the artist is required to perform services much like a general contractor.

Why can't the commission contract simply be with the licensed professional who is used to meeting requirements for indemnification, professional liability insurance, workers' comp, performance bonds, and so on, such as the general contractor, my fabricator, or the architect? Why are we required to have professional liability insurance if we're having a subcontractor do the installation? My subs have all the liability insurance needed.
Sometimes these types of insurance are with the licensed professional. My own preference is that the artist holds the prime contract and passes on the liability to the subs who have the required insurance. Yes, you didn't necessarily have to spend $3,000 a year. It is usually possible, with careful contract negotiation, to obtain the maximum benefit and control for the artist at the same time that issues of indemnification, insurance, and so forth are properly

allocated where they belong. Like anything else, you have to know what you are doing, or hire someone who does.

These are difficult questions and it may not always be possible to fix things. But certainly a well-drafted contract can allocate liability and risk to those most capable of paying for it without pure nonsense and a huge waste of money.

What do "risk of loss" and "risk transfer" mean? How is the cost of the risk determined? What should artists be aware of when encountering this section in a contract?
Risk of loss simply defines who is going to be responsible for replacing an object or an installation if it is damaged. The uniform commercial code, which is the law that governs sales of goods in most states, has specific rules for allocating risk of loss if the contract does not otherwise provide. My own preference is to write out clearly in the contract which of the parties have the risk of loss at any given time. The insurance coverage period obtained by the artist should be coextensive with the artist's risk of loss.

Indemnity
What is an indemnity clause? What are the implications for artists? (Lajos Héder, an artist with many years of experience as a public artist, writes, "Most contracts include a nasty indemnity clause that says something like 'indemnify, hold harmless, and defend the city—or "client"—against any and all claims.' I have argued against this with varying levels of success, particularly against the 'defend' part that implies that the artist actually has to hire an attorney to defend himself or herself against the city in a lawsuit that could be quite frivolous.")
An indemnity clause is a provision in a contract which provides that the entity indemnified will be protected from third-party claims arising out of certain contractually defined circumstances. Generally, each party to a contract can sue the other part for a breach. Breach of contract claims are not available against individuals who are not contract parties. Similarly without an indemnification or hold harmless clause, one party to a contract sued by a third party has no right to be compensated by the second party for damages and attorney's fees. Indemnification clauses are usually "boilerplate." That is to say, clauses which have been, in the case of government commissions, approved by the city council or some other governing body. It is therefore difficult to negotiate them. If there is some room to negotiate, artists should

try to narrow indemnification to those situations arising from the artist's "sole negligence." The model agreement referred to earlier in this chapter recommended that the client or commissioning agency indemnify the artist for final acceptance.

Various states, as a result of lobbying by design professionals, have leveled the playing field slightly by limiting the ability of public entities allowed to impose broad indemnification provisions on design professionals. In this respect, California's new legislation, AB 753, signed September 25, 2006, by Governor Schwarzenegger, makes indemnity agreements requiring designers to compensate public entities for more than their share of negligence unenforceable for contracts entered into after January 1, 2007. The drawback is that the law defines design professionals as licensed architects, registered engineers, land surveyors, and landscape architects; thus, artists are not included in the legislation. Hopefully, however, in many of these large-scale public projects where artists form a part of a collaborative team with these other design professionals, they will benefit from contract language newly drafted by government attorneys to comply with the new law.

Apparently, one factor which led to the legislation is that most current professional liability insurance policies no longer provide for extra or contractual risks that may exceed professional liability for negligence. If design professionals are found liable at trial based on these broad indemnity provisions and are accessed damages beyond their own negligence, they may not be covered under their professional liability policies.

Warranty

Is there anything I should look out for in the "Warranties of Title" section of a contract? It appears all it is asking is that I vouch for the fact that I am the originator of the idea for the artwork and didn't steal it from anyone else. Is there more to it that I should be aware of?
No.

Regarding warranties of workmanship, how much is a reasonable amount of time for the artist to be responsible for guaranteeing the work be free of defects? I've seen contracts with periods ranging from one all the way to ten years. Is this negotiable? If so, is there an industry standard for how long this warranty should last?
Warranties of workmanship depend on what it is you are doing and the nature of the materials you are using. My advice is never give a warranty

beyond a warranty that your subcontractor or material supplier is willing to provide. In short, the industry standard depends in large part on the nature of the materials that you are using and the warranties characteristically given in that industry. In general, these clauses are negotiable.

After the warranty period was up, some tiles fell off of a mosaic mural I did. The city had their maintenance crew go out and patch it up with what looked like bathroom tiles. The artwork looks terrible now. What recourse do I have?

If you read the model agreement and signed it, you would have had contractual options available to you as well as rights under the Visual Artists Rights Act. Without knowing whether or not you waived these rights, it is difficult to provide you with any advice except to say pay more attention to your contract and artist's rights the next time around.

INCORPORATION

Should I incorporate my business?

The primary purpose for incorporation is to provide the individual with limited liability. Particularly if one has assets and/or many employees, it is desirable to incorporate. Currently, while it is difficult to provide general advice without knowing the various details involved, the best corporate form is the limited liability company (LLC). That is because it is a hybrid corporate structure which provides corporate protection toward personal liability but at the same time provides a pass-through on taxes. The LLC has replaced the subchapter S corporation as a preferred form for those who wish to protect their individual assets by use of the corporate form. This may also avoid some of the risks of double taxation involved. Regardless of whether the artist is a sole proprietorship, an "S corp," or an LLC, attention must be paid to avoid the situation where the artist may receive a large payment in one year for fabrication but not expense it until the following year. In both cases of the LLC and sole proprietorship, the artist will not be able to deduct the expenses from the income in that year; however, with the corporation, which is not an "S," the artist may have double tax action.

In the next chapter, I will discuss several of the most important aspects involved in the public art commission, including copyright, fair use, and the Visual Artist Rights Act (VARA).

Questions were contributed to this section by the following artists:
Alice Adams, Dale Enochs, Cliff Garten, Nicole Gordon, Lajos Héder, Brad Kaspari, Guy Kemper, Jack Mackie, Mike Mandel, Julia Muney Moore, Marilyn Ines Rodriguez, Koryn Rolstad, Vicki Scuri, Survilla M. Smith, Ginny Sykes, Stephanie Werner, Chana Zelig.

Ask the Expert—
A Primer on Copyright
and Artists' Rights
By Barbara T. Hoffman, Esq.

Because the collective questions posed to me in this chapter reflect some basic confusion about copyright and artists' rights, I believe a nutshell analysis of these two areas would be useful before responding to particular questions concerning copyright and artists' rights as they apply to public art commissions.

COPYRIGHT BASICS

The source of Congress's power to enact copyright laws is Article I, Section 8, Clause 8, of the Constitution (the "Copyright Clause"). According to this provision, "Congress shall have Power . . . to promote the Progress of Science and useful Arts by securing for limited Times to Authors . . . the exclusive Right to their respective Writings."

To be protected under current US copyright law, a work "must be an original work of authorship fixed in a tangible medium of expression." The copyright law imposes no requirement of aesthetic merit as a condition of protection. However, a work must have "at least some minimal degree of creativity." Works of visual art—a painting, a photograph, a sculpture—are protected by copyright. Thus, the simple act of creating an original work in a "fixed" medium, including electronic, gives the author copyright of the work.

Rights of the Copyright Owner

Under Section 106 of the 1976 copyright law, the copyright owner has the exclusive right to (1) reproduce the work in copies or phonorecords; (2) prepare derivative works based on the copyrighted work (which includes the right to recast, transform, or modify); (3) distribute copies by sale or other ownership transfer, or to rent, lease, or lend copies; (4) perform the work publicly; and (5) display the work publicly.

For certain one-of-a-kind visual works of art and numbered and limited signed editions of two hundred copies, authors (artists) have the right to claim authorship (attribution), prevent the use of their names in conjunction with certain modifications of the works, and to prevent alteration of their work (preserve its integrity) (Section 106A). The latter two rights are known as *droit moral*, or moral rights. Section 106A states that "the author of a work of visual art" shall have the right, subject to the exceptions provided in 17 U.S.C. § 113(d), "to prevent any intentional distortion, mutilation, or other modification of the work which would be prejudicial to her honor or reputation." She has the right to prevent any destruction of a work of recognized stature, and "any intentional or grossly negligent destruction of a work that is a violation of the right." However, 106A(c)(2) provides an exception: "The modification of a work of visual art which is the result of conservation, of the public presentation, including lighting and placement, is not a destruction, distortion, or modification unless the modification is caused by gross negligence." Additionally, there is an exception in 113(d) for works that are integral to a building, these artworks being deemed outside the scope of VARA.

Ownership of the bundle of intangible rights comprising copyright is separate and distinct from ownership in the work of art. Under current law, in the absence of a writing expressly conveying copyright, the sale, gift, or transfer of the original work of art does not transfer the copyright in the work of art. Under the Copyright Act, copyright interests can be transferred *inter vivos*, or at death, and in whole or in part. For example, a copyright owner can transfer all the rights, one or more of the rights, or create joint ownership of rights. A copyright owner may license or assign copyright in the work in a number of ways: (1) by the type of use and/or media, (2) by an exclusive or nonexclusive license, or (3) by territory or duration, to name only a few possibilities.

It is no longer the practice for most clients to request that the artist grant copyright in the work of art as a condition of the commission. To the extent that there is an assignment or "license" of a copyright interest, it is usually a nonexclusive license allowing the use of the artwork for noncommercial purposes. A nonexclusive license is not a transfer of copyright ownership, but a transfer of a contract right; thus, the artist should be aware that the client cannot rightfully file a copyright infringement action and that he or she (or the artist's heirs) must bring any action for copyright infringement. Both nonexclusive and exclusive licenses are usually negotiated. The commissioning entity usually requests that the artwork be unique, so the artist normally

agrees to a limitation on his or her exclusive right to make exact reproductions of substantially similar size and materials.

Different language will be negotiated for artists who work in editions or in repetitive themes or styles. For those artists acting as "architects," the basic American Institute of Architects' model agreement is useful. That document protects the artist's drawings and entitles the client to reproduce them only as "instruments of service" for the project.

The Copyright Act vests initial ownership of copyright in the creator of the work, unless it is a "work for hire." In the case of a work for hire, it is the employer and not the employee who is considered the author. Section 101 defines work for hire as (1) a work prepared by an employee within the scope of his or her employment and (2) a work specially ordered or commissioned for use as a contribution in one of nine categories. The United States Supreme Court decision in *CCNV v. Reid* clarified that a public art commission cannot be a work for hire in category (2). Thus, a commission is only a work for hire if the artist is an actual employee of the client with a W-2.

Duration of Copyright

The 1909 copyright law prescribed a twenty-eight-year term of copyright from the date of the work's first publication. Thus, until 1978, the effective date of the 1976 act, the term of federal copyright was twenty-eight years from the date of publication. To maintain copyright protection during the second, or renewal, term, a copyright owner has to file a renewal application during the twenty-eighth year of the initial term. The 1976 copyright law, effective in 1978, provided that federal copyright protection of works created by "identified natural persons" run from the work's creation—rather than its publication—and that such protection would last until fifty years after the author's death. In 1998, Congress passed the Copyright Term Extension, which extended the duration of copyright to the life of the author plus seventy years and which retroactively extended the term of copyrights in existence to the seventy-year term.

What Is Fair Use?

The fair use doctrine, from the infancy of copyright protection, "has been thought necessary to fulfill copyright's very purpose, 'to promote the Progress of Science and useful Arts'" (*Campbell v. Acuff-Rose Music, Inc.*, 510 U.S. 569, 575). What is fair use? As the syllabus for a crash course in copyright by the University of Texas stated, "We would all appreciate a crisp, clear answer,

but far from clear and crisp, fair use is described as a shadowy terrain whose boundaries are disputed."

Recognized as common law, the doctrine is now codified in section 107 of the copyright law, 17 U.S.C. § 107 (1994). It provides an affirmative defense to a claim of copyright infringement that a work was used without the copyright holder's authorization or permission. Section 107 provides in its first sentence an illustrative list of the purposes for which the doctrine may be invoked, including "comment" and "criticism." Section 107 then lists four vague factors that courts consider in determining whether a use is "fair." These factors are (1) the purpose and character of the use, (2) the nature of the original copyrighted work, (3) the amount and substantiality of the original work taken, and (4) the effect of the use on the market for the original work. (For more about fair use, check the articles on my website at www.hoffmanlawfirm.org.) Artists have prevailed with the fair use defense in a number of recent cases involving parody, satire, and appropriation.

THE BATTLE OF US ARTISTS FOR "MORAL RIGHTS"

Under French law, every creator has a personal, perpetual, and inalienable right to respect of the artistic integrity of the creative work. The five components of *droit moral* are (1) the right of paternity: a work must be attributed to its creator and no one else; (2) the right of creation: no one except the creator may determine whether or when the work is put before the public; (3) the right of integrity: no one except the creator can change the work; (4) the right to protection from excessive criticism; and (5) the right to withdraw the work from the public. Legal protection of an artist's so-called moral or personality right was controversial in the United States because US copyright law focused primarily on the protection of economic rights and interests. Prior to 1990, artists relied on theories of contract law, or defamations of trademark as a "moral rights equivalent." As noted previously, in 1990, after years of debate, Congress enacted the Visual Artists Rights Act (VARA) as section 106A of the copyright law, a limited form of "moral rights" protection.

Legally, this vests in the artist a right of attribution and a right of integrity. VARA provides that the author of a work of visual art shall have the right to claim authorship of that work, and shall have the right to prevent any intentional distortion, mutilation, or other modification of that work which would be prejudicial to his or her honor or reputation, and to prevent any destruction of a work of recognized stature.

An artist who wishes to state a claim under VARA must first establish that the laws apply to his or her case by proving that the work meets the statutory definition of visual art. A work of visual art is defined by VARA in terms both positive and negative. VARA affords "protection only to authors of works of visual art—a narrow class of art defined to include paintings, drawings, prints, sculptures, or photographs produced for exhibition purposes, existing in a single copy or limited edition of 200 copies or fewer." VARA applies at the moment of creation. An artist's right of integrity enables the artist to protect his reputation and personality by protecting the physical integrity of his work.

Works of "recognized stature" within the terms of VARA, are those works of artistic merit that have been recognized by members of the artistic community and/or the general public. To obtain this protection, an artist must prove not only the work's artistic merit on its own but must also show that it has been recognized in a community as having such merit. The stature of a work of art is generally established through expert testimony.

A Few Limited Victories

Can a sculptor of a permanent installation of forty metal Canadian geese on display at a shopping center prevent the mall operator from adding red ribbons to decorate the sculpture at Christmas? Can a nonprofit organization that commissioned a sculptor to create an artwork hire the sculptor's assistant to complete the artwork in order to override the sculptor's objections? Does an artist have the right to prevent an owner who commissioned a work of site-specific art from removing it?

The preceding questions illustrate whether and when an artist has the right to control the integrity of his or her work after it has been sold or before it has been completed. VARA may or may not give the artist a right of action. The first example is based on a well-known Canadian case. The court approved the sculptor's request to take down the ribbons on the grounds that the modification of the work would harm the professional and artistic reputation of the artist, and would, therefore, be in violation of the integrity of his work. Canada has endorsed moral rights since 1931.

The second example is based on the case of the distinguished sculptor Audrey Flack, which I litigated and which stands as one of the few precedents on the side of the artist under VARA.

The facts of *Flack v. Friends of Queen Catherine* are interesting because they provide insight into the risk of certain business models used to

commission works of public art. In 1989, for the purpose of memorializing the life of Catherine of Braganza, princess of Portugal, queen of England in the midseventeenth century, and the namesake of the borough of Queens, the Friends of Queen Catherine (FQC) undertook to create a monument for installation on donated public property facing Manhattan. On the basis of a model she created for the project, Flack was commissioned to further design and supervise the fabrication of a twenty-two-foot model and then a thirty-five-foot clay model to be cast as a bronze sculpture and installed at the site. FQC entered into a contract with the foundry Tallix to fabricate the project based on Flack's designs under her supervision. Flack had no contract with the foundry. By the time Flack had completed preparatory work on the project and, in 1997, began the fourth phase to create the full-size statue, unfounded rumors that Catherine of Braganza was involved in the slave trade created public controversy around the project, resulting in the loss of the site. Flack, nevertheless, completed a full-size clay statue, which was presented to visitors and the press at Tallix.

By 1998, given the controversy, Tallix sought assurances of FQC's ability to fund the project, which were not forthcoming. The foundry terminated the contract. Tallix and FQC finally settled their differences, permitting work on the thirty-five-foot bronze statue to begin one year later. However, Flack discovered that, in the interim, the clay sculpture of the head had been placed outside in Tallix's garbage dump. In addition, the waxes and molds drawn from the thirty-five-foot clay sculpture had been damaged; thus, it was necessary to reconstruct the clay face to develop new molds. Flack offered to resculpt the face but demanded an additional fee. Tallix, at the suggestion of FQC, hired one of Flack's assistants to resculpt the face. The result of the assistant's work was a "distorted, mutilated model," which Tallix and FQC were in the process of casting and shipping to Portugal. Flack came to see me to see whether she had any remedy against Tallix or FQC for the modification or destruction of the sculpture.

We began an action for infringement of Flack's rights under VARA and copyright laws based on the unauthorized creation of derivative works and other claims. We also asked the court for temporary emergency relief to maintain the status quo, which was granted.

Because the clay sculpture had been exhibited at Tallix and because we submitted expert affidavits testifying to the "recognized stature" of Flack's work and this work by her dealer, an art critic and curator, the work's recognized stature was acknowledged by the defendants. However, the court held

that Tallix's placement of the head in the garbage did not constitute a willful destruction of the artwork, and its modification was caused by "time and the elements," both an exception to the rights granted under VARA.

Flack prevailed on her claim against Tallix and FQC for hiring her assistant. While Tallix and FQC argued that hiring Flack's assistant was a conservation measure, an exception to VARA protection, the court, nevertheless, decided that hiring the assistant to sculpt the clay head could be gross negligence and permitted a VARA claim, as well as a claim for copyright infringement based on the creation of an unauthorized derivative work.

Thus, while it is clear that a property owner, foundry, or commissioning entity does not have the right to complete the work without the artist's approval, contrary to the law in France, courts in the United States have been reluctant to compel a client to permit an artist to complete a work the artist was commissioned to create. Another case in which an artist was successful in bringing his VARA claim involved a suit against the City of Indianapolis, which demolished a work of art that was installed by agreement of the city on private property. The court awarded damages in the maximum amount allowed for nonwillful VARA violation. On appeal, the artist argued that the violation was willful, and enhanced damages were warranted. The city argued that the evidence admitted to establish the recognized stature of the art was an inadmissible, out-of-court statement, or "hearsay." The court held that the evidence admitted was not hearsay and that the destruction of the art was not willful but rather the result of bureaucratic failure.

Artists by and large have not been successful in their VARA claims either because the work falls within one of the exceptions in the statute or, even more troublesome, because the work is not of a recognized stature, raising the likelihood that judges will make aesthetic value judgments.

Some Major Setbacks: Judges don't get VARA. Sculptors have lost their VARA claims because the artwork was work for hire, or had been "used for promotional or advertising purposes," another VARA exclusion. Most recently, and in my opinion, incorrectly, the United States Court of Appeals for the First Circuit (Massachusetts) determined that VARA did not apply to "site-specific" work. The artist sued the defendant realty company, arguing that removal of his work from a Boston municipal park would violate his rights under VARA because the removal of work that is site-specific would destroy it. The court's flawed reasoning disregards the purpose of Congress in enacting VARA and the careful balancing of interests between the rights

of private property owners, artists, and the public it represents, and elevates the rights of property owners unnecessarily over the interests of the artist and the public in preserving artwork of recognized stature for future generations.

Let's hope that the recent decision of the Honorary David H. Coar in *Kelley v. Chicago Park District* (N.D. Ill. 2007) represents a new and welcome judicial sensitivity to public art in nontraditional materials. Although the reasoning is somewhat stretched, the court's conclusion that the garden *Wildflower Works* was copyrightable and fell within VARA is welcome.

Because of the difficulties in achieving VARA protections, many public and private commissions provide for artist's rights in contracts. The model agreement provides for artist's rights, including identification, maintenance, repairs, and restoration. In addition, the model agreement provides that the artwork shall not be intentionally altered or mutilated and extends protection to the site for site-specific works.

Unfortunately, many commissioning works of art for public display seem to ignore that it is the public as well as the artists who lose when VARA rights are waived. For large-scale public commissions, I believe the compromise which I negotiated with Dale Lanzone, then head of the General Services Administration Art in Architecture program is a good solution: "For the purposes of section 17 U.S.C. 101, 106A, the Artist will determine the significant characteristics of the Artwork which will be subject to the protection of sec. 101.106A et seq. against any intentional or grossly negligent destruction."

COPYRIGHT Q&A

How does copyright work with regard to public art? Do I automatically have copyright once I create the artwork, or should I register with the US Copyright Office? Do I still own copyright even if I don't put a copyright symbol on the actual artwork?

There is no special category for public art in copyright law. The work will either be a pictorial graphic and sculptural work or a work of architecture or landscape architecture. Copyright of the work exists from the moment it is fixed by the artist in a tangible form. If you do a drawing or a clay model, copyright exists of that particular image and the resulting final artwork is a derivative work based on the original image. Registration is not necessary for copyright protection, but copyright law provides several incentives for registration, including (1) coverage of statutory damages and attorney's fees if the work is registered before an infringement occurs, and (2) *prima facie* evidence

for the facts on the copyright registration certificate. Since the United States joined the Berne Convention in 1989, it is no longer necessary to put the copyright symbol on the artwork or in any other place as a condition for copyright protection. Copyright notice still provides the useful service of informing people with interest in a given work that someone is claiming copyright to this artwork.

I've been asked to sign away my copyright. Should I do that?
Remember that as the "author" of the work, you own all rights to that work. When clients commission an artwork, they are paying you for the physical artwork and not necessarily for the intangible rights that accompany it. Most clients today, after negotiation, will not ask for a surrender of all rights, but will limit their request to only what they need or what they are willing to pay for in addition to the commission fee.

Who owns the design once it is submitted? Am I free to reuse it elsewhere if it isn't selected? If my design isn't chosen, can I get a guarantee that they won't use it (even in a modified form) down the road? And if they do choose my design as the winning one, does it become solely the property of the agency?
The answers to these questions turn on two principles. First, unless this is a work for hire, the artist owns all the intangible rights of the designs submitted. Second, did the artist assign or license any of the exclusive rights of copyright to the client when the designs were submitted? That is to say, the remaining answers are dependent on what the artist signed at the time of submitting the designs and what terms are specified in the contract. If the artist signed no agreement, then he or she is free to exercise all of the exclusive rights of the copyright owner. It is also important to distinguish between ownership of the drawings and ownership of the intangible rights. Often, the artist may not be able to negotiate to retain the drawings submitted; however, in my experience, this is not a foregone conclusion.

Regarding artist teams: At what point is an idea copyrightable? For example, if an artist team thinks up an idea, does sketches, tells the client about it, but then one of the artists goes off on his own and executes the idea himself (i.e., puts it in tangible form), do the other members of the artist team have any recourse? How can they protect themselves from this at the beginning, especially if the commission contract expressly requests

that the contract only be with one artist team member who represents the whole group? Are there any sample contracts out there?

This is an excellent question, with many possible answers. First, unless there is a contract among the team members at the beginning, anyone is free to use an idea. An idea is only copyrightable when it is expressed in a tangible form (i.e., a sketch, drawing, notes). It is really important, particularly in the scenario described above, to have a contract among all the team members outlining the scope of their services and how they will define their intellectual property rights whether in ideas, concepts, or copyrighted materials. There is no model agreement for collaboration, but two areas do require discussion and agreement. First, is the work product to be a work of joint authorship, as that is defined by the copyright law? Second, what happens if the collaboration terminates? If it is a work of joint authorship and the parties have not signed a written agreement about their rights, any one of the joint authors has a right to exploit the copyright but must account financially for any profits to the other joint authors based on the proportionate share. So for example, if three authors create a work, the profits will be split into thirds absent a ruling to the contrary.

If I had others fabricate the artwork, am I the copyright holder of the final piece, or is my ownership limited to the plans for the artwork?

The fabricated artwork is more likely than not a derivative work of an original drawing. In order for the fabricator to claim copyright of the artwork, the fabricator would have to argue that this was an authorized derivative work. Depending on the complexity of the original underlying work, in my view, the relationship of the fabricator to the artist should always be clearly defined to prevent any disputes from arising in the future.

May I sell multiples of smaller versions of one of my artworks that was commissioned, for example a maquette of a sculpture?

It depends on what the contract stipulates. If you surrender all rights to the artwork, then you cannot sell multiples. If the contract provides that the work is unique, there is an issue as to whether or not you can sell a maquette of a smaller size. To avoid problems, this should be clarified in the contract.

Who owns the copyright to photographs of my work? Do I need to get permission from the photographer if I want to use images of my own work for promotion, publicity, or salable items? When a photo of my work is pub-

lished, whose name goes after the copyright symbol, the photographer's or mine?

The photographer owns the copyright to the photographs of your work unless it is a work for hire. The photographer needs the artist's permission to reproduce images of his or her work since the artist owns copyright in the artwork. If the artist retains the photographer, the artist should have a simple letter of agreement with the photographer giving the artist a nonexclusive license to reproduce the photographs for certain specified purposes as part of the basic fee that the artist has paid the photographer.

Practices vary, but normally the copyright symbol is followed by the name of the photographer with the words "photo credit," then followed by the name of the artwork and the artist. Alternatively, sometimes the photographer will not require a credit in his or her name, and the photograph will simply feature the copyright symbol, the name of the artist and the work, and the date. Particularly difficult situations may arise with respect to both credit and copyright for photography of performance art if written agreements are not entered into prior to the shoot.

Because my work is in the public domain, can others take pictures of it and then sell those images?

Your work is not in the public domain. The public domain is a term of legal art. It is in a public space. If your work is in the public domain, it means it is free of any copyright protection. Normally, if a photograph of the artwork is incidental to a photograph of the site as a whole, it may not infringe the copyright of the artist. However, a more substantial use of an artist's work may in fact infringe his or her copyright. There have been a number of lawsuits that involved artists suing movie studios for the use of their artwork which was located in a public space. In one lawsuit involving Andrew Leicester, Leicester failed to prevail because his sculpture was seen as an integral part of a building, which was not protected by copyright.

VISUAL ARTISTS RIGHTS ACT (VARA), 17 U.S.C. § 106A (1990) Q&A

Do moral rights laws vary from state to state? If so, how can I find out what they are for a particular state?

Prior to 1990 and the enactment of VARA, a number of states, including California, New York, and Massachusetts, enacted artists rights laws. VARA,

as part of the copyright law, is a federal law and specifically states that it pre-empts (replaces) any state laws which provide equivalent rights. If there is an issue where the artist must rely on state, as opposed to federal, law, consult with an attorney.

I've been asked to sign away my VARA rights. Should I do that? What are the ramifications if I do? If I want to convince the agency's attorneys to let me retain my VARA rights, what can I do to persuade them? Aren't VARA rights kind of like civil rights? Why should I sign them away? Can I nego-tiate extra compensation for signing them away?
The short answer to the first question is "No." More often than not, artists are explicitly asked to sign away their VARA rights. This is a problem, and, in my view, the client or administrator who seeks the waiver of VARA rights is not exercising the proper stewardship role of a public art collection. From the point of view of city attorneys, VARA conjures up lawsuits by unreason-able artists seeking to achieve fame and fortune. Usually, a compromise with a limited waiver is possible. Sometimes it is possible to protect an artwork's integrity via contract, although, as I indicated, contractual protection is not as good as VARA Protection. So, yes, in my view VARA rights are like civil rights and in principle an artist should not be required to sign them away. Good luck and congratulations on your skill as a negotiator if you succeed in getting paid for signing away your VARA rights.

Ownership
I'm confused about who owns the artwork. Is it the agency that commis-sioned it and contracted me or the owner of the building where the artwork is located? If ownership of the building is transferred, then do the provi-sions of my contract for the artwork transfer with it? (For example, if the city that commissioned my artwork sells a building to a private developer.)
There is no one answer to this question. If the commission is a percent-for-art commission or part of a redevelopment project, the ultimate owner of the artwork will not be the agency. If your contract is only with the agency, any contract rights you as an artist have will only be enforceable against the agency unless the agency is required to assign the contract rights to future purchasers. VARA rights do not depend on contract unless they are waived by contract. VARA rights exist independently of a client's ownership rights and independent of contract.

Duration of Responsibility

When does the artist's responsibility end for maintenance and repairs? What is a reasonable amount of time for the artist to be responsible for maintenance?

The answer to these questions depends on contract and ethical commitment. The artist is not responsible for maintenance beyond the contractual obligation of the warranty of quality and providing maintenance instructions. Artists will often wish to include an obligation on the part of the client and the agency to maintain the work in accordance with reasonable conservation standards and with the artist's right of integrity.

If controversy about an artwork is still going on for some time after the artwork has been installed, how long can the artist be reasonably asked to attend community meetings about it without getting paid?

It's your artwork and it is a question of how much time you want to spend to defend it. If you can prove that the artwork is of recognized stature, the agency or client will not be able to destroy it unless there is some contractual provision giving the client the right to remove the artwork in the case of controversy or you have waived your VARA rights.

Working with Fabricators

Many public artists do not execute their own artwork. We outsource the production to fabricators. You don't need to know how to pour a terrazzo floor, fuse glaze to glass, or piece a mosaic. All you need to know is how to hire a reputable expert to do it for you. As long as you can render a reasonable facsimile of your idea as a drawing, painting, or model that can ultimately be translated into a digital format, an entire universe of materials opens up to you.

However, there's a trade-off. If you're able to do the work yourself, you'll pocket more of the budget because you'll be receiving the artist's fee as well as being able to charge for labor. But then you're out the "opportunity cost." In other words, what other profitable opportunities did you miss during the months you spent on that one project? Could you have been applying for more six-figure commissions, some of which you might have received? Or creating a body of studio work? Or developing and supervising three or four more projects that you've outsourced? And do you really have the time to learn how to weld? Do you even need to learn how to weld?

Most public art agencies will require that you find your own fabricator to subcontract with directly. A few have a list of local vendors who work with artists that they can point you to. Increasingly, some will have prescreened and contracted directly with the fabricators that they want artists to work with. The latter arrangement is particularly good for artists with no prior public art experience because it levels the playing field so that you're competing based on the quality of your concept, not on your ability to find, contract with, and supervise a fabricator.

FINDING FABRICATORS

Fabricators fall roughly into two groups: those who specialize in working with artists on site-specific commissions, and those who work mainly with other trades. There is no centralized source of information on how to find these firms. Like many other aspects of public art, you'll need to rely on exchanging information with other artists and your own initiative.

Artist Fabricators

The emergence of public art as a viable market has brought a number of fabricators to the foreground who work exclusively with artists to translate their ideas to permanent materials. Some have spawned in response to recent demand, while others have been in business for generations using centuries-old techniques. Firms that are used to working with artists should be your first choice because they'll understand your concerns about having your work interpreted into a medium that you're not used to seeing it in. Nor will they treat you like an exotic creature who is liable to do something unpredictable at any moment.

Be sure not to overlook other artists whom you can commission to execute your ideas. You might be surprised at the number of artists who have come to the very practical realization that if they can't make a living solely from their own work, they'd rather stay in business for themselves by subcontracting with other artists than get a job doing something else.

Sculptors have the most established network of art fabrication specialists because of the contiguous history in their practice of creating work so large that they can't do it by themselves. Public sculpture today can involve light, video, earth, wind, fire, water, and state-of-the-art electronics, in addition to traditional stones and metals. It shows up in the form of gateways, signage, bike racks, historical markers, war memorials, bus shelters, and kiosks. Instead of being shaped with hammer and chisel or molded in a forge, it can also be cut by lasers, water jet, and plasma.

Painters and others working in two-dimensional mediums are limited only by the ability to envision their work in another material. Legions of fabricators are standing by who can turn your work into mosaic, terrazzo, glass, fiber, wallpaper, and sculpture.

Look for full-service companies who will help you engineer your idea, go with you to the committee meetings to explain technical details, and install the finished work. It's up to you to be sure they have all the appropriate

insurance, bonds, and permits that your client requires for them to work on site. (See chapter 7 on insurance for more detail.)

Where to Find Fabricators

An internet search is the best way to find fabricators. You could ask other artists, but that could be awkward in the likely event that they consider that proprietary information. As artists we're supposed to be generous, but there's "generous" and then there's giving away the farm. Here are a couple of places to look that will narrow down your search and put you on the path to building up your own team.

International Sculpture Center (sculpture.org). The International Sculpture Center (ISC) has ambitiously created a section on its website available for members to find fabricators in stone, metal, and fiber, as well as digital and material engineers who help artists figure out how to make their ideas work without falling over or falling apart. Each fabricator has its own searchable section that links to the full website. When I wrote the first edition, the ISC was just beginning this service, and a spokesperson told me their goal is to be the most valuable source of fabricators for artists on the web.[1] Looking at their site today, I can see that they made good on that ambition. It's kind of buried on their website, but it's worth the trip: navigate to "Directories and Resources" > "Artist Supplies and Services" > "Vendor Search." In the "Resource Directory" choose "Vendor" from the drop-down. You'll be able to take it from there.

Public Art Review **(forecastpublicart.org).** The *Public Art Review*, published since 1989 by Forecast Public Art, is the trade journal of our profession. Ads from some of the best fine-art fabricators can be found in each of the biannual issues, which are available by subscription. It's well worth the price, not just for the resources but to keep up with what's going on around the world of public art.

1 Lauren Hallden-Abberton, telephone interview with the author, June 30, 2007.

If you find fabricators who . . .

* understand they are making a work of art and are excited
 about it,
* respect your vision,
* respond to you promptly so that you can get samples and
 information to your client on time,
* stay within budget, and
* celebrate your victories with you and back you up when the going
 gets tough . . .

. . . treat them like gold, and never let them go.

WORKING WELL WITH FABRICATORS

Working with fabricators is one of the most straightforward relationships you'll have in the entire public art process: you need stuff made; they make stuff. Even if they're not used to working with artists, anyone who has successfully stayed in business for a while will know how to stay within deadlines and finite budgets. Each of you will forge your own way of working with your respective subcontractors, but there are a few things that will smooth the path if you're aware of them early on.

Estimates

Fabricators need certain information before they can give you a meaningful estimate. You can't just call them up and get a square-foot cost to plug into your budget. I mean, you could, but you'd be running a terrible risk of having that budget approved and then finding out that your concept will cost 50 percent more to make. Any shop with integrity will tell you it can't pull a number out of the air; they will need to know some basic specs first.

Like most fabricators, Mosaika Art and Design says it can work from any starting point including a drawing, painting, or digital image, but that dimensions, proposed timeline, and location are also needed. "Also, if we know the budget parameters, that will greatly speed up the estimate process because then we will be able to show the artist what level of complexity he can afford."[2]

2 Kori Smyth, Saskia Siebrand, and Jennifer Hamilton, Mosaika Art and Design, email message to the author, June 28, 2007.

Erica Behrens, the US associate rep for Franz Mayer of Munich, adds, "We get emails from artists all the time asking how much our glass or mosaics cost. They think there's a standard square-foot price, and there really isn't. Size, proportions, complexity, whether the work is integrated into a building, loose, or abstract, type of mosaic materials used—all affect the price dramatically."[3]

Terrazzo fabricator Dave Santarossa, who is the third generation to run his family's mosaic and tile business in Indianapolis, sees himself as an enabler of each artist's vision. He says at the beginning, the artist can provide a very basic design, illustrated as briefly and simply as he or she can to convey the intent and overall meaning of the piece. Santarossa is expert enough to give the artist some very general square-foot pricing at that point.

"The difficulty," says Santarossa, "is trying to price something and put restraints on something that doesn't have an end. There's no final design until the end. Can we budget enough money to create the art and still stay within the parameters of our costs? That's the most difficult thing to do. That's why we try to avoid 'budget busters.' If you price it high enough to give the artist some latitude, some kind of creative real estate inside the time restraint, the piece will evolve by itself and become something that is within budget."[4]

Expectations

You, the artist, need to wrap your head around the fact that your work will look different in another material than what you're used to seeing it in. Prepare yourself for a certain amount of change to your original concept to occur at the hands of the fabricator as he or she translates it into his or her medium. No matter how much you perfected the color on the painting, drawing, or printout, it will not look the same when it is turned into mosaic, terrazzo, or glass, and so forth. Color will respond differently on these materials than it does on paper or canvas depending on how light interacts with the particular substance you've chosen. You'll quickly learn that there are gaps in the pigments available for coloring various mediums, and that some of the colors are less fade resistant than others. Some of the gestural quality of your original rendering may be lost—although most good fabricators will struggle mightily to maintain that

3 Erica Behrens, Franz Mayer of Munich, telephone interview with the author, June 30, 2007.

4 Dave Santarossa, Santarossa Mosaic and Tile, telephone interview with the author, June 28, 2007.

aspect of your design. Scale is a big thing—so to speak. What looked perfectly legible when viewed at arm's length could turn into an incoherent blob when enlarged 3,000 times and put on the floor—unless viewed from a drone.

"We hope that the artist will be very open and embracing of how their work becomes an artistic piece but in a different format," says Behrens of Franz Mayer. "Communication and education about the techniques is key. If an artist is expecting something or doesn't understand the limitations of the material, they can be disappointed or, perhaps, even feel that they have been misled. They need to understand the materials; the piece is just as much their work as the work in their studio."

Communication

When I asked the fabricators I interviewed for this chapter to identify the most important factor in a good working relationship with an artist, they all answered, "Communication!" (exclamation point included).

"The most important factor in having a fabricator make an artist's work is a relationship based on trust," says Stephen Miotto of Miotto Mosaic Art Studios. "There should be enough communication between the artist and the fabricator before work begins that the fabricator has no questions about the spirit of the work, and the artist feels confident that the spirit of the work is understood. If the fabricator feels free, the work will be as fresh as the original; if work begins with uncertainty, the work will end up feeling stiff."[5]

Underlying Miotto's advice is something artists would do well to remember about their fabricators: they're artists, too. They have an intuitive feel for the material, a highly developed command of their craft, and a genuine passion for finding elegant solutions to make things work. If you treat them with the respect for their abilities that you expect to receive as an artist for yours, they'll be much more inspired to do good work for you.

At Franz Mayer, the fabricators encourage as much participation as is practical from artists. "We recommend the artist come to Munich and experiment in the studio, particularly during the beginning part of the process, so that they engage in a back-and-forth dialogue with the craftspeople who are working on their piece," says Behrens. "If they are painters, they need to work with our painters so they can become comfortable with how their work is going to be interpreted. Our painters become the arm of the artist. The artist

5 Stephen Miotto, Miotto Mosaic Art Studios, telephone interview with the author, June 30, 2007.

does not have the training to physically, for example, airbrush float glass, set mosaic, or prepare glass for fusing in the kiln. Our craftspeople are there to work collaboratively as an extension of their artistic process."

Barbara Derix of Derix Glasstudios emphatically seconds this. "It's a collaboration! First and foremost, the artist needs to know what effect he or she wants to create! Everything else is a collaborative process!"[6]

Flexibility

Santarossa understands that entrusting the making of their work to hands other than their own is a balancing act for artists. "They need to have a firm grasp on their design intent, the meaning of that particular piece, to really truly know what they're after and not change their work in response to every suggestion. But they also need to be open to better or easier ways to do things. Some artists can't bend." The ideal balance, he says, is to work with the fabricator to explore other techniques that could get across the original design intent by modifying the methods and materials to the point where it's not physically impossible to do within the budget.

Says Miotto, "The nature of art is to push the envelope. A fabricator needs to say what is not possible, but not before trying to come up with a solution to the impossible."

Another area where artists need to be flexible is with the schedule. "Not too many artists like to work on a timetable," says Santarossa. "We're all like that. If this were a perfect world, we would all have enough time to do all our projects; we would not be hurried at all to produce an artwork. But time constraints and other responsibilities require that we have some kind of a deadline and structure in working. It's a blending of a more structured industry (construction) with a less structured industry (art)."

Practical Matters

On the topic of what can go wrong on a public art project, the word "substrate" came up more than once. In simple terms, the substrate is the surface that will hold the artwork. It's also the not-so-metaphorical convergence point where, if all of the dominoes have fallen into place—payments, fabrication, site prep—the artwork installation schedule intercepts the construction schedule when it's supposed to. This is where communication and coordination between the fabricator, architect, general contractor, engineer, client

6 Barbara Derix, Derix Glasstudios, telephone interview with the author, June 30, 2007.

agency, and artist is crucial. The foundation, the first domino, is the contract you astutely negotiated at the beginning of your commission.

Schedule Coordination

There was a sign at the copy center in the hospital where I once worked that read, "Lack of planning on your part does not constitute an emergency on my part." Do everything you can to avoid crunch time for yourself and others. Prioritize your projects and the tasks within them. Make sure your fabricators get the information they need in ample time to do what they need to. This not only includes information that needs to come directly from you but through you as the conduit from the client agency to the fabricator.

It is not unheard of that a simple bit of paperwork could sit on some bureaucrat's desk for weeks or even months when you and your fabricator should be using that time ordering materials and beginning production. Of course, your deadline doesn't change just because someone upstream took all the time they needed (and then some) to do their job. Fortunately, the solution to this is simple and twofold.

1. As discussed elsewhere in this book, be sure the timeline you submit as part of your contract includes benchmarks for receipt of necessary information, as well as approvals and payments from the client, fabricator, and anyone else who could be a bottleneck. Specify that your tasks are contingent on receipt of that. If not received within the specified timeframe, tell them in writing that the deadline for installation will be adjusted accordingly.

2. Be a squeaky wheel. It's your responsibility to keep your part of the project moving. Remind, remind, remind. Keep an email trail of your reminding. Log your phone calls and what was said. This will come in handy if whoever held up the process tries to cover their butt about why the artwork won't be installed in time for the dedication ceremony. The first line of defense will be, "Oh, you know how flakey artists are." If you don't nip this in the bud, the agency may try to withhold payment from you for noncompliance with the contract even if it wasn't directly your fault. If worst comes to worst, you'll need a paper trail for legal action.

Payments

Fabricators require payment up front because the vendors along their supply chain expect payment before they'll deliver raw materials. That and there's a host of employee mouths to feed and the mouths those employees have to feed. This gets a little tricky if your contract with the agency says you don't get paid until you come through with certain deliverables (drawings, models, material samples) or until you meet certain benchmarks (engineering stamps, permits, percent of production completed). Most agencies will listen to reason and adapt their contracts accordingly, but it's up to you to catch the changes that need to be made and be assertive enough to negotiate for them.

Artist Alice Adams says the single most important piece of advice she can give is that "the artist should make every effort (and instruct their lawyer to make every effort) to tie the payment schedule of their contract with the commissioning agency to the contract with their fabricator. This way, the artist is not left hanging and having to make payments to a fabricator if, for whatever reason, their payment from the client agency is late or withheld."[7]

Or you could play hardball like Ken von Roenn. Here he is again with another lesson he learned so that you don't have to.

> **Lesson:** Imagine the worst case scenarios and provide for them in a contract.
>
> **Story:** I had a large project for a skylight and subcontracted with a Japanese company to produce a printed laminated glass artwork with a complicated pattern. In writing the contract, I provided the provision that if the glass was incorrect or failed, they would be financially responsible for all costs associated with not only replacing the glass but also the expenses of removing and reinstalling it. I also set up the payment schedule so that 80 percent of the payment would be made only after the glass was installed. During the installation, I discovered they made a mistake in aligning the pattern, which meant all 4,000 pounds of the glass had to be lowered by crane from the roof, which was seventy-five feet above ground, be remade, delivered, and lifted back up to the top of the roof and

7 Alice Adams, telephone interview with the author, June 30, 2007.

reinstalled. All of this work ultimately cost more than 75 percent of the original contract, which I deducted from the final payment. They threatened to sue, but in the end their lawyer told them they couldn't because of the clauses in the contract.

Net result: I saved more than $75,000.

Making the Leap

Even though percent-for-art programs are looking for new artists all the time, especially as they seek to diversify the pool of applicants, they can't take the risk of handing tens of thousands of taxpayer dollars to someone with no proven track record, no matter how much mentoring they're able to provide. It's the old "you can't get the job if you don't have experience, and you can't get experience if you don't have the job." Fortunately, there are as many ways out of this infinite loop as there are artists. In this chapter I'm going to show you a few pathways to get you started. I'm starting with actions that you can take right now from the comfort of your laptop and working up to those that involve more exertion.

INSPIRATIONS AND INFLUENCES

Educate yourself about what other artists have done and are doing. Note the work that you feel an affinity for and how it got where it is. Spend some time on the Public Art Network "PAN Year-in-Review and Database," not necessarily to see what work professionals in the field are excited about, but to see what resonates with you. I guarantee that it will give you ideas about other forms and materials your work can take. Pay attention to your immediate gut reaction when you look at each example, even if it looks nothing like your work. Think critically about what qualities it has that you're responding to, and imagine how your work could embody them on its own terms.

ACT LOCALLY

Besides searching the databases of the resources in chapter 2 and signing up for notifications of public art opportunities, make it your business to find

out all of the ways public art is funded where you live, and widen your search from there. Are there any city, county, or state percent-for-art programs? If you live in a city with public transportation or a large park system, find out if they commission artists. Are there nonprofit organizations, foundations, or corporate headquarters that are looking for ways to give back to the community? Every time you see a contemporary artwork or artist project in a public space, find out where the funding came from, when it was funded, and note what kind of work it is. Is it by a local artist? A midcareer or emerging artist from another region? An established artist? Soon you'll get a good sense of where the money is coming from and what sort of work it funds. Pay the most attention to what has been commissioned within the past five years because those funding sources have a better chance of still being active.

SHOW UP

Once you learn which organizations support art in public places, attend their talks or workshops. Most percent-for-art programs go out of their way to offer technical assistance; universities and art schools host lectures by visiting artists who have a public side to their practice; and for every public artwork there's an unveiling ceremony attended by those who are most invested in it. By showing up you'll become familiar with the people and conversations active in the field. Pretty soon you'll start seeing people you're happy to see and who are happy to see you. You already have something in common: they're interested in art, too.

SELF-EDUCATE

It's only been gradually in the past thirty years that public art has become professionalized to the point where you can get an advanced degree in some aspect of practice, theory, policy, or administration which, increasingly, are merging in the way artists engage with real life. It's not necessary (yet) to go to grad school specifically for public art if you want to have an active practice, but, as in every profession, it helps to be conversant with the context, complexities, and consequences of making art for public places. There are countless books, articles, and essays emanating frequently from the art press dealing with the intersection of art and public life, especially in its most recent incarnation, "creative placemaking," which I'll go into more later in this chapter. The bibliography lists some of the books I've found to be essential, but it should not be considered exhaustive.

You can also find videos online that document the "making of" public artworks, as well as lectures by artists. Here are a few recommendations to get you started. In a filmed lecture given at the Denver Art Museum, sculptor Lawrence Argent generously shares his thought process into some of his many public art commissions,[1] while another video takes you backstage as Argent meets with architects and engineers to discuss the installation of his monumental red rabbit at the Sacramento International Airport.[2] The YouTube series *Brilliant Ideas* looks at Jaume Plensa's evolution as a public sculptor. *Third Ward TX*, described on its website as "a documentary about art, life, and real estate," is an award-winning film about artist Rick Lowe, how he founded Project Row Houses in Houston, and the ripple effect that created in the community. The Museum of Contemporary Art in Chicago filmed a discussion with artist and architect Amanda Williams about how she went from covertly painting houses slated for demolition on Chicago's southside in colors of products marketed toward black people[3] to exhibiting at the Venice Architecture Biennale. And many more.

EXPERIMENT WITH MATERIAL SAMPLES

There's no need to wait until you're a finalist to become familiar with how to translate your aesthetic into materials suitable to withstand the demands of public space. If you've been looking at a lot of art as I recommended earlier in this chapter, by now you should have a pretty good idea of the wide variety of substances that are used for that purpose. Using the tips in chapter 10 on how to find fabricators, pick one or two who work with materials that you think would be a good fit. Expect to pay the fabricator to make a sample for you. Unlike artists, they aren't part of a culture that expects them to work for free.

To decide what sample to make, start with an idea for an artwork that you would actually like to see built. While fabricators are problem solvers and will spend a considerable amount of time helping you make a concept concrete, they aren't mind readers. You need to show up to your appointment with a scale sketch of how your artwork would look in the hypothetical site, and a more detailed

1 "Logan Lecture: Lawrence Argent," YouTube video, 1:20:15, posted by "Denver Art Museum," May 22, 2013, https://www.youtube.com/watch?v=bsKbFpsDtQc.
2 "Lawrence Argent_ The Red Rabbit," YouTube video, 8:04, posted by "LCampling1," March 5, 2010, https://www.youtube.com/watch?v=vA9X0TAhUfI.
3 Amanda Williams, artist's website, accessed December 6, 2018, https://awstudio art.com.

sketch of the sample that includes dimensions and the colors or effect that you'd like to achieve. Since the fabricator knows the material they work with better than you do, it's their job to guide you about what approaches will be the most feasible. A typical conversation with a fabricator is a mutually respectful give and take. Don't feel like they're trying to usurp your role as the artist when they tell you what will or won't work, just as you wouldn't tell them how to do their job.

When I was living in Seattle and first trying to break into public art, I saw that artists whom I had only known as painters had been commissioned to do mosaics on columns in the then new Seattle-Tacoma International Airport. I asked Cath Brunner, who was in charge of the project through King County's 4Culture program, how the mosaics came about. She told me that they were made by Miotto Mosaics in Carmel, New York. I got in touch with Stephen Miotto, exchanged some emails, he sent me a few samples, then I got on a plane and flew from Seattle to his studio in the Hudson Valley. I'm so glad I did because I was able to get a much better understanding of the possibilities, and limitations, of hand-cut stone mosaics. He made some samples for me that I was later able to use in a mock up for a finalist proposal for the first public art commission I ever won (at the Indianapolis International Airport).

Remember that materials are not neutral. They can be used to add meaning to your artwork by symbolizing the history or aspirations of a place, just as they can carry the baggage of environmental destruction or human exploitation. Since art is scrutinized for metaphorical meaning in a way that, say, a parking meter is not, what it's made of matters.

How One Artist Made the Leap

If you've ever been to the Bush Intercontinental Airport in Houston, you've probably seen the spectacular seventy-three-foot-long serpentine mosaic mural that includes five large columns and a terrazzo floor design with a lushly realistic bayou theme. Incredibly, this was artist Dixie Friend Gay's first public art commission. I asked Dixie to lead us through how it came about, and she generously agreed.

Did you enter an open call? RFQ or RFP?

I replied to an RFQ, and I think it was limited to professional artists who lived in Texas.

How large was the budget?

The budget was $250,000.

How were you able to convince the client that you had what it took to do a project on such a scale and with materials you'd never worked with before?

I had traveled to see famous mosaics and understood how they could be incorporated in buildings. I had been doing mosaics in my studio, so I knew the medium. I included images of my studio mosaics and the painting and sculpture installations I had done for galleries and museums in the RFQ. I had a friend who is an architect who helped with the RFQ letter so it would address concerns the airport and art committee would have. After I was short-listed, she helped with my presentation. I had a realistic budget and time frame for the work to be done, and I had created my own samples for the project. In the years before I decided to do public art, I had volunteered for various nonprofits, helping with fund-raising and creating elaborate decorations for galas on a very short time frame and limited budget. Several people on the jury knew me through my volunteer work, which may have helped. The lead architect, whom I had never met, asked me why I thought I could handle a budget of this scale. I replied I just built my own house and studio for a similar budget and it came in on time and under budget, so I thought this airport project seemed much easier.

Any advice you can give to artists who want to make the leap from studio to public art?

Read Lynn Basa's book on public art. Keep informed about what is happening in design and public art, as well as new materials that are being used. When viewing other artists' public art, envision your own work in the space. Question how you would create something for the space, how to make it safe and low maintenance. Get out of your own studio, meet others, volunteer, apprentice, or work for someone who is doing public projects. Set goals. Don't wait to apply for RFQs until you have it all figured out. Apply now, you learn in the process. Have the very best professional images or videos of your work to submit to RFQs. When you get the first project, follow the rules, communicate the progress, and work within the budget. Be nice; the public art world is small.

NO EXPERIENCE REQUIRED

As I mentioned earlier, public art programs are trying all kinds of ways to broaden the applicant pool by lowering obstacles to entry. Many offer some form of professional development and technical assistance to artists, like this: According to Norfolk Arts manager Karen Rudd, "We are beginning a group of projects, Community Canvas, that will offer workshops to potential public artists. Artists who are selected and attend the workshops will then be eligible to apply for specific projects. We will ensure the workshops represent the demographic makeup of Norfolk."[4]

Fort Worth Public Art has a special category in its prequalified artists registry for artists based in North Texas who work in any media, and "previous public art or design team experience is not required."[5] If accepted, artists must attend one of the public artist training workshops held in collaboration with the Dallas Office of Cultural Affairs. That means you'll not only become a known entity to Fort Worth's public art program but also to Dallas's big new program, too.

For the past thirty years, Forecast Public Art has had microgrant programs for early- and midcareer Minnesota artists to give them a boost for realizing public projects. In addition, they offer technical assistance, insurance, PR, training, networking, and other fundamental project support.[6]

One of the highest priorities (and perks of the job) for managers of public art programs is to know as many artists as possible, so make it easy for them by introducing yourself and your work in an email with periodic updates as you have new work. Lucas Cowan, the public art curator of the Rose Kennedy Greenway Conservancy in Boston, says, "I welcome artists to send me info and to keep me abreast on their practice, but for the most part, I am very interested in working with artists who have never created in the public realm." He is "constantly putting artists on lists for consideration that I find interesting or are doing something completely out of the norm."[7]

More public art commissions are issuing calls for artwork that can then be digitally reproduced onto bus shelters, billboards, and other rectangular

4 Karen Rudd, Norfolk Arts Manager, email message to the author, November 5, 2018.
5 Fort Worth Public Art, *Fort Worth Public Art Pre-Qualified Artist Lists*, CaFÉ, March 5, 2018.
6 Jack Becker, Forecast Public Art, email message to the author, September 10, 2018.
7 Lucas Cowan, Public Art Curator, Rose Kennedy Greenway Conservancy, Boston, email message to the author, September 10, 2018.

spaces in public places. Like this RFQ to North Texas artists for a new commuter rail line: "Selected artists will be responsible for furnishing high-resolution digital files of the artwork to Trinity Metro who will be responsible for having the images reproduced as print graphics and integrated into polymer resin windscreens."[8]

While still relatively rare, there are calls for artists that encourage artists with little or no experience to apply. Look for phrases like this one from the city of Bloomington, Indiana:

> **Artist Eligibility**
> All professional visual artists, designers, and architects, eighteen and over, are invited to submit qualifications. One of the City's objectives for the One Percent for the Arts Program is to encourage artists new to the public art process to consider this opportunity.[9]

Further on in the same application there's even more help, a list of local fabricators, and a link to where artists can get small-business loans through a Community Development Financial Institution if they lack the money up front to begin their commission.

Still others, although also infrequent, include opportunities for local artists to be mentored by an experienced artist who has been hired to do a commission. Most public art programs have little or no capacity to train artists, nor is it their prime directive, but since providing on-the-job training opportunities is a direct pipeline for artists to enter the field, I wouldn't be surprised if more mentoring programs cropped up.

ARTISTS-IN-RESIDENCE

It's not uncommon for artists to be hired to work within an existing city department or neighborhood. In chapter 1, I mentioned some of the cities that have ongoing programs where "embedded" artists are expected to bring a different perspective on institutional culture that can result in new projects

8 Trinity Metro TEXRail, "TEXRail Station Art Program Call to North Texas Artist-Public Art Opportunity," CaFÉ listing, accessed November 26, 2018, https://artist.callforentry.org/festivals_unique_info.php?ID=6019.

9 Bloomington Community Arts Commission, *Trades District Public Art: Request for Qualifications*, September 26, 2018.

or approaches. The first and most well-known example is Mierle Laderman Ukeles, who was hired (without pay) in 1978 as artist in residence by New York City's Department of Sanitation, a position she still holds. She came to the city's attention through a practice she called Maintenance Art that she began in 1969 after the birth of her first child. She would perform services around the city such as washing the steps of the Wadsworth Atheneum, or documenting the maintenance workers within a museum by taking a polaroid of them and asking if what they were doing at that moment was work or art. These actions were simultaneously questioning the domestic role of women; the connection between class, race, and labor; and the very definition of art. (If you get the chance, you should read her *Manifesto for Maintenance Art 1969!*)

Her first project for the department was *Touch Sanitation Performance* (1979–80). It was a conceptual performance where she spent eleven months shaking hands with and thanking all 8,500 of New York City's sanitation workers all over the city, spending eight- to sixteen-hour days "visiting sanitation crews in different locales, shadowing workers, interviewing them, delivering speeches about her own work and the value of theirs."[10] It was more than a morale booster for the workers to be individually recognized; they and their labor were made visible to the general public by the department's authorized actions of this artist.

The influence of Ukeles's practice continues to this day. Austin painter Rehab El Sadek spent nine months of 2017 embedded in the city's Watershed Protection Department. In 2018 Dallas's Office of Cultural Affairs launched week-long microresidencies in nine city departments as research for a new cultural plan. Washington became the first state to embed an artist in a statewide agency when it partnered with ArtPlace America and Transportation for America to create an artist-in-residence program within the department of transportation in 2019.[11]

Aisling Maki sums it up nicely: "Engaging people through art can help inform city planners about what issues are most relevant to residents and

10 Jillian Steinhauer, "How Mierle Laderman Ukeles Turned Maintenance Work into Art," *Hyperallergic*, February 10, 2017, https://hyperallergic.com/355255 /how-mierle-laderman-ukeles-turned-maintenance-work-into-art/.

11 Smart Growth America, "Washington State Department of Transportation to Be the First Statewide Agency to Host an Artist-in-Residence," accessed December 4, 2018, https://smartgrowthamerica.org/washington-state-department-of-transportation -to-be-the-first-statewide-agency-to-host-an-artist-in-residence/.

what changes and areas of growth they want to see in their communities. This will impact the short and long-term strategies to improve the quality of life for residents that will be laid out in the final comprehensive plan."[12]

Residencies

Residencies are an excellent laboratory for taking your work to another place, literally and conceptually. They can become more than a field trip for your studio work if you consider the site of the residency itself as an opportunity for experimentation. Maybe I've just begun to notice, or maybe it's a new thing in the last decade, but there seem to be more artist residencies that are flexible enough to accommodate artists who are interested in working beyond the traditional studio.

There are over one thousand residency opportunities around the world. TransArtists (www.transartists.org) is the mother ship of international directories and lists more residencies than you could ever do in one lifetime. Some residencies are by invitation or application and pay you to be there; some of them you pay for in full or in part.[13] Besides looking for ones that will allow you to spread your public art wings, think about what else you want to get out of it. Do you want to meet other artists to broaden your community and have an exchange of ideas, or do you want uninterrupted time all to yourself? Do you want to be in a cultural capital or in the middle of the woods? Can you only afford to be gone for a week, or do you want to immerse yourself for months or a year? Most residencies don't allow you to bring spouses, pets, or children, which can limit your options (or be a relief).

Another factor to consider is the prestige of the residency. There are a few that, if you get accepted, signal that you're one of the anointed to the career makers within the commercial art system who pay attention to those things: curators, collectors, critics, certain gallerists.[14] It's not a guarantee by any means; I'm only mentioning it because these residencies are a box to check

12 Aisling Maki, "The Intersection of Art and Urban Planning Makes Memphis 3.0 a Multimedia Strategy," *High Ground*, February 28, 2018, http://www.high groundnews.com/features/Memphis30Arts.aspx.

13 Many state and local art agencies have professional development grants you can apply for to supplement the cost of a residency.

14 Here are some of them: Ox-Bow, Skowhegan, Whitney Independent Study Program, MacDowell, Eyebeam, the Land, Rome Prize, Chinati Foundation, Headlands, Vermont Studio Center, Core Program, Kohler.

if that's a path you care about. They don't give you extra points on public art applications. What matters is that you can demonstrate in your portfolio and your approach that you consider the public realm as a context for your work, and that you have a continuous record of commitment to growing as an artist. So, when looking for residencies, prioritize the ones that will give you the opportunity to develop work that shows you've got what it takes to engage with public space.

TransArtists has an excellent keyword search function of their 1,400-plus residency listings, but nothing will pop up if you enter "public art" or "place-making." Instead, search for "social," "collaborative," and "community." "Sculpture" and "installation" are also catchalls for art in public spaces.

Here are a couple of examples of the kind of opportunities you should look for. I found these without having to go any further than the current deadlines on the TransArtists home page:

ZK/U Berlin: ZK/U encourages applications from aspiring residents whose own practices fit into ZK/U's conceptual frame, and invites fellows to involve themselves with the residency programme and propose their own formats. In the frame of this open call, ZK/U is particularly interested in initiatives that create spaces for encounter and exchange between citizens from diverse backgrounds; formats that question and reclaim urban infrastructure and public space for the commons; practices that make global complexities graspable in a local context; and projects that imagine forms of local belonging within post-migration societies. As such, the ZK/U aims to be a platform for active-collaborative, socially engaged and locally involved art and research praxis.[15]

Stone Street Co-op & Residency, Flint, Michigan: The Stone Street Co-op & Residency offers both short duration 30-90-day residencies for visiting artists and longer-term month-to-month residencies for local artists. In addition to housing, residents get the chance to work with artists, architects, planners, journalists, activists, and teachers from Flint and around the country and

15 TransArtists, home page, accessed November 23, 2018, https://www.transartists .org/article/open-call-zku-berlin.

the world who are rethinking and reinventing the way we share resources, activate abandoned spaces, strengthen neighborhoods, and make art. All residents will produce work that responds to or extends the Flint Public Art Project mission to activate vacant spaces, connect people and places, amplify the local culture, and transform the identity of the city.[16]

MURALS

Murals—in this case, paintings done directly onto a building or wall—are, by definition, high-profile, low-cost thresholds to entry into public art. The modern-day version of murals as a populist art form took root in the 1960s with the Chicano art movement in the American southwest, and in Chicago with *The Wall of Respect*, a community mural led by local artist William Walker. Their more renegade relative, "graffiti art," took hold around this time, too. Whether their subject matter was political protest, celebration of people overlooked by the establishment, or spray-painting their crew name on the side of a boxcar, what they had in common was going around institutional systems to make the kind of art they wanted to see, where they had access to it themselves.[17]

While mural artists may still not be getting as much direct support from percent-for-art programs as other art forms, murals have gone mainstream. Even artists who normally plied their trade in alleys and overpasses under the cover of darkness are now being sought after by tech companies who want their lobbies painted with something that will be perceived by their employees as hip, with it, and now. Community organizations and chambers of commerce in towns of every size are looking to murals to distinguish their commercial districts and project how they want to be perceived.

Since the modern mural movement has been around for over half a century, it has naturally become more organized, while still being accessible to artists operating outside of the gallery and museum system. Nonprofit mural organizations abound, many with a mission similar to that of Mural Arts Philadelphia: "Our community-driven mural making process builds

16 TransArtists, home page, accessed November 23, 2018, https://www.transartists .org/air/flint-public-art-project.

17 Community Rejuvenation Project, "A Historical Overview of Murals," accessed December 4, 2019, http://crpbayarea.org/painting/murals.

on Mural Arts' guiding principles of collaboration and equity, and is open to every individual in Philadelphia. We are looking for ideas that tell the story of our city and connect people through creativity."[18] Others are the Chicago Public Art Group, Groundswell NYC, Urban Artworks in Seattle, Portland Street Art Alliance, SPARC in Los Angeles, to name a few such organizations.

Chicago Artist James Jankowiak Tells How He Got His Start on the Streets

Myself and Carlos Rolon, we started a crew called Aerosoul Crew in 1989. We kind of started the whole "permission wall" movement. We got paid for at least half of the walls we did, the ones we didn't, we were granted permission by the owners to do whatever we wanted, whenever we wanted, and we invited all our friends to get down.

We actually started getting paid for doing graffiti murals when we were pretty young, 18, 19 years old. Back in the late '80s Chicago was saturated with gang graffiti. We sold ourselves on the premise that we were beautifying the area and that the gangbangers wouldn't mess with it, which was pretty much true with a few exceptions. We started having gallery shows when we were 20 years old because the hip people back then saw us as being "edgy."[19]

One route you can take is to volunteer for one of these organizations to get some experience. Another way is to approach chambers of commerce, individual businesses, and property owners with a proposal for their walls to see if they're interested in commissioning you for a mural. First, they'll want to know what's in it for them. Second, they'll want to know what's the catch. Common questions they'll have will be if you can provide them with a certificate of insurance (see chapter 7) so that you won't hold them liable if you hurt yourself in the process and how much it's going to cost them. You can cobble together funding from the business that is providing the wall; from crowdsourcing sites such as Patronicity, Kickstarter, Hatchfund, and Ioby; and

18 Mural Arts Philadelphia, "Apply for a Mural," accessed December 4, 2018, https://www.muralarts.org/about/apply-for-a-mural/.
19 James Jankowiak, email message to the author, December 4, 2018.

from local arts agencies' artist support grants. Paint shops will often donate paint for community causes. Of course, make sure you do your research so you know how to prepare a wall for a mural, especially if it's outdoors, and the best paint to use that will stand up to time and the elements. Another benefit of murals is that actual artists are painting in actual public space, often with community members pitching in to help. Any artist painting a mural should add in extra time to answer dozens of questions a day from passersby about what, how, and why they're painting a wall. Add some music, and you'll create a mini happening.

CREATIVE PLACEMAKING

Creative placemaking is urban planning tied to socially responsible economic development. In theory, anyway. It's part of a lineage that includes the City Beautiful Movement,[20] urban renewal,[21] Jane Jacobs's human-centered approach to urban design,[22] and contemporary iterations, such as

20 "The City Beautiful Movement was a reform philosophy of North American architecture and urban planning that flourished during the 1890s and 1900s with the intent of introducing beautification and monumental grandeur in cities. The movement, which was originally associated mainly with Chicago, Cleveland, Detroit, and Washington, D.C., promoted beauty not only for its own sake, but also to create moral and civic virtue among urban populations. Advocates of the philosophy believed that such beautification could promote a harmonious social order that would increase the quality of life, while critics would complain that the movement was overly concerned with aesthetics at the expense of social reform; Jane Jacobs referred to the movement as an 'architectural design cult.'" Wikipedia, s.v. "City Beautiful movement," last modified December 3, 2018, 05:43 (UTC), https://en.wikipedia.org/wiki/City_Beautiful_movement.

21 According to BusinessDictionary, "urban renewal" is "the process where an urban neighborhood or area is improved and rehabilitated. The renewal process can include demolishing old or run-down buildings, constructing new, up-to-date housing, or adding in features like a theater or stadium. Urban renewal is usually undergone for the purposes of persuading wealthier individuals to come live in that area. Urban renewal is often part of the gentrification process." BusinessDictionary, s.v. "urban renewal," accessed December 6, 2018, http://www.businessdictionary.com/definition/urban-renewal.html.

22 In *The Death and Life of Great American Cities* (1961) Jane Jacobs "argued that urban renewal did not respect the needs of city-dwellers. It also introduced the sociological concepts 'eyes on the street' and 'social capital.'" Wikipedia, s.v. "Jane Jacobs," last modified February 16, 2019, 11:02 (UTC), https://en.wikipedia.org/wiki/Jane_Jacobs.

New Urbanism, that incorporate environmental sustainability by encouraging walking and transit use by design. The term "creative placemaking" came into widespread use in 2010 when the National Endowment for the Arts (NEA) published a white paper that looked at towns all over the country that, for the previous two decades, had been working in an interdisciplinary way to revitalize their economies. The NEA came up with this definition:

> In creative placemaking, partners from public, private, non-profit, and community sectors strategically shape the physical and social character of a neighborhood, town, city, or region around arts and cultural activities. Creative placemaking animates public and private spaces, rejuvenates structures and streetscapes, improves local business viability and public safety, and brings diverse people together to celebrate, inspire, and be inspired.[23]

It's gained so much currency that there are papers, conferences, and an institute dedicated to the field of creative placemaking. Not surprisingly, its emphasis on using art and artists as part of economic development strategies appeals to real estate developers and local politicians looking to make targeted neighborhoods more attractive to new residents and businesses. In reaction, concerns about gentrification displacing longtime residents and disrupting stable communities led to accusations of "artwashing," where artists, galleries, theaters, and the cafés and shops that follow them are used as a Trojan Horse to raise real estate prices to the point where only rich, and presumably white, people can afford them. It's an ongoing debate that, frankly, I'm in the middle of every day with the Corner Project, but it is beyond the scope of this humble book to go into it as much as I would like to. I'm bringing it up because it raises questions all artists working in public space need to ask themselves: Whose interests are we serving? How are we being used? What are the unintended consequences of our actions, our mere presence? What responsibility do we have to mitigate that?

It can get messy when the ideals of artists clash with the expectations of their clients. The Macon (Georgia) Art Alliance (MAA) hired artists Samantha Hill

23 Ann Markusen and Anne Gadwa (2010), quoted in: Margo Handwerker, "A Rural Case: Beyond Creative Placemaking," in *Creative Placemaking: Research, Theory, and Practice*, eds. Cara Courage and Anita McKeown (Oxon, England: Routledge, 2019), 83.

and Ed Woodham to create work in response to the Mill Hill neighborhood, a four-block stretch of mostly dilapidated and boarded-up homes that is being revitalized into a community arts hub by MAA and the Urban Development Authority.[24] After hearing from the residents of the neighborhood that they were feeling taken advantage of, the artists sent a letter to their clients accusing them of using the artist residency for artwashing. Their contract was soon terminated.

New Mexico artist Nora Naranjo Morse was invited by Albuquerque's public art program to be part of a "tri-cultural collaboration" of an Anglo artist, a Hispanic artist, and her, a Tigua Indian from the Santa Clara Pueblo, to create a monument to Spanish conquistador Juan de Oñate in celebration of the state's first Spanish colony, established 400 years ago. During the public process, Morse found out with everyone else that Oñate had ordered the massacre of hundreds of residents of the Acoma Pueblo in 1599 in retaliation for their murder of thirteen Spanish soldiers. He sentenced the five hundred survivors to twenty years of servitude and mandated that all men over the age of twenty-five have a foot cut off.[25] This buried history was brought to light when an anonymous letter was sent to a columnist at the *Albuquerque Journal* with a photo of the severed right foot from an existing man-on-a-horse statue of Oñate. The ensuing controversy pitted Spanish descendants who saw Oñate as the father of Hispanic culture against Native Americans and others who objected to further glorification of colonization. By adding Morse to the project, the city hoped to add an element to the artwork that would balance things out somehow. But when Morse arrived at the finalist presentation, the other two artists had already worked together on a proposal showing Oñate on a horse. They offered Morse the opportunity to design the pedestal. She said, "I felt insulted, I felt hurt, I felt marginalized. I didn't think I could do that. Although in myself I was thinking that there was a solution. That art could tell a story that was truthful."[26] Despite being urged to quit by other Pueblo people, she made the decision to "stay in the game" so that she would "at least be able to fight for that voice. Not just my artistic voice but the

24 Matthew Terrell, "What Went Wrong with the Macon Social Practice Residency?," Burnaway, August 9, 2016, https://burnaway.org/what-went-wrong-with-macon -artists-residency/.
25 Wikipedia, s.v. "Juan de Oñate," last modified February 7, 2019, 22:50 (UTC), https://en.wikipedia.org/wiki/Juan_de_Oñate.
26 Stan Alcorn, "Monumental Lies," December 8, 2018, in *Reveal*, produced by Fernanda Camarena, podcast, MP3 audio, 36:05, https://tunein.com/podcasts /News--Politics-Podcasts/Reveal-p679597/.

voice of these people who had gone through this incredible experience that had changed their culture completely." Eventually, Morse and the other artists stopped being able to work together. The city ended up with two artworks outside of the Albuquerque Art Museum. One with Oñate leading a line of bronze figures, Spanish settlers traveling into New Mexico. Another, an earth sculpture by Morse, called *Numbe Whageh*, which means the center place, or the place of the earth. It's a dirt spiral on which native plants grow that ends at a small spring at the center where all you can see is the sky and the desert. (For a full account of this controversy and its outcome, listen to the *Reveal* podcast "Monumental Lies," from December 8, 2018.)

Case Study: Big Car, Indianapolis

Big Car is one of my go-to inspirations for the Corner Project. It was founded in 2004 by artist/curator couple Jim Walker and Shauta Marsh. It now encompasses the Tube Factory, a twelve-thousand-square-foot museum and community space converted from an old tire factory, a radio station, and an artist residency. In 2017 they formed a land trust and began buying modest homes on the block as they became available to offer affordable housing for community-engaged artists in Indianapolis. Here is cofounder Jim Walker's account of how they got started. It ends before they opened the Tube Factory in 2016, but it's a good case study of how they built up from scratch, using their wits and what resources were available.

> Big Car started in a classroom, a newsroom, a bathroom. It was early 2004. I was working several jobs to piece together a living for our young family in Fountain Square. One of those jobs was teaching creative writing on Saturday mornings to IUPUI students, many my age or older, who really wanted to learn. I also worked as staff photographer at NUVO Newsweekly, allowing me the chance to meet lots of great people in the arts, government, and philanthropy in our city. I snapped their pictures, heard their stories, visited their offices and studios and homes. And many became my friends, too. On top of all that, I spent every day with a staff of multitalented writers, designers, and artists right there at NUVO.
>
> In the middle of that mix, a small group of artists, writers, designers and musicians—pulled together from these circles—began

working to make creative things happen in Indianapolis. Instead of sitting around and complaining about the cultural offerings our city lacked, we started making things happen. We started by renting a tiny studio—formerly a bathroom—in the Murphy Art Center in Fountain Square for $135 per month. We stuck a handmade sign on the door that said "BIG CAR."

Soon, we moved from the bathroom into a larger studio space, pooling our money and sharing the room with belly dancers, a visiting artist from Hungary and a local record label, to make rent. Meanwhile, we brought First Fridays to Fountain Square and worked hard, then as volunteers, to do what artists can do to help turn our neighborhood around. That happened. And Big Car continues to thrive in this friend-based, collaborative, multi-disciplinary, yes-saying way.

After a few years of operating mostly as a board-run all-volunteer organization, a handful of big-vision people helped us grow up and into a full-fledged nonprofit. First, Ken Honeywell hired me to work for him at his new marketing company in Fountain Square. There, I was able to split my time venturing into nonprofits myself, including working on Big Car, while also learning about nonprofits from the inside by writing about Well Done's clients, including LISC and their quality-of-life plans. In 2009, Big Car received a $50,000 GINI Imagine Big grant from the Indianapolis Neighborhood Resource Center. With the guidance of Marc McAleavey, then at the INRC, we completed social practice projects in eight neighborhoods—all with no paid staff time. Then we found Service Center in Lafayette Square and began receiving support from the Indianapolis Foundation and enjoyed the mentorship CICF's president, Brian Payne. At that same time, the Allen Whitehill Clowes Charitable Foundation began supporting us too.

Then, Jeremy Efroymson, of the Efroymson Family Fund—who, along with the Arts Council of Indianapolis, was the first to back Big Car in early years—granted us a three-year gift so I could begin working as our first full-time employee and executive director. This grant that started in 2011, allowed me to focus on Big Car programming, fundraising, and strategy. Soon, we received a similar two-year grant from the Nina Mason Pulliam Charitable

Trust and hired Anne Laker, also one of our founders, as our full-time program director. Upon the suggestion of Michael Twyman, then of Pulliam Trust, we began a fee-for-service design program that allowed us to bring our creative director, Andy Fry, also a Big Car founder, on staff full time. Also in 2011, David Forsell of Keep Indianapolis Beautiful connected us with Lilly Day of Service and Sherrie Bossung of Eli Lilly & Co., who leads this effort.

Since then, we've enjoyed many public art projects in partnership with Lilly, including one in 2014 that had us complete community-engaged murals in 10 cities across the United States.[27]

Thanks to artists and community activists who have organized, pushed back, and asked hard questions, creative placemaking initiatives have begun taking into account the powerful effect that art can have on a local ecosystem. It has taken a page from artists who have socially engaged practices and has evolved to include an emphasis on racial equity, social justice, and economic revitalization without displacement. In other words, artists are now seen as being useful for more than sticking art in a public space; we're increasingly being relied upon as a vehicle for engaging (or infiltrating) the public. This is not only because of art's capacity for metaphor that can cross class and ethnic boundaries, but also because when we show up in a community, it's not with an obvious agenda. We're not the police, we're not real estate agents, we're not the government—at least on the face of it. This is why I keep coming back to warning artists that we shouldn't be naive about who we are working for and why, nor should we underestimate the real-world effect we can have.

Even as its motives have been suspect, creative placemaking thrives and is expanding as a field of opportunity for artists who have the talent and temperament to work with and within communities. Increasingly, artists are being sought who already live in those communities as the field learned through experience that parachuting an artist in isn't as effective as one who knows firsthand who their neighbors are and what matters to them. With data mapping getting better all the time, funders are able to target neighborhoods with the most need. For example, the Field Foundation

27 Jim Walker, "Our History," Big Car, accessed December 9, 2018, https://www
 .bigcar.org/history/.

created a "heat map" of Chicago that takes into account quality-of-life indicators such as poverty levels, education outcomes, commute times to work, violence, and access to arts organizations. What they found was "an incredible nexus of poverty, trauma, and divestment that aligns directly with ALAANA (African, Latinx, Asian, Arab, Native American) communities." So, in good conscience, that's where they are focusing the funding in their program areas of justice, art, and leadership investment.[28] This is the next wave of creative placemaking.

Funding for creative placemaking can be found through government percent-for-art opportunities; even if it doesn't use that exact term, it's often implied. It's also opened up a new pipeline of grant funding for artists, through private foundations such as Field, Kresge, United States Artists, Surdna, and many more, and corporate grants and sponsorships. You need to be a nonprofit to apply to most of these, but some will allow you to apply through a "fiscal agent." It's an organization that will act as a nonprofit umbrella for funding that you receive through a grant in return for a percentage of the award amount. It's totally legit. Fractured Atlas[29] has been the go-to for thousands of artists over the years and takes a 4 to 7 percent fee. But look first for partnering with a local organization, such as a neighborhood association, chamber of commerce, or social service agency. A short but good overview of the different sources for grants can be found in an article by grant writing consultant, Tom Camacho, "The Three Types of Grants: Finding the Best Option for Your Nonprofit."[30] *The Artist's Guide to Grant Writing* by Gigi Rosenberg is an entire book on the topic. Finally, there are many artists and arts administrators who freelance as grant writers if you need one-on-one help, which I recommend when you're first learning the language of grant applications.

It would be convenient to end this section here, but I'd be leaving out an area of potential funding that I'm intrigued by but don't quite have a handle on yet. These are large national research and advocacy organizations, such as Smart Growth America, American Association of Retired Persons

28 Angelique Power, "A Letter from Our President," Field Foundation of Illinois, accessed December 7, 2018, https://fieldfoundation.org/about/president-letter/.

29 Fractured Atlas, "Fiscal Sponsorship," accessed December 7, 2018, https://www.fracturedatlas.org/site/FiscalSponsorship/.

30 Tom Camacho, "The Three Types of Grants: Finding the Best Option for Your Non-Profit," Chicago Artists Resource, April 27, 2014, http://www.chicagoartistsresource.org/articles/three-types-grants-0.

(AARP), and Local Initiatives Support Corporation (LISC), who support art and culture as part of their missions to make communities more livable. This statement from the LISC website creative placemaking page is an example of where they see art fitting in:

> We believe creative placemaking can and must be inclusive and equitable to everyone, reflecting the hopes, dreams and desires of community members, including traditionally marginalized groups.
> It works best when embedded in a broader program of community development that addresses affordable housing, education, health and safety. LISC's core creative placemaking goal is to leverage the unique power of arts and culture to empower people [sic] build vibrant, resilient and socially connected communities in the places they call home.[31]

LISC received a major grant from the Kresge Foundation's Arts and Culture program: "Kresge's unique niche in Creative Placemaking is our commitment to influence community development-related systems and practices that expand opportunities for low-income people in disinvested communities in American cities."[32] LISC, in turn, regrants these funds to its network of community organizations, such as the Logan Square Neighborhood Association (LSNA). I know this because LSNA is one of the community organizations I've cultivated as part of the Corner Project, an extension of my public art practice focused on revitalizing the three blocks of a disinvested neighborhood main street where my studio and LSNA's offices are located. Because of my relationship with LSNA, I was able to get a grant from LISC for street banners. So, if you're still reading, my point is there is access to funding from these giant organizations that trickles down through hyperlocal neighborhood service organizations, which you should be making a point of getting involved with anyway.

As I said at the beginning of the chapter, I would start with simple things you could do to jump-start your public art practice and build up from there

31 LISC, "Creative Placemaking," accessed December 7, 2018, http://www.lisc.org /our-initiatives/economic-development/creative-placemaking/.

32 Kresge Foundation, "Arts and Culture," accessed December 7, 2018, https: //kresge.org/programs/arts-culture.

to more labor-intensive, long-term efforts. That brings us to the final section, self-initiated projects.

MAKING A DIFFERENCE

The best way to get other people to take a chance on you is to take a chance on yourself first. I guarantee that wherever you are right now, there are at least five possibilities for you to do work that is relevant to the people whose lives intersect with the nearest shared public space. Is there a dangerous crosswalk on the street near you? Vacant storefronts? A neglected park? A disconnected community? Once you start looking at the world outside your door knowing that you have the agency and creative wherewithal to have a positive impact, you'll start to train your brain to see opportunities everywhere. Ones that you can do yourself without waiting for permission or outside funding. Self-initiated projects are about more than just doing something to add to your portfolio to become eligible for public art commissions. They're a form of service that becomes its own reward even as it opens up more possibilities for your work. By calling attention through art to issues that are being dismissed or discounted because the community doesn't have political clout, artists are able to open the doors to access political power. In other words, Art alone can't change the world, but artists can.

There are as many approaches you can take as there are situations. Here are a few examples of projects by artists who have responded to the needs, resources, and opportunities relevant to their communities.

Peter Svarzbein, Transnational Trolley Project

What started as a master's thesis project in 2010 for El Paso artist Peter Svarzbein led to the reopening of a vintage trolley line to connect the city to Juárez, Mexico—even if he had to get elected to city council to make it happen. When Svarzbein found out that the city of El Paso was going to scrap the art deco street cars that had been mothballed since 1974, he began a fake advertising campaign that was "part performance art, part guerrilla marketing, part visual art installation."[33]

33 Sean Doyle, "El Paso Is Rolling Again With Its 1970s Streetcars," Smart Growth America, November 19, 2018, https://smartgrowthamerica.org/el-paso-is-rolling-again-with-its-1970s-streetcars/.

The project began with a series of large posters in downtown El Paso and Juárez advertising the return of the El Paso-Juárez streetcar that featured Alex the Trolley Conductor, a new mascot and spokesperson for the alleged new service. An actor dressed like Alex appeared at comic cons, public parks, conferences, and other events to promote the return of the streetcar. Even though this was all a performance for an art project, it caught the attention of the public to the point where it became clear to Svarzbein that it had enough momentum to work in real life.[34]

With the help of the City of El Paso, Svarzbein was able to collect thousands of signatures, enough to convince the Texas Department of Transportation to grant $97 million to build a streetcar line. By 2015, a new mayor had been elected, and things weren't looking politically favorable for the streetcar, so Svarzbein ran for city council and won. His vote was able to get the streetcar project back on track. In November 2018, the El Paso Streetcar opened for full service. Svarzbein is currently advocating for phases two and three of the service, which would eventually restore transnational service to Ciudad Juárez.

According to Svarzbein, one of the guiding principles of the project was to help the city and region "imagine a better future, because if you can't imagine a better future you can't have one."[35]

Tonika Johnson, Englewood Rising Billboard Project

The only time photographer Tonika Johnson's Chicago neighborhood, Englewood, was mentioned in the news, the story was about crime and poverty. To counter this "damage-centered narrative," Johnson partnered with a neighborhood organization that she helped cofound, the Resident Association of Greater Englewood, to fundraise and rent billboard space featuring images of the "everyday beauty" of her community. Called "Englewood Rising," the 2017–18 billboard campaign depicted scenes such as young men dressed for the prom; a grandfather pushing a baby in a swing; a girl picking flowers in a vacant lot; and portraits of artists, entrepreneurs, and other community leaders. By recognizing the power of the ordinary, Johnson helped her neighbors reclaim control over their story and bring positive attention to the area. The project has brought positive attention to Johnson, too, who has since gone on

34 Doyle, "El Paso."
35 Doyle, "El Paso."

to exhibit her work in museums and galleries while working full time as the program manager of R.A.G.E.[36]

Maria Gaspar, 96 Acres Project

Artist Maria Gaspar was raised in Chicago's Little Village neighborhood, a neighborhood that is dominated by the walled, 96-acre presence of the Cook County Jail. It is one of the largest single-site county predetention facilities in the United States, with an average daily population of 7,500. In 2012, with the fiscal support of the Chicago Public Art Group, a nonprofit primarily known for murals, and Enlace, the Little Village neighborhood association, Gaspar began to work with the incarcerated in and around the jail on inter-disciplinary, site-responsive art projects. She invited proposals from other artists working in all disciplines and set up an advisory group to review them comprised of educators, activists, artists, violence prevention workers, community leaders, the formerly incarcerated, youth, and parents. By 2016 she had received grants from the Local SSA #25, the National Endowment for the Arts, the Field Foundation, and the Chicago Community Trust.

According to the project's website, "Through creative processes and a diverse steering committee, 96 Acres Projects [sic] aims to generate alternative narratives reflecting on art, power, and responsibility by presenting insightful and informed collective responses for the transformation of a space that occupies 96 acres, but has a much larger reaching outcome." You can see for yourself how that manifested as an artwork in the 2018 video *Radioactive—Stories from Beyond the Wall*, documenting an extraordinary event where the animated drawings and voices of the detainees were projected onto one of the massive exterior walls of the complex.[37]

36 Tonika Johnson, personal website, accessed December 8, 2018, https://www.tonij photography.com.

37 96 Acres Project, "The 96 Acres Project," accessed December 9, 2018, http://96acres .org/the-96-acres-project/.

Voices of Experience

In the first edition, I invited eleven experienced public artists to answer some of the most pressing questions addressed in this book in their own words. These are artists who have been in the public art trenches for decades and whose experience has made them justifiably confident in their opinions—even if they sometimes contradict mine. Now that they are eleven years older and wiser, I asked them what they've learned in the intervening years. The answers of those who responded are included in the last portion of this chapter, just before the bios of these obliging artists.

(1) What advice can you give to studio artists who want to make the transition to public art?

Pam Beyette: A successful transition from studio art to public art is a process that is as individual as the creative process itself. The character, approach, media, and intent of artists shape the course they take in public art. The most prudent advice is to ask studio artists to carefully assess what it would look like for them to be a public artist. Ask them if they are willing collaborators, communicators, creative thinkers, and mediators. Are they interested in sharing their ideas in community outreach environments, city council briefings, neighborhood community meetings, municipal design commissions, and review panel presentations? Question their capacity and aspiration against the skill sets required. Do they feel their approach to art making could bring compelling qualities that could contribute to the public realm?

Robin Brailsford: You have to want to work big. You have to have a very tough skin—handle rejection on a daily basis with one hand and juggle a design team for years top heavy with engineers, insurance agents, and arts administrators with the other. You have to be sure of yourself. You have to

be trustworthy. You have to know how to build things—all sorts of things, intimately—to be able to design for them, from a neon tube to a turning radius. You have to be strong, tough, resilient, patient, and of course bright, creative, and learned. You have to be able to explain yourself and your work through your work, with words (written and spoken), and via images and budgets.

And it's not just about you and your "special (art school) vision." It's about becoming a part of the world at large, being part of/facilitating other people's daily vision. It's about accepting that social responsibility and honoring it.

Dale Enochs: I would suggest that a studio artist should start by thinking that his work will be intended for a specific context. The artist should consider scale, environment, and thematic issues, and how to articulate these ideas to others. I would further suggest that a studio artist begin looking at his finished work as a maquette for a larger environment and thinking about how that work would be enlarged, constructed, transported, and set. I believe that making maquettes within scaled environments is an excellent way to begin to understand how that work will relate to a specific environment and how it will be perceived therein. Ultimately, much is learned by simply applying to calls for proposals. The process of putting together a proposal is a learning experience in itself. If the artist submits enough proposals, he might land one. Then, one is faced with much more to learn.

Larry Kirkland: First, some important questions should be answered. Why are you interested in making art in the public arena? If it is for money, I would encourage you to think hard about it. The tasks involved in making a permanent artwork—working with contracts, consultants, and construction companies—are very demanding. Artists often get into financial trouble because they lack the experience to understand these demands.

If you really think that making public artwork is something you want to pursue, you might try making some studio-related work that explores your potential for creating site-specific art with materials that have been tested for longevity.

Jack Mackie: The moment that artists understand that they do not have to make "it" (a.k.a. the Work) is perhaps the most freeing moment they will discover. In realizing that he doesn't need to fabricate the artwork, an artist is freed to work in whatever medium a project requires. When asked what me-

dium I work with, I get to ask, "Wha'd'ya got?" Artists' best fabrication tool is their brain—their methods of thinking, their worldview.

Second moment is *the project is the medium*. If the artist is awake and paying attention, the project will define the material(s)/medium(s) that best support(s) the project goals and the artist's ideas. Artists who enter a project with a material they've already decided on will be frustrated when that material won't succeed in the project due to any number of deterrents. The artist will miss numerous possibilities and will be hobbled as they struggle to figure out where they can insert their preferred material, their art.

Study the project, the site and its deep ecologies, and the community who live or will live with the artist's work. Find the idea, the nugget, the anchoring concept, then ask what materials best reveal that idea. When you have the idea and best material in hand, remember that you don't have to make it yourself.

An artist whose studio work is primarily cotton, silk, wool, or other fabric will not find many projects in which conditions will not allow for fabric. What could carry the methods of fabric yet have the substance to live, successfully, in the rough and tumble of the public realm? I've always said that one could put a painting on a wall, but what about options to pull painting from the wall and lay it into the floor? Replicate that painting, weaving, oil pastel drawing through the mediums of terrazzo, granite, and concretes (remember—work with that material's fabricator). A wall mural effort for an airport, convention center, library, school, or city hall becomes the entire wall-to-wall floor. A side benefit here is that the artist's budget doesn't pay for the whole thing. A building must have a floor, meaning that the vast majority of cost is already covered in the building's flooring budget. Key here is to be a bit of a greedy artist. Dig into the larger building budget, find the line cost for flooring, windows, and wall and column cladding, and ask, "Why settle for a large painting when I could translate my work through terrazzo, tile, stone, or glass?" That is entirely possible. That is your option to take. And remember, Nike stole it from us. *Just Do It!*

Aida Mancillas: Studio artists need to prepare themselves to move away from solitude and from acting solely on their own initiatives and interests, to intense engagement with the public. That includes working with a variety of people who may or may not care about the arts in general or understand the nuances of art. A solitary individual who is public-phobic will have a hard time. You have to deal with regulatory folks, bureaucrats, community leaders,

politicians and others. Suddenly you've moved from private, internal space, to public, wide open space. You're now on a different path.

Tad Savinar: This transition is not an easy one, nor is it a transition for all artists to make. I was an artist who was fortunate—or unfortunate, as time will tell—to have made a shift to public art at a time (1990) which embraced the design team artist. It was a time when the artist's thoughts and intuition were deemed to almost have more value than the objects the artist made. In a gross generalization, I see artists as being from two groups; those who are in love with the act of making things, which borders on hedonism, and artists who are scientists operating using the language of image, content, and humanity. The design team movement encouraged and embraced artists of the latter division. Artists who live in the first group are not well suited to public art. They should be encouraged to follow the money and the opportunities within the studio. My long-winded point is this. Artists should take a long look at themselves, their works, their aspirations, and their realities to determine which group they feel they are best suited to.

T. Ellen Sollod: Don't think you can simply make what you make bigger. Learn how to budget. Don't lose your soul.

Ken von Roenn:

- Understand the difference between creating work that is for a public space (rather than a gallery), for people who will view it as they go through their daily life, and for those who don't make a special effort to come see the work.
- Understand that the bureaucratic work is all part of the creative process—something to be valued and nurtured, not dismissed as a necessary evil.
- Understand and encourage the participation of others in the process of executing a project.
- Most importantly, remember that their art has a responsibility to a larger entity and is not just about self-expression.

Clark Wiegman: Develop communication skills. Learn how to navigate ideas through organizations and groups of people who don't necessarily have any art background or training. Check your ego at the door and be willing to

learn from the process. Take the long view. Be patient. Find humor in each situation. Sustain willpower.

(2) How did you get your start in public art?

Pam Beyette: My start in public art was a series of installations in a city public safety building lobby shared by police, finance department, and city council in 1994. Although this was a seminal public project, my transition from studio work to public work was more gradual and began several years earlier. Collecting discarded and reusable materials and transforming them into art became my passion in the early nineties. The work became larger in scale, less personal, and more sourced from environmental, historical, and cultural references.

Robin Brailsford: I started very small, initiating projects on my own for a minuscule budget that then got great reviews. In my case, it was a beach shower mosaic in Imperial Beach, California, for which I got a $1,000 grant, made all the tiles with senior citizens, and then spent six months setting them at the surf's edge. Before that I had been a jeweler....

Dale Enochs: Initially I began with an interest in creating large-scale outdoor work. I placed much of the work that I did in my yard with a consideration for that space. While in school, the university I attended built the I. M. Pei Art Museum (one of many throughout the country). I was attracted to the museum's atrium and designed a piece specifically for it. I made models, did studies on how the path of the sun would cast shadows within the atrium, and wrote a detailed proposal. I then submitted it. I knew it was unlikely that it would be accepted, but it was a great learning experience. Several years later, the city in which I lived conducted a public sculpture competition, which I entered with a different proposal. That one was accepted.

Guy Kemper: I worked my way into it slowly, doing bigger and bigger jobs, over a period of about twenty years.

Larry Kirkland: I was a studio artist working with impermanent materials for many years. I would exhibit in galleries and competitions. An interior designer saw one exhibition and approached me about working on a commission. More commissions were offered after that, and I eventually started working in materials that were more appropriate for the public arena.

Jack Mackie: Got my start at breakfast, the most important meal of the day! I was plying my artist life as a photographer, black and white, shooting outside, finding a place, waiting for a person/people to fill the place, waiting for the light to move to just so. Click. This in the Jurassic Year, 1978. An artist call came out from the Seattle Arts Commission requesting qualifications from artists to join a streetscape design team. I had no idea what a design team was or what a streetscape project was, but, as a photographer, I knew how to look and watch, and how to see.

Aida Mancillas: I was awarded my first public art commission by then San Diego Public Art Coordinator Gail Goldman who had forged a program for San Diego's Commission for Arts and Culture out of her own conversations with San Diego city heads of various departments. She convinced some of these department heads to include public art in their plans for any capital improvements they were doing. She appealed to engineering to include public art on a replacement pedestrian bridge that had been on the drawing boards. This girder bridge was my first project. It is the Vermont Street Bridge in San Diego, a sandblasted surface with laser-cut steel quotation in stainless steel. It received tremendous community support and just celebrated its ten-year anniversary with a community party. The community was heavily involved in its coming together and take care of it still. I attended many community meetings, sometimes to distraction, but you need to do the time to insure a greater buy-in for the whole thing. You will need the community support at times when resistance comes from unexpected sources. You need your allies.

Tad Savinar: Mine is not a simple story, nor do I suspect it to be a traditional one. As a studio artist crisscrossing the country for exhibitions in the 1980s, I was unable to find an opportunity which allowed me to translate my text- and image-based, temporary museum installations into public art. (Read: I was applying for public art projects, but not getting selected.) Then an opportunity to be involved in live theater presented itself. To make a long story short, I found it to be such a revelation that, having built a pretty good national studio career, I closed my studio, sold my tools, canceled my subscriptions, and burned my Rolodex. I declared myself no longer an artist. Of course, once you have declared that you no longer do something is just about the time someone calls you to say they want to pay you to do that thing. So after building a career working in the theater, I accepted an offer to make some

public art. And in doing so, I found a new world where I could combine all of the core aspects of my studio work (text, image, social comment) with the skills I had learned in the theater (working with a team of skilled craftsmen, dealing with emotional content and an audience, and receiving pay for work completed). Of course, this was only a blip that lasted ten years, for soon after that I began to move beyond the role of the public object maker and design team member to managing architect teams, authoring design guidelines and land-use master plans, or drafting construction documents. In this work I am using the artist's brain to problem solve, but the results are not designs or objects but rather the development of criteria or management opportunities, which drive the entire design process. I still make studio work, which is very personal, and I still make the occasional public work, but only when it is an extremely compelling project.

T. Ellen Sollod: I had a background in art, arts administration, and public policy. I knew how things worked "from the other side." An urban designer I barely knew, but who knew me by reputation, and an architect who had seen my work in an exhibition took a chance on me. These were my two first experiences, the former as a design team member, the later as a site-specific commission. It was outside the normal public art channels.

Ken von Roenn: My first project came by accident, not by planning. The universe had a better idea of what I should do than I did as twenty-one-year-old man. Lesson: Trust what comes your way, and accept that you have less control than you think you do.

Clark Wiegman: I sort of fell into it. I was installing these unsanctioned ephemeral pieces all over the place in the eighties as sort of social and political statements. Upon return from a long road trip through the Midwest in '87, I received a phone call from Jake Seniuk (then an administrator at the Washington State Arts Commission). He told me I'd been selected from a pool of over two hundred artists for a commission at Franklin High School, even though I hadn't applied. He said it would take three years before the site was ready for installation and wondered if I'd be interested. I remember thinking $25,000 was like winning the lottery since I'd never made more than $500 from my art before. Sure I was interested.

(3) Do you think it is possible to make a living from public art? Why or why not?

Pam Beyette: Making a living as a public artist is akin to other design professions. There is a vast range of income potential, from the luminaries who appear to land multiple large projects, to those that struggle, not quite making ends meet. The challenge is to juggle several projects at once while carefully managing budgets and schedules. Since some projects take years to complete, it takes foresight and long-range planning to stay in play.

Robin Brailsford: Yes—I have done it basically since that beach shower wall.

Dale Enochs: Yes. I think that people within the United States are increasingly understanding the importance of the quality of our public environment and the role that it plays in our psyche. Consequently, there appear to be many more calls for public art projects than there have been in previous years.

Guy Kemper: I don't think it's likely one can make a living solely from public art. It's certainly not a line of work you enter into simply. Like most professions, it takes many years of hard work to build credibility and skill. Otherwise, you'd better have another job, a rich daddy or mate, or be in the top 10 percent of the field. A fat line of credit and serious balls also come in handy.

Diversifying your customer base is critical. I would never rely solely on public art for a livelihood.

Larry Kirkland: There are some good examples of contemporary artists making a living in public art. I live with a roller coaster checking account! It is always a challenge, especially because I believe in what I create and don't want to reduce the quality of materials, proper scale of the work, or level of detail within the work. These factors often combine to make real demands upon the contract budget. I think many artists face these issues. The successful artists spend a lot of time balancing their desire to create meaningful work for tight available funds. Nothing new to that!

Jack Mackie: Of course I can make a living at this. Key is to be versatile and to have a flexible focus . . . goes back to, "I don't have to fabricate it." I broadly define what it means to be a public artist. I design, fabricate, have fabricated, install, oversee installation of my work. I also use my take on what public art does and can do to work as a public art planner and as an advocate/speaker

for public art. I work on projects that will not have me engaged as a designing artist but as the artist who cuts a path for other artists, like what someone did for me once-upon-a-time-ago.

Aida Mancillas: I believe one can make a living from public art *if* there are the following shifts:

- Artists must receive a living wage. All art contracts must be clear as to what is expected, with clear timelines and duties outlined. No one can pull the plug in the middle or shift without adequate notice. The budget for any project should be realistic and fair. There should be no expectation to do a $250,000 project for $7,000. *Just say no.* These tiny budgets encourage the proliferation of truncated ideas. They are exercises in frustration. The agency should go back to the community for more money, or partner with another agency, or look for more grants from local politicians, but not try to do a bigger idea that is not supported by the initial budget. An artist is a professional and needs to be compensated to the level of skill and education he or she has acquired. Honor your experience.
- Eventually artists will have to organize, maybe unionize. Certainly create and/or join together whenever possible. There is strength and support in numbers. Public Address in San Diego is a good example of artists coming together to encourage and support one another. You have to set ego aside and step away from the usual competitiveness that is set up in the art world. That won't work for public art and artists. And it's not good practice anyway. It's a poverty mentality of "there isn't enough to go around" that generates the competition. There *is* enough, it just needs to be redistributed fairly.

T. Ellen Sollod: Yes. I do it, but I work *very* hard.

Ken von Roenn: Yes, but only an artist that approaches it with a serious dedication to a public process and not just as a way to make money doing "his" art.

Clark Wiegman: Possible? Yes. Easy? No. There are so many ways these projects can go sideways, it's amazing most get completed. Over a twenty-year career, I've managed to complete thirty-four out of thirty-six.

Since I started working in the field, contractual, liability, and insurance issues have practically exploded. In this country's litigious climate, there's a huge risk factor now associated with placing anything in a public setting. And while the number of commissioning entities is expanding and more artists are creating public art, there's wide variance regarding program and artist capabilities.

(4) How do you find new projects? For example, do you apply to open calls? Do you cultivate prospects such as art consultants, architects, and engineers? Are you at the stage in your career where the jobs are finding you or do all of these apply?

Pam Beyette: Now with the increase of prequalified artist rosters and registries, I find myself more frequently being short-listed without a query. I also respond to requests for qualifications (open calls) for new projects. I focus on established publications, online listservs, and direct mail or email for opportunities. Because I am also a public art planner, I additionally network with architects, planners, engineers, and agencies for potential projects. Very seldom have I used art consultants unless they are hired directly by the client.

Robin Brailsford: Listservs—the best for years has been one from 4Culture in Seattle.

Guy Kemper: For all practical purposes, there is no such thing as "the jobs finding you." I was shocked when one of the leaders of the field, a giant, told me he still had to work like hell to find his projects. Every morning, you gotta get behind that mule. Amateurs wait for inspiration and the knock on the door; the rest of us get up and go to work. (Claes Oldenburg or somebody said something like that.)

Open calls have given me mostly heartache and revenue loss, which I've learned to take in stride.

Get a media packet together and make sure it looks good. Pay a professional photographer for good photos to document your projects. With promotional materials, pay a professional writer to do the copy and a professional graphic designer to do the layout. Amateurish promotional materials

make professional artists look like amateurs. Good designers and photographers can sell anything, even bad work. Packaging is everything.

Don't talk or write too much—no one cares about how clever you are; they just want your work. Let the work speak for itself.

Spend about half the day marketing and the other half working. It's essential to know basic Photoshop and mail merge skills. The wider you cast your net, the more fish you catch.

Larry Kirkland: All of the above. I sometimes apply for open calls but usually only if I am personally asked by one of the design team or art administrators involved. I have had many good relationships with art consultants and work steadily with architects and landscape architects.

Jack Mackie: At this point, I'm answering the phone and accepting or turning down work. This means I agree to enter open competitions for massive projects with planners, architects, landscape architects, engineers, and so forth. It also means I get phone calls and am told I'm short-listed for a project that I didn't even know existed. It also means that I've established relationships with planning/design firms or agencies who call me and say they want me to work on XYZ.

However, getting to this point is the drill. I tended to respond to every open call that interested me (which meant that up until 1985, I kept my day job—this being approximately the first twelve years of my illustrious career!). I learned that it's not worth taking on work just to work. When I did, I ended up regretting it. I don't recall ever applying to a project that asked for a proposal up front. The only proposals I submit in a competition are those that first asked for qualifications and a letter of interest.

Key to a competition, I think, is to take your best shot at each stage. Meaning, if not selected, I've had opportunity to define the need and opportunity of the project to the selection panel from my point of view. Each and every other contestant is then weighed against the agenda I've set. Or at least I like to think so. . . . Plus, I have received plenty of Dear John letters from projects that I applied for. When I see who is selected, I tell my wounded artist soul that I really didn't want the project after all, and it just would have been a nightmare.

Tad Savinar: I have plenty of work and am continually turning things down. I probably only go after, apply, or compete for a public art project every five years and I am very picky. I consider the following:

- The location of the project—is it a pleasant city to work in, will travel consistency be impacted by weather, how many times zones away is it, and so forth.
- The timeline of the project—how will it impact the other clients and projects I am already serving?
- The amount of the budget—is there really enough money to undertake the project, create something timeless that is proper for the site, pay myself a decent fee, and provide a good contingency?
- The other team members already on board—is the client/ agency known for a good process and advocacy, is it an architect/landscape architect that I would choose to work with?
- Project—is there something extraordinarily compelling about the project that draws me, does it offer an interesting site, does it have charged content opportunities and/or a challenging social climate?

I am really very picky about what I work on. These projects are incredibly complex and time-consuming, and I prefer to only work on projects that are enriching. I have a little sign on my desk that says "Don't work for assholes" as a reminder.

T. Ellen Sollod: I'm on a number of lists that send email announcements of available opportunities fairly regularly, which I peruse. I only apply for open calls when the project really resonates with me. I am on several artist rosters or registries, and, consequently, I get a certain number of invitations to apply. I have a community of architects and landscape architects with whom I have a history of working. They will often call me to become part of a team for a project they are going after. It is not easy.

Ken von Roenn: I rely on a wide range of methods of getting new projects. I don't think anyone could, or should, use any one method.

- Competitions can be very frustrating because they short-circuit the process of working in collaboration with the architect/designer and the client. But they are opportunities to explore new approaches or concepts, something often lacking with a commission because a client often hires an artist from something they have seen and have already made a decision that this is a direction they want to go.
- Consultants and representatives can be very effective agents and should be cultivated.
- Publications—magazines, newspapers, books—are good sources of promotion.
- Previous clients are always the best sources and should be cultivated for future projects.
- Blind introductions can be good if done with taste and *understatement.*
- I do at least twenty presentations every month to architects and designers across the country, which is our primary source of new projects.

Clark Wiegman: All of the above. At this point—after applying to something like one thousand projects and giving over one hundred interviews or presentations—I feel like it's simply part of the practice to be out in the world, talking to people, getting feedback, presenting, and being a contributing member of a community.

There's an emerging dialog about the state of the planet—reaching beyond the business of art—that we who practice art in a public realm are both privileged and required to participate in as global citizens. Both the urgency of the discussion and the critical role that artists play as imaginers within it, maintains my enthusiasm for the entire process. I want to be part of some of the solutions for problems facing the world my children will inherit.

(5) What percentage do you budget for your artist's fee?

Pam Beyette: The artist fee can vary by project depending on the scope of work and the extent of oversight responsibilities. I find it prudent to approach the artist fee on a case-by-case basis. I find that small projects can take just as much effort as very large ones. Typically, I look for between 20 to 30 percent in artist fees, but that is hardly a fixed number!

Robin Brailsford: 15 to 20 percent.

Dale Enochs: Therein lies my greatest stumbling block. Every project has a budget, and I consistently work within that budget. Every project also brings forth new ideas and with that a renewed excitement. Over the years, I've gotten pretty good at organizing budgets for projects. I know what it takes to get a project accomplished. However, in my excitement/enthusiasm, I feel that I have been negligent in providing an adequate budget for my labor. I recognize that when I am presented with X amount of dollars, I have a strong desire to do the most that I can with the money available. Paying myself takes a backseat.

I think that many artists (often unconsciously) struggle with meshing the ideals of art with the realities of living. I always want to create the most that I can within a given budget, but I know that I need to provide myself with an adequate income in order to proceed to the next piece. The entire process is a delicate dance.

Guy Kemper: I can't really say what percentage I budget because that depends on the project. Let me answer it this way: I try to end up with 5 to 10 percent net profit.

Larry Kirkland: That is a tough question with no pat answer. I would love to say I budget 20 percent of a budget for artist's fee and oversight. However, that also doubles as the contingency fee! It fluctuates with every project. Sometimes I make no fee. Sometimes I make a decent fee. I have never made what I projected in a spreadsheet for a contract.

Jack Mackie: Ranges. If there is a high public face—meaning many community meetings, city council face time—I push toward 20 to 22 percent. If it's just shut up and draw, it tends more to 15 to 18 percent. This does not include fees required for engineering or stamping by architect, landscape architect. Also not covered are costs for travel. Travel can consume 20 percent of a budget. So, starting at 100 percent budget minus fee at, say, 18 percent minus 20 percent for travel, minus another, say, 2 percent for engineering fees, the client needs to understand way up front that means they're getting 60 percent of the budget for the actual work. I'm in the business to stay in the business . . . ain't gonna play the starving yahoo. . . .

Tad Savinar: When I look at a budget, I immediately reserve 50 percent for my fee. Now I know that many who are reading this will roll their eyes. But wait, because this is not the way the story ends. That is only at the beginning. I see so many artists who take on a project, come up with a concept that they are really excited about, and then ultimately find out that they don't have enough money to properly pay themselves and make the project. I always start off with 50 percent and ask myself, "Now, what can I make for what's left over in the other 50 percent?" During the conceptual phase, I continue to estimate costs and gauge the progress. Finally, when the concept is completed, I start drawing from my imaginary 50 percent fee for contingency and material upgrades; it's a little game I play with myself. By the time the project is completed, I generally come out with a 25 percent fee. As a matter of information, I track all my time on a project diligently in fifteen-minute increments. This record is a wonderful tool to actually see how much time one really spends on a project and has been a great clarification of process when there have been questions legal or otherwise.

When I first started out, I remember trying to work my way up to a $50,000 project. Now, I rarely ever engage in a project that is less than $200,000. However, there were two occasions. One was the opportunity to work with two other artists that I had worked with recently, and we all agreed that we would forgo our fees just to repeat the fun of the partnership. It turned out to be a great piece. And the second was an opportunity to do a sweet little project in a city park in my hometown where I put every dime into the fabrication and taking no fee was my gift to the city.

T. Ellen Sollod: I usually budget 20 percent for my artist fee. I also do a project management set aside and calculate an overhead rate as part of the project fabrication expense.

Ken von Roenn: This will depend on the amount of work required. If there is a model, the fee is usually around 10 percent.

Clark Wiegman: I don't calculate my budgets that way. Instead, I try to place numbers on each area of work: presentation, research, conceptual development, design development, project management, construction documents, fabrication, installation, documentation, and so forth.

It's probably a bit curmudgeonly to say this, but the approach relates to the old idea of being a "cultural worker" as opposed to a "divinely inspired

artiste." It also helps if there's ever any dispute about project costs to be able to point to all the intellectual as well as physical labor that went into its making.

(6) What percent of your time is spent exclusively on art making versus tending to business needs?

Pam Beyette: This is a tough one! But if the truth is told, maybe 10 percent?!

Robin Brailsford: Ninety-five percent business, 5 percent actual art making.

Dale Enochs: I would guess that the business activities constitute about 15 to 20 percent of my time.

Guy Kemper: Ninety percent business, 10 percent art.

Larry Kirkland: Like most artists, I make most of my creative decisions after "working hours." I work almost every weekend and often late in the evening on the creation of the ideas and the working through of a concept. My work takes a lot of research, so much time is spent reading, listening, and interacting to inform myself about a specific subject. My work is always about something with a narrative thread and it takes time to understand the story I am trying to form. Weekday working hours are often spent working on contract issues, budget issues, and making decisions with a fabrication and engineering team. All of these are creative endeavors but not the hands-on creation of a "thing." All of this time is about making a creative idea come to life, so I think I spend all my time making art, just not in the romantic sense of what we imagine it to be.

Jack Mackie: One hundred percent to both. I have no idea. Monday is a business day, I know that. First day of every month is invoice day, I know that.

T. Ellen Sollod: This is difficult to judge because it depends on the various stages of a project; however, administration/marketing/financial management probably take 80 percent of my work time. Depressing, yes?

Ken von Roenn: I don't distinguish between "doing business" and "making art," for they are the same thing. One requires artistic skill, the other requires planning and organization, though both should be done with a sense of creativity and joy.

Clark Wiegman: Unfortunately, probably near 50 percent is spent on the business aspect. It's a constant battle to avoid getting lost in business details (attending meetings, managing employees, dealing with subcontractors, balancing books, running errands, etc.) and keep the focus on creativity.

(7) Under what circumstances would you or have you signed away your VARA rights or your copyright?

Pam Beyette: When addressing the Visual Artists Rights Act (VARA), I carefully read the contract for each and every project since many agencies ask the artist to waive these rights for most infrastructure projects. I am mindful that public buildings and their uses change over time and because my work is often site integrated and always site-specific, it is essential that the contract provide appropriate protection for the integrity of the artwork. I never agree to allow the agency to relocate or remove the artwork, and/or substantially modify the site on which it is built without notifying me of the proposed change. The agency will usually attempt an agreement with the artist regarding the future appearance or location of the artwork.

I would never under any circumstances relinquish my copyright to the artwork! It's vital that artists retain their full rights to reproduce images of their work in all media, including books, magazines, promotional materials, and video, with credit to the client/agency. In turn, the client/agency is free to reproduce the artwork crediting the artist as copyright holder.

Robin Brailsford: I turned down a big project in California that would not honor the VARA rights a few years ago. It was a shout in the wind that no one heard. . . . I myself have since (and often) signed awful contracts with inexperienced cities; otherwise, they will often just give the opportunity to the next guy. Clients are much more eager to avoid their fear-mongering attorneys than their literati and perceptive art committees.

Dale Enochs: Whenever I end up writing a contract I include a brief clause saying that I hold the copyright, that the work cannot be destroyed or removed without giving me notice, and that if repairs are needed, I will be notified and given the opportunity to make those repairs. Most clients agree to these requests. At times, particularly on larger projects, I am asked to forgo these issues. In the end, it depends on how much I want to do the project. The same goes for copyright.

Guy Kemper: I've done a couple of large airport projects in Orlando and Baltimore/Washington where I had to sign away all VARA rights and copyright for both commissions. A few observations:

- Clients often need flexibility to change the building over time. They need full freedom to do this without legal interference from past commissioned artists whose work may be affected. In Orlando, they took out a one-hundred-foot-long wall I did so they could expand the concourse. I doubt they'll ever use it again, and, if they do, it won't be as good of a site as the original. For me to whine about this would be counterproductive, I think.

- A client may reasonably want ownership of the design to prevent the artist from reusing it, which is more likely than the client copying the work for use in another location. Once something is purchased, it is presumably owned by the purchasers to use as they see fit.

Honestly, why do I need copyright? I don't copy myself; I'm through with it—it's theirs. It belongs to the building and the client, not to me. I'm an architectural artist. My work is part of the public realm and, as such, it is sort of a gift to society when I'm through. Artists are constantly appropriating others' work, and, especially in the twenty-first century, I think America's copyright laws are outdated. Of course, there is a blurry line between borrowing and thievery, but it is virtually impossible not to plagiarize. Half of Shakespeare, and probably the same percentage of the best paintings, owe a legal debt to previous works that could be prosecuted under American copyright law. Bob Dylan has never denied a request or charged for another musician to incorporate a sample of his work into his own. What if Picasso (or Cezanne?) copyrighted Cubism? Some things are meant to enter the common public cultural realm, and good artists are flattered when their work enters the realm of common culture; they don't feel they should be paid for parts being appropriated. Most artists are egotistically fooling themselves that their art is unique in the first place.

Jack Mackie: Artists need to waive VARA when working in infrastructure projects. Examples:

- An artist has designed and installed a discrete stand-alone artwork on a light-rail platform. Many years postinstallation, the transit agency determines that the passenger platform needs to be expanded, and a passenger shelter must go where the artwork is. In this case the infrastructure need—the passenger shelter—trumps the artwork, and the artwork will be moved.
- An artist has designed and installed an integrated artwork in an infrastructure project. Say an artist-designed fence along the perimeter of a waste water treatment plant outside of Washington, DC. The plant, due to the ever-expanding amount of unprecedented shit coming out of the White House, must expand, thus requiring a "rearrangement" of the artist's fence work. Shit wins.

Waiving copyright? Short answer? No. Principle: At the end of the day, all an artist has (especially those working in public) is control over how their work is represented and by whom.

T. Ellen Sollod: I have never completely signed away my VARA rights, though I have agreed to a modification when the artwork includes a landscape component. In those cases, I have agreed to work with the agency to revise the landscape if needed and described what my intent was with the landscape (e.g., scale, color palette, texture). In this case, it was agreed that changes, if necessary, would be made with these artistic guidelines in mind. The VARA applied exclusively to the art elements.

I have never signed away my copyright. This would mean that I was doing work for hire, such as that work done by a graphic designer or copyeditor.

(8) What lessons from the school of hard knocks do you have to share with artists who want to enter into creating art for the public realm?

Pam Beyette: Apply for projects that are compelling and speak to your creative sensibilities. Create not to please, but to transcend the expected. Develop designs that leave room for flexibility. Generate succinct, compelling narratives that augment concepts. Design proposals or concepts with a budget clearly in mind.

Robin Brailsford: Live in the now—forget the past. Lose to great artists with grace; work harder to beat the lesser ones. Travel, read, go to shows, hike—but always go back to the studio to get to work.

Guy Kemper: Ideally one wants to deal with, or be in, the top 10 percent of any profession. That bottom 90 is not a pretty thing, but often one must rely on it to do one's job properly. Look out for that bottom 90! They can make life miserable.

Always remember the two driving forces of bureaucracies: the diffusion of responsibility/CYA (Cover Your Ass) and preservation of job security. These two forces make it difficult for anyone to make a decision or admit a mistake, so often blame will be placed on the artist. Because the artist stands alone, there is no bush of bureaucracy to melt back into if things go awry. His head, and his alone, is on the chopping block. Of course, many artists are raving narcissists and business nightmares, so it goes both ways.

Larry Kirkland: Ask many, many questions up front. Don't be afraid to ask dumb questions because there is no such thing. Make sure your contract covers the discovery of unknown environmental, construction, or materials issues. Realize that a contract is a document that has a life beyond the personal relationships of the people who made the initial agreement. People change jobs or leave a project for some reason, and then you are left working with a very different personality with different agendas than the initial contracting officer. Understand who is allowed to install your completed work—you or a labor union. Make sure your own team of engineers and fabricators have a clear line of communication with you and your contract agency.

Jack Mackie: This work isn't for everyone. I can no longer imagine going through the demands of making boutique art for gallery sales. Same with public art. In working outside in the messy grays of sidewalks, there is no such thing as a white room, a freshly gessoed canvas, a white page. Somebody is always standing squarely on that page, and they have an idea about what's supposed to happen on the page. And, whether an artist agrees with that point of view or not, it is valid and must be considered. This is hard, hard work for artists who need to be right.

Aida Mancillas: Don't hold on to a bad project or a bad client. Let go. We artists tend to go the extra distance out of guilt or poverty mentality or something. Believe me, other licensed professionals don't. They do the work contracted, pick up the check, and go home. We artists need to do likewise. Treat it like a job.

Tad Savinar: Never take on a project "for the money." Always ask yourself if you would choose to take on this project, or is it just for money. This act is demoralizing for any artist.

Never say in an interview that you will have no problem with a schedule when you know this is not true. This is my public art world pet peeve. Once, on a large light-rail design team project, there were five artists selected, the project was supposed to start immediately, and all had said in the interview that they were ready to go with no conflicts. I actually promised in the interview that I would take on no new work for the upcoming year so that I could be available. However, when the five of us sat down to figure out when we would have our first design session, none of the other four artists could agree on four days until two and a half months out. Public art is more than a job. It is not an assignment I take lightly. I am always amazed when I encounter other artists who are stretched too thin to really take the time to consider the importance of what they are engaged in, who have been greedy in their project loads, who are lazy in their service of clients, or who are cavalier in their treatment of the public.

More importantly, I am amazed at the number of public artists who do not consider the push-me/pull-you of artistic trends and fashion versus the need for timelessness in the public realm. There is a difference between studio art and public art. In the studio, the artist is the client. In public art, the artist is engaged in a partnership with the public realm. There is a very big difference and a very different set of responsibilities.

T. Ellen Sollod: It doesn't seem to me that my years of hard work and projects have made it easier to get work. Public art should not be something one pursues because one thinks one can make a living at it. There should be something about the idea of working in the public realm that drives you. Be willing to walk away from a situation that is clearly not going well. This doesn't mean to easily throw in the towel, but there are times when a graceful exit is the best strategy. Develop a thick skin. Learn to be patient. It takes years to get things completed. This is a challenge because the excitement you

had when you started a project wanes through the delays of getting it done. Learn how to be collaborative. You need partners in other disciplines (engineers, landscape architects, architects) with whom you enjoy working. If you can, develop a relationship with a structural engineer who likes your work and wants to help you achieve your goals in the manner which fits you best— you want a problem solver. If you aren't going to fabricate your own work, develop relationships with fabricators on whom you can rely. Treat them well. Pay them on time.

Clark Wiegman: Here are a few mantras I've shared with younger artists: Don't assume anything. Negotiate contracts carefully. Push gently for imaginative solutions. Dream big, but focus on "essential gestures." Try to keep as much fabrication in-house as possible. Wear a respirator. Get several bids. Be persistent and tenacious. Document early and often. Take time to go fishing. Breathe deeply and often.

(9) In November 2018, I emailed each artist these questions: What changes have you experienced in your individual practice and in public art as a whole? How has your attitude toward public art changed?

Pam Beyette: After mulling this over, I'm merely sending my encouragement to emerging and potential public artists in this evolving field. What I said in the first edition still seems applicable.

For me, public art is still a field that is as individual as the creative process itself. The methods of public discourse have shifted enormously in the last decade, as have modes of expression in public art. But fundamentally, each project is still a study in exploration, discovery, collaboration, perseverance, and creative thinking.

Robin Brailsford: After thirty-five years in the public art field, I am reinventing the public art process for myself, my clients, and my communities. It has been an exciting time of new directions for me. Tired of the forever-responsive, wait-and-see/Pop-Tarts mentality of public art, I am on a different path. Instead of being reactive, I am being proactive. Instead of being offered spaces and ideas that are not inspiring, were selected by others, and for which competition in the age of the internet is fierce, I have gone in another direction . . . to make work in sites that I discover and have a passion for, in cities and at museums that have been pivotal in my life.

Dale Enochs: In the interim I've continued to keep busy with public work, some smallish pieces and some quite large. One that was particularly interesting was for the west side of the Indiana Statehouse. . . . Currently I've also got another public piece in the works. . . . As always, the work in progress is what is most exciting and compelling.

One thing that has changed for me is the amount of "gallery work" that I'm making. I have always created "independent work" but this has seemingly increased as my gallery has asked for and shown more of my work. I find myself in a dance between site-specific work and independent work. Perhaps juggling might be a better metaphor. I love doing both. Public work requires getting out, doing research and talking to people. Independent work is usually created in a more isolated environment where I work on ideas with less constraints. Ultimately, both approaches are interrelated.

Regarding my public work, I have always endeavored to create pieces that are long-lasting, that will withstand the elements of the environment. The rule of thumb has been a "100-year approach." Meaning that the work should potentially stand on its own for at least 100 years. In recent years I have encountered calls for public work whose life expectancy might be 3, 5, or 10 years. I see this as a different way of thinking about what you are creating. This is not a judgment, it is merely an observation and recognition. These observations have been absorbed into my ways of thinking.

Jack Mackie: Changes have most definitely occurred within the practice of public art. Site-specific and user-group-specific work seem to have been kicked to the curb. Administrators are not starting artists early in a capital improvement project (CIP) process and are opting for after-the-fact art placement—what was earlier known as "plunk." This approach is more predictable, safer, creates work that is often irrelevant to the community in which it sits, provides less money for the artist, doesn't challenge artists, is a bit cowardly, but doesn't rock political boats. A majority of the practitioners seem to have forgotten that art outlives politics.

But this is not all the fault of the administrators. Artists, willing to take any bone thrown their way, have become less discriminating in what they will *not do*. Their work has become predictable and, again, close to irrelevant the day after the work was installed. There is very little community engagement and very little understanding by the artist of the people who will pass by their work. They, with administrators, have removed *the public* from public art. Too often I've seen artists with an idea meant for one locality but was

rejected just schlepp it over to another locality for one more try. One public is not every public. Artwork that is outside (a.k.a. too big to fit through a door) is not by itself "public art," especially if there was no genuine public process in the creation of the work. Again, there has been an unfortunate return to *plunk*, to *eye candy*, and to *Startists*.

Tad Savinar: I've read what I originally wrote a number of times and really don't have anything to add. Seems like the old opinionated, know-it-all Tad is completely in sync with the current opinionated, know-it-all Tad.

T. Ellen Sollod: Over the last decade or so, there has been a veritable explosion in the number of artists that are pursuing public work. The graduate schools belch out a new crop every year. Artists who have given up on the gallery world think they can just shift to public work. Applications are sought through online services from Call for Entry to PublicArtist.org to CODA, among others. The number of applications for any given call can number over three hundred. The budgets have remained generally static, while the fees for artists' services seem to have shrunk. Many agencies have adopted a "procurement" attitude toward artist selection, including requesting full proposals for a nominal honorarium. This does not allow the artist to immerse him/herself in a community and develop an appropriate response. The agencies want to know what they are going to "get." Many agencies, on the one hand, have become more risk averse and, on the other, seem to follow trends such as wanting media, lighting, and interactive technology—but not wanting to maintain it. They generally have gone away from seeking artists who are good collaborators and who are effective at making places as art with a larger vision, to reembracing stand-alone sculpture. It feels to me the field has become increasingly impersonal and conservative. This is a very difficult environment in which to get work and, when one does, the projects are often fraught with conflict. All of this is antithetical to my values. My motivation for creating art in the public realm in the first place was grounded in an authentic commitment to a belief that the public deserves gracious public spaces that function as a community living room—whether that "living room" is a park, a street, a plaza, or some piece of infrastructure. While I favored integrated work, I did not embrace art as decoration or "wallpaper" or a thin layer of mayonnaise but as something that can add meaning and metaphor to the public realm. I find the vast majority of public art that I see trite, hackneyed, and uninspired. Whew. Did I just say all that?

At this point, I am continuing to work on some design teams on issues of placemaking in which art, landscape, transportation, infrastructure and the community come together to enhance its vitality. Starting with the idea of making places for people, I am driven by a belief that things need to be done with an eye toward the totality of experience and nurturing cultural engagement. As an artist on design teams, I am able to influence places far beyond what the art budget would allow. The vast majority of this work is not through the "public art pipeline" but through collaborative teams engaged by cities for urban design-related projects. I am no longer responding to general calls for artists unless there is something particularly compelling about the opportunity—which is rare.

The last two years have seen drastic challenges to our democracy at the national level. The rising autocracy and its attacks on the free press ultimately threaten freedom of expression in the United States. With that in mind, I have shifted my practice from creating large-scale, site-specific, highly integrated public work to using my artist voice in political activism. Through a series of projects, I have reached out to people in a vast array of situations to promote dialogue and to encourage people to stay focused on taking our country forward. This has included mail art projects, artist books, photography projects, and other forms of engagement. I still believe in the importance of civic dialogue—which public art at its best can enhance—but my form of participation in the public realm is more immediate and, hopefully, constructive.

Ken von Roenn: I am no longer entering competitions for several reasons:

- the process of selecting and administering projects overall is flawed;
- the budgets for a great many projects are inadequate for a quality project; and
- the selection process generally is inconsistent and unpredictable with inferior projects being selected in many instances.

I have become disillusioned with public art, though there have been some wonderful projects. While I still believe in the value and importance of public art, the way it is being developed in the United States is significantly inadequate. My biggest complaint is that artists are brought into a project too late, which eliminates the opportunity for their involvement in a genuine

integration of art and architecture. Public art in architecture continues to be not much more than "frosting on the cake."

VOICES OF EXPERIENCED ARTISTS

Many thanks to the artists who contributed to this chapter:

Pam Beyette is a public artist living in Seattle, Washington. Her site-specific artwork, inspired from environmental, historical, and cultural experiences, is incorporated into schools, parks, libraries, universities, transit stations, and justice centers nationally.

In addition to being a full-time artist, **Robin Brailsford** is a founding and board member of Public Address, an association of public artists.

Dale Enochs is a stone sculptor. His numerous public works can be seen throughout Indiana, Indiana's sister state in China, and in Osaka Prefecture in Japan. He lives and works near Bloomington, Indiana.

Guy Kemper makes architectural paintings in blown glass. His projects include installations at Orlando, Baltimore/Washington, and Chicago O'Hare International Airports, Mt. Baker Station in Seattle, and the Catholic Memorial at Ground Zero. He resides in Versailles, Kentucky.

Since 1974, **Larry Kirkland** has collaborated with design professionals and community leaders creating meaningful places throughout the world. Over the past several years, he has been a juror for both art and architecture programs throughout the country. He resides in Washington, DC.

Jack Mackie works as a public artist and arts consultant on major civic projects throughout the country and Great Britain. He resides in Seattle.

Aida Mancillas passed away in 2009. She created large-scale public artworks and was a commissioner with San Diego's Commission for Arts and Culture, where she sat on the Diversity, Policy, and Creative Communities Committees.

Tad Savinar is an artist based in Portland, Oregon, who has focused much of his work on urban design teams, master planning exercises, downtown revitalization plans, urban waterfronts, and regional infrastructure projects.

T. Ellen Sollod has been involved in public art as an artist, art planner, and art policy maker for over twenty years. She lives in Seattle.

Ken von Roenn stumbled into becoming an artist of large architectural glass installations in the 1970s when, only two weeks away from entering law school, he had an accident and, because he had no health insurance and was no longer able to afford school, went to work in a small stained-glass studio. It inspired him to obtain a master's degree in architecture and to found a large studio in Louisville, Kentucky, where he resides today. In 2018, he began a new consulting business called Von Roenn Collaborative.

Clark Wiegman has been a professional multimedia artist for the past twenty-five years. Projects include civic planning, plaza and transit center design, earthworks, fountains, landmarks, soundworks, and illuminations.

Bibliography

These are some of the books and essays that have been helpful to me in more fully understanding the public art universe and how to navigate it.

Abbing, Hans. *Why Are Artists Poor?: The Exceptional Economy of the Arts.* Amsterdam: Amsterdam University Press, 2002.

Alinsky, Saul. *Rules for Radicals.* New York: Random House, 1971.

Belfiore, Eleonora, and Oliver Bennett. *The Social Impact of the Arts: An Intellectual History.* New York: Palgrave Macmillan, 2008.

Bielstein, Susan M. *Permissions, A Survival Guide: Blunt Talk about Art as Intellectual Property.* Chicago: University of Chicago Press, 2006.

Bishop, Claire. *Artificial Hells: Participatory Art and the Politics of Spectatorship.* London: Verso, 2012.

Bogart, Michele H. *The Politics of Urban Beauty: New York and Its Art Commission.* Chicago: University of Chicago Press, 2006.

Burton, Johanna, Shannon Jackson, and Dominic Willsdon, eds. *Public Servants: Art and the Crisis of the Common Good.* Cambridge, MA: MIT Press, 2016.

Cartiere, Cameron, and Martin Zebracki, eds. *The Everyday Practice of Public Art: Art, Space and Social Inclusion.* London: Routledge, 2016.

Cox, Geoff, and Jacob Lund. *The Contemporary Condition: Introductory Thoughts on Contemporaneity and Contemporary Art.* Berlin: Sternberg Press, 2016.

Dewey, John. *Art as Experience.* New York: Penguin, 2005.

Dissanayake, Ellen. *What Is Art For?* Seattle: University of Washington Press, 1988.

Finkelpearl, Tom. *Dialogues in Public Art.* Cambridge, MA: MIT Press, 2014.

Goldbard, Arlene. *The Culture of Possibility.* Richmond, CA: Waterlight Press, 2013.

Grant, Daniel. *The Business of Being an Artist.* 5th ed. New York: Allworth Press, 2015.

Harper, Glenn, and Twylene Moyer. *Artists Reclaim the Commons: New Works-New Territories-New Publics.* Hamilton, NJ: ISC Press, 2013.

Helguera, Pablo. *Education for Socially Engaged Art: Materials and Techniques Handbook.* New York: Jorge Pinto Books, 2011.

Jackson, Maria Rosario. *Creative Placemaking and Expansion of Opportunity.* Troy, Michigan: Kresge Foundation, 2018.

Jacob, Mary Jane. *Dewey for Artists.* Chicago: University of Chicago Press, 2018.

Jacob, Mary Jane, and Christian Boltanski. *Places with a Past: New Site-Specific Art at Charleston's Spoleto Festival.* New York: Rizzoli, 1991.

Jacob, Mary Jane, and Michael Brenson. *Conversations at the Castle: Changing Audiences and Contemporary Art.* Cambridge, MA: MIT Press, 1998.

Jacob, Mary Jane, Michael Brenson, and Eva M. Olson. *Culture in Action: A Public Art Program of Sculpture Chicago.* Seattle: Bay West, 1995.

Jacobs, Jane. *The Death and Life of Great American Cities.* New York: Random House, 1961.

Jordan, Sherrill. *Public Art, Public Controversy: The Tilted Arc on Trial.* New York: American Council for the Arts, 1987.

Kammen, Michael. *Visual Shock: A History of Art Controversies in American Culture.* New York: Knopf Doubleday Publishing Group, 2006.

Kester, Grant. *Conversation Pieces: Community and Communication in Modern Art.* Berkeley: University of California Press, 2013.

Kwon, Miwon. *One Place after Another: Site-specific Art and Locational Identity.* Cambridge, MA: MIT Press, 2004.

Lacy, Suzanne. *Mapping the Terrain: New Genre Public Art.* Seattle, WA: Bay Press, 1994.

Lippard, Lucy R. *The Lure of the Local: Senses of Place in a Multicentered Society.* New York: New Press, 1998.

Louden, Sharon, ed. *The Artist as Culture Producer.* Chicago: University of Chicago Press, 2017.

Metzger, Janice. *What Would Jane Say: City-Building Women and a Tale of Two Chicagos.* Chicago: Lake Claremont Press, 2009.

Mitchell, W. J. T., ed. *Art and the Public Sphere.* Chicago: University of Chicago Press, 1992.

Murphy, Gavin, and Mark Cullen, eds. *Artist-Run Europe: Practice/Projects/Spaces.* Eindhoven, Netherlands: Onomatopee Projects, 2017.

Odenkirk, Sarah Conley. *A Surprisingly Interesting Book about Contracts*. Los Angeles, CA: Ammo Books, 2013.

Palmer, Brian, and Seth Freed Wessler. "The Costs of the Confederacy." *Smithsonian*, December 2018.

Rachleff, Melissa. *Inventing Downtown: Artist-Run Galleries in New York City 1952–1965*. New York: Del Monico Books/Prestel, 2016.

Rosenberg, Gigi. *The Artist's Guide to Grant Writing: How to Find Funds and Write Foolproof Proposals for the Visual, Literary, and Performance Artist*. New York: Watson-Guptill, 2013.

Russell, Elizabeth. *Arts Law Conversations: A Surprisingly Readable Guide for Arts Entrepreneurs*. Madison, WI: Ruly Press, 2015.

Sacramento, Nuno, and Claudia Zeiske. *ARTocracy: Art, Informal Space, and Social Consequence*. Berlin: jovis Verlag GmbH, 2010.

Satinsky, Abigail, ed. *Support Networks*. Chicago: School of the Art Institute of Chicago, 2014.

Senie, Harriet. *Critical Issues in Public Art: Content, Context, and Controversy*. New York: Random House, 2014.

Sholette, Gregory. *Dark Matter: Art and Politics in the Age of Enterprise Culture*. New York: Pluto Press, 2011.

Thompson, Nato. *Culture as Weapon: The Art of Influence in Everyday Life*. Brooklyn, NY: Melville House, 2018.

Thompson, Nato. *Seeing Power: Art and Activism in the 21st Century*. Brooklyn, NY: Melville House, 2015.

Tucker, Daniel. *Immersive Life Practices*. Chicago: School of the Art Institute of Chicago, 2014.

Willats, Stephen. *Artwork as Social Model: A Manual of Questions and Propositions*. Manchester, England: Research Group for Artists Publications, 2012.

Willats, Stephen. *Stephen Willats: Between Buildings and People*. Hoboken, NJ: Wiley, 1996.

Willett, John. *Art in a City*. Liverpool: Liverpool University Press, 2007.

Acknowledgments

I'd like to acknowledge with gratitude the community of artists and arts administrators who contributed to this book. With special thanks to Barbara Hoffman, Nancy Herring, and Kristin Enzor, who generously donated their expertise to demystify law, budgeting, and insurance for artists. Daniel Grant for allowing me to use his clarifying essay on health coverage. Mary Jane Jacob, not just for the foreword, but for her mentorship and steadfast support of artists' relevance to every aspect of life. To my publisher, Tad Crawford, who believed enough in this book to give it a second life. And to Doug vanderHoof for being there through it all.

About the Author

Lynn Basa is a full-time artist whose practice includes painting and public art. In 2017, she began The Corner Project, a community development initiative to revitalize the old working-class main street in Chicago where she has a studio. Prior to moving to Chicago in 2002, she was the curator of the Safeco Insurance Company collection and the founding director of the University of Washington Medical Center's art program in Seattle. She has a master's degree in public administration from the University of Washington and a master of fine arts degree from the School of the Art Institute of Chicago where she developed and taught a course on public art professional practices.

Index

123
3-D modeling programs, 39
4Culture, 44, 162
96 Acres project, 181
100-year approach, 205

A
AB 753, 132
Abbing, Hans, 85
accessibility, 5, 7, 8, 9,
 177, 186
accountants, 77, 78
accounting software, 38
Acoma Pueblo, 173, 174
Actors Fund of America,
 115
Adams, Alice, 134, 157
addendums, 122
add-ons, insurance
 policies, 112
Aerosoul Crew, 170
Affordable Care Act, 91,
 109
agencies, 17–18, 206
AIDS (acquired immune
 deficiency syndrome),
 112–113
Albuquerque Art Museum,
 174
Albuquerque Journal, 173
Albuquerque "tri-cultural
 collaboration," 173–174
Alex the Trolley
 Conductor, 180
alternative health care, 113

American Association
 of Retired Persons
 (AARP), 177–178
American Craft
 Association, 112
American Crafts Council,
 112
American Federation of
 Musicians, 112
American Institute of
 Architects, 105, 137
Americans for the Arts, 1,
 6–7, 15, 21
annotated image list,
 41–43, 55–56
annual gross revenue, 94i
anti-artist boilerplates,
 119, 121–122
Apple Keynote, 38
application readiness,
 37–59
 digital submissions
 annotated image list,
 41–43, 55–56
 completed vs
 unrealized project
 images, 42–43, 59
 computer aided
 drafting (CAD),
 39–40
 digital images, 40–41
 software applications,
 37–39
letter of interest
 Cath Brunner on, 44

conclusion, 46
example of, 52–54
first paragraph,
 45–46, 193
opportunities in, 44
second paragraph,
 46–47
third paragraph, 47
tips from a pro, 57–58
project diary, 97–98
references, 43
requirements, 26–27
resumes, 26i, 31, 41,
 93–94
RFQ example, 48–52
streamlining the
 process, 37
support material, 44
Tips from a Pro
 application packets,
 55–56
 letters of interest, 56,
 57–58
 tricks of the trade,
 58–59
approval rights, 127
architects, 20, 39–40,
 73–74, 88, 124, 125, 189,
 193, 194, 195, 197, 209
Argent, Lawrence, 161
Arneill, Porter, 55–56, 67
Art in State Buildings
 Program, 58
Art Institute of Chicago, 9
art placement, 205

artist eligibility, 23–24, 50, 165

artist engagement, 1–2, 3, 4, 124

artist fee, 61, 70–71, 96, 124, 127, 128–129, 195–198

artist registries, 17–18, 164, 192, 194

Artists Health Insurance Resource Center, 114–115

artists in residence, 2, 50, 165, 166–169

artist's rights. *see* copyright; Visual Artists Rights Act (VARA)

Artists Talk on Art, 110

ArtPlace America, 166

artwashing, 172–173

artwork goals, 25, 35, 49, 66

assistants, 98–99

Association of the Bar of the City of New York, 120, 126

attribution, right of, 136, 138

auto insurance, 102, 106

AutoCAD, 39–40

autocracy, 207

Autodesk, 39

B

banking services, 89

bankruptcy, 93

Basa, Lynn, viii, 120

Bauhaus University, 11

Becker, Jack, 2, 12

Behrens, Erica, 153, 154–155

benchmarks, 79, 127, 129, 156, 157

Berne Convention, 143

Beyette, Pam, 183, 187, 190, 192, 195, 198, 201, 204, 208

bid bonds, 130

Big Car, Indianapolis, 174–176

billboard project, 180–181

Black Lives Matter, xi

blind jury, 31

Blue Cross, 113

bodily injury, 105

boilerplates, 118, 119, 121–122, 131–132

Bond, Fiona J.M., 52

bonds, 102, 108, 130

Bourgeois, Louise, 87

BP Pedestrian Bridge, 9

Brailsford, Robin, 183–184, 187, 190, 196, 198, 199, 202, 204, 208

breach of contract, 131

Brilliant Ideas, 161

Brunner, Cath, 44, 162

budgets, 85–99. *see also* business practices

appropriate for scale of project, 191, 194, 207

building, 185

calls for artists and, 24–25, 29, 50, 63

construction overlap, 25, 63, 95, 185

and contract negotiating, 121

finalist proposals, 70–78

artist fee, 61, 70–71, 96, 124, 195–198

consultants, 72–74

contingency, 78, 129, 156, 196

electrical and lighting, 76

fabricators, 73–74, 75, 152

five work phases, 81–82

installation needs, 76

insurance, 77

labor, 71–72

materials, 75

overhead, 76–77

site preparation, 75

taxes, 77–78

tracking costs and variance, 94–95, 197

transportation, 74–75

travel, 74

for public art, 20, 67

staying on budget, 88, 94–95, 96

Building Information Modeling (BIM), 39–40

building permits, 64

built environment, xii, 2, 6. *see also* infrastructure projects

Bush Intercontinental Airport, 162–163

business auto insurance, 102, 106

business community, 5, 8, 9

business expenses, 88

business of art, viii, 12, 13, 30, 38, 85, 198–199. *see also* financial strategies

business practices. *see also* insurance

annual gross revenue, 94i

budgeting

costs, 96

gross revenue, 95

hiring help, 98–99, 185, 192–193

productivity, 96

project diary, 97–98

tracking commissions, 94–95

variance, 94–95, 96

careful spending

banking services, 89

communication costs, 90

credit cards, 90, 93

credit score, 90

health care, 91

housing, 91

transportation, 90–91
charging for artwork, 86
day jobs, 99
earning enough money
 living expenses,
 87–88
 making a living wage,
 88, 96, 190–192
 remaining an artist,
 89
 staying on budget, 88,
 94–95, 96
 taxes, 88
maximizing value of
 commissions, 93–94,
 95
money = freedom,
 86–87
multiple income
 streams, 93–94, 190
project diary
 opportunities, 97
 strengths, 97
 threats, 98
 weaknesses, 97
saving strategies
 cash cushion,
 building, 91–92, 99
 compounding, 91–92
 debt, 93, 99
 future goals, 92
value of art skills, 85–86

C
CaFÉ, 1, 38, 40
CallForEntry.org, 15, 206
calls for artists
 competitions and, 15,
 16–17
 components of
 artist eligibility,
 23–24, 50, 165
 artwork goals, 25, 35,
 49, 66
 artwork location
 description, 26
 budget, 24–25, 50, 63
 call summary, 24

deadline, 23
project description,
 24, 48–49
project timeline, 25,
 52, 62, 63, 156, 194
proposal
 requirements,
 sample, 50
site history
 description, 26, 48,
 49–50
deciding to apply, 27
digital file formats and,
 40–41
and letter of interest, 45,
 52–54
new artists, 164–165
and RFPs, 19–21
selection process. see
 also finalists
 cuts at selection
 meeting, 31–32
 example of, 51
 human interaction,
 28, 31, 35
 panels, 2, 27–29, 30,
 31–32, 35, 41, 55
 scoring sheet, 32
 selection criteria, 24,
 32–35, 51
 tips from a pro, 55–58
 von Roenn on, 207
 understanding, 95
 voice of experience on,
 188
Camacho, Tom, 177
Cameron Park Zoo, 48–52
Campbell v. Acuff-Rose
 Music Inc. (1994), 137
Canadian copyright case,
 139
capital improvement
 project (CIP), 205
cash cushion, 91–92, 99
Catherine of Braganza,
 140–141
CCNV v. Reid (1989), 137

Center for Creative
 Placemaking, 15
certificate of insurance,
 104, 170
CETA (Comprehensive
 Employment and
 Training Act), 2
change order, 128
changes in the public art
 world, 204–208
Cherokee history, 69
Chicago Artists Coalition,
 99, 110
Chicago Community
 Trust, 181
Chicago Public Art Group,
 170, 181
Chicano art movement,
 169
City Beautiful Movement,
 171
City of Indianapolis case,
 141
Cloud Gate, 9
Coar, David H., 142
CODAworx, 15, 206
collaboration, 12, 124, 127,
 132, 143–144, 186–187,
 194, 197, 202, 204, 207,
 208
College Art Association
 (CAA), 41
color, and medium
 variations, 153
Colorado State University,
 46
Columbia Graduate School
 of Business, 99
commercial general
 liability insurance, 102,
 105
commercial property
 insurance, 102
Commission for Arts and
 Culture, San Diego, 188,
 208
commissions, 15, 93–94, 95
communication costs, 90

communication skills,
154–155, 186
Community Canvas, 164
community development,
xi, xii, 1–2, 7, 8, 10,
166–167, 169, 172, 176,
178, 183, 185, 188. *see
also* making the leap
Community Development
Financial Institution,
165
Community Foundation
of Greater Greensboro,
Inc., 9
competence and reliability,
30–31
competitions, 15–22
calls for artists, 15,
16–17
experienced artists on,
193, 195
how art agencies find
artists
artist registries,
17–18, 192, 194, 206
direct purchase, 18
invitational, 18
open calls, 18
persistence, 21–22, 28, 204
RFQs and RFPs, 19–21,
26, 32, 37, 45, 46,
47, 58, 68, 122–123,
162–163, 165
tips from a pro
application readiness,
55–56
letters of interest, 56,
57–58
compounding, 92
computer aided drafting
(CAD), 39–40, 72
concept drawing, 42,
68–70, 81
conceptual art, 166
Constitution of the United
States, 135
construction budgets, 25,
63, 95, 185

consultants
architects, 73–74
budgeting for, 98–99
costs, 72–74
fabricators, 73–74, 75.
see also fabricators
finding work and, 15,
192, 193, 195
historians, 73
legal advice, 73
photographers, 73
specialist trades, 73
contact information, 41,
58, 67, 69
contingency plans, 78, 79,
129, 156, 196
contracts, 117–134
artist teams, 144
and artist's rights, 119,
142
and boilerplates, 118,
119, 121–122, 131–132
breach of contract, 131
and budgeting, 72, 73,
76, 78
and copyright laws, 142,
144, 199–201
design changes,
charging for, 96
experienced artist on, 202
and fees, 124, 126,
127–129
finalist advice, 62, 63
and government
programs, 123–124
incorporation, 133
and insurance, 104, 107
and legal advice, 63–64,
73
maintenance
responsibility, 147
and model agreements,
120, 126, 132, 133,
137, 144
negotiating
addendums, 122
and artist's rights,
119, 121–123

challenges, 119
clauses, negation of,
122
and copyright laws,
136–137
dispute resolution/
mediation, 123
and extra work
requests, 121, 128
lack of contract,
handling, 120
legal assistance, 120,
122
"power" skills,
118–119
unanticipated
demands, and
budgeting, 121
oral agreements, 118
overview of, 117–118
and ownership of
artwork, 146
and payments, 79,
81–82, 157–158
poor estimates in, 96
and RFPs, 19
and schedules, 78
specific clauses
change order, 128
contingency, 129, 156
documentation,
129–130
indemnity, 131–132
insurance, 130–131
late payment, 128–129
payment schedule,
127–129
project size changes,
128
quality control, 127
risk factors, 131
scope of services/
scope of work, 126
storage, 127
timelines, 129, 156
warranty, 132–133,
147
types of

off-site individual
 projects, 123–124,
 126
purchase orders,
 124–125
on-site collaborative
 projects, 124, 127,
 132
subcontractors, artists
 as, 125–126
understanding, 95
Cook County Jail, 181
copyright. see also Visual
 Artists Rights Act
 (VARA)
attribution, right of, 136,
 138
and contracts, 142, 144,
 146
Copyright Term
 Extension, 137
derivative work and,
 140, 141, 142, 144
design ownership, 143
duration of, 137
experienced artists on,
 199–201
fair use doctrine,
 137–138
of ideas, and joint
 authorship, 143–144
integrity, right of, 136,
 138, 147, 199
laws, 135, 142–143. see
 also legislation
and moral rights
 Canadian case, 139
 City of Indianapolis
 case, 141
 creation of the VARA,
 138–139
 five components of, 138
 Flack v. Friends of
 Queen Catherine
 (2001), 139–141
 laws, 136
 major setbacks,
 141–142

state variations,
 146–147
visual art definition,
 139
works of recognized
 stature, 139, 141,
 147
photographs of artwork,
 144–145
public domain, 145
registration, 142–143
rights of the copyright
 owner
 Copyright Act, 136,
 137
 licenses, 136–137, 143,
 145
 work for hire, 137,
 141, 143, 145
 waiving rights, 143, 144,
 146, 199–201
Copyright Act, 136, 137
Corner Project, xii, 172,
 174, 178
corporations, 104–105
costs, 72–76, 96
Couch Surfing Project, 74
Cowan, Lucas, 164
Craigslist, 99
creative class, 5, 8
creative placemaking, xi,
 15, 160, 171, 207. see also
 making the leap
Creative Waco, 48–52
credit cards, 90, 93
credit score, 90
crowdfunding, 170
Crown Fountain, 9
cultural factors, xi, 6, 7–8,
 166, 172, 173–174

D

Dallas Office of Cultural
 Affairs, 164
Day, Lilly, 176
day job, 99
deadlines, 23, 63, 79, 156
debt, 93, 99

dedications, 63, 82
deductibles, and health
 insurance, 111
delivery, 82
Denver Art Museum, 161
Denver Musicians
 Association, 112
Department of Sanitation,
 NYC, 166
Department of
 Transportation, Texas,
 180
dependents, 111
derivative work, 140, 141,
 142, 144
Derix, Barbara, 155
Derix Glasstudios, 155
design teams, 186, 189,
 207, 209
designer, artist as, 124,
 190–191
diary, project, 97–98
digital applications. see
 application readiness
digital art, 3–4
Digital Art (Paul), 3
digital images, 40–41
direct purchase, 18
disability insurance, 102,
 103
documentation, 129–130
droit moral (moral rights),
 136, 138–140, 141–142,
 146–147
duration of responsibility,
 147
Dylan, Bob, 200

E

economic revitalization, 5,
 8, 169, 172, 176, 178
economics and public art,
 5, 6, 7, 9, 10
Editorial Freelancers
 Association, 110
education, 160–161
Efroymson, Jeremy, 175
Eickoff, Fred, 108

El Paso-Juárez project,
 179–180
El Sadek, Rehab, 166
electrical costs, 76
eligibility, 23–24, 50, 165
embedded artists, 2,
 165–167
Emily Hall Tremaine
 Foundation, viii
Englewood Rising
 Billboard Project,
 180–181
Enlace, 181
Enochs, Dale, 134, 184,
 187, 190, 196, 198, 199,
 205, 208
environmental impact
 statement (IES), 64
environmental materials,
 75, 187
environmental regulations,
 64
environmental
 sustainability, 171, 172
Enzor, Kristin, 101
equity, artistic, xi
estimates, fabricator,
 152–153
exclusive license, 136, 143

F
fabrication and
 construction, 82
fabricators
 artistic expertise,
 150–151, 154, 155, 162
 budgeting for, 73–74, 75,
 152–153
 and copyright, 144
 finding on the internet,
 151
 and freedom of artistic
 design, 184–185
 full-service companies,
 150–151
 mutual respect, 152,
 154–155, 161–162, 204
 painters, 150

and performance bonds,
 108
prescreened, 149
sculptors, 150
as subcontractors, 125,
 149, 185, 190
tradespeople, 150
working with
 communication,
 154–155
 estimates, 152–153
 expectations, 153–154
 flexibility, 155
 payments, 157–158
 practical matters,
 155–156
 schedule coordination,
 155, 156
fair use doctrine, 137–138
FedEx Office, 72
feedback, 16–17, 68
fees, 61, 70–71, 96, 124,
 127, 128–129, 195–198
feminism, xi
FICA, 77, 88
Field Foundation, 176–177,
 181
Fields, W. C., 118
final cut, 31–32
finalists, 61–83
 and budgets, 63, 67
 contracts, 62, 63, 72, 73,
 76, 78
 Five Work Phases
 of a Public Art
 Commission, 81–82
 interview, 19, 61
 presentation
 aims, 82–83
 handouts, 83
 samples, 83
 visuals, 83
 pro tips for, 65–67
 and project managers,
 63–65, 69, 71, 95
 proof of approval, 63–64
 proposals, 20, 39, 42,
 61–62, 65–66

anatomy of, 80–81
 budgets, 70–78,
 81–82. *see also*
 budgets
 components of, 67–68
 concept, 68–69, 81
 cover letter, 68
 and extra work
 requests, 121
 number of ideas to
 present, 68
 place ethic, 70
 schedule, 63, 78–79,
 81–82
 questions for yourself,
 62
 references and, 43
 selection panels and,
 32, 57
 site details, acquiring,
 64, 68, 69
financial strategies,
 85–86. *see also* business
 practices
fine art insurance, 102–103
first cut, 31
fiscal agents, 177
Fischer, Roger, 118–119
Five Reasons Why Public
 Art Matters, 6–7
Five Work Phases of a
 Public Art Commission,
 81–82
Flack, Audrey, 139–141
*Flack v. Friends of Queen
 Catherine* (2001),
 139–141
flexibility, 47, 62, 64, 66,
 78, 155, 190, 201
Flint Public Art Project,
 169
following instructions, 59
Forecast Public Art, 2, 15,
 151, 164
Forsell, David, 176
Fort Worth, 17
Fort Worth Public Art, 164
Fractured Atlas, 177

fragmented industry, 86
Franklin High School, 189
Franz Mayer of Munich,
 153, 154
freedom, as artist, 86–87
freedom of expression, 207
Friend Gay, Dixie, 162–163
Friends of Queen
 Catherine (FQC),
 140–141
front-loaded payments,
 127, 129
Fry, Andy, 176
full-service insurance
 agency, 102
fundamentals of public
 art, 1–14
 digital art, 3–4
 Five Reasons Why
 Public Art Matters,
 6–7
 government/political
 support for, 5–6, 7–8,
 28, 180, 205
 inclusiveness and
 engagement, 1–2, 3, 4,
 124, 176, 186, 188
 sponsorship programs
 and funding, 1–2
 training, 11–13
 trend spotting, 4
funding
 of creative placement
 initiatives, 177–178
 government, viii, ix, 1,
 5–6, 7–8, 123–124, 177
 grants, 65, 164, 171, 175,
 177, 178, 187
 private, xi, 1, 10, 177
 public, 10, 11
 research and advocacy
 organizations,
 177–178
 sources of, 160, 170–171

G
Gail M. Goldman
 Associates, 15

gallery work, 205
game development
 software, 39
Garten, Cliff, 134
Gaspar, Maria, 181
Gehry, Frank, 9
general contractors,
 125–126
General Services
 Administration, 125,
 142
gentrification, 172–173
Getting to Yes (Fischer),
 118–119
GGN, 9
goals, 25, 35, 49, 66
Goldman, Gail, 188
Google (SketchUp), 39
Google Docs, 37
Google Earth, 39, 64
Google Sheets, 38–39
Google Slides, 38
Gordon, Nicole, 134
government funding,
 viii, ix, 1, 5–6, 7–8, 28,
 123–124
graffiti art, 169, 170
Grant, Daniel, 109–115
Grant Park, 9
grants, 65, 164, 171, 175,
 177, 178, 187
Great Depression, 8
Great Recession, 89
Greensboro, 9
gross revenue, 95
Groundswell NYC, 170
group health insurance,
 110, 111, 112, 115
guerrilla art, 2, 179

H
Hale, Michael, 39–40
handouts, 83
Harvard, 11
Hatchfund, 170
Health Education
 Outreach Center, CSU,
 46

health impacts, 7, 91
health insurance, 91, 102,
 103, 109–115
health maintenance
 organizations (HMOs),
 109–110
health savings account
 (HSA), 103
Héder, Lajos, 131, 134
Herring, Nancy, 62, 85,
 87–99
Hill, Samantha, 172–173
Hispanic culture, 173–174
historians, 73
Hoffman, Barbara T., 117,
 120, 135
hold harmless clause,
 131–132
homeowners insurance,
 102–103
Hospitality Club, 74
hospitalization plan,
 113–114
hourly wage, 88
housing, 91
human-centered design, xi

I
I. M. Pei Art Museum, 187
ideas, and copyright,
 143–144
Imperial Beach, CA, 187
income streams, 93–94,
 190
incorporation, 133
indemnity clauses, 131–132
Indianapolis, 141
Indianapolis International
 Airport, 108, 162
individual health
 insurance, 111, 115
influences, 159
infrastructure projects,
 127, 168, 199, 200–201,
 209. see also built
 environment
inland marine insurance,
 106

inspiration, 159
installation needs, costs of,
76, 82
instructions, following, 59
insurance, 101–115
agents, finding, 101–102
budgeting for, 77
business auto, 106
and contract
negotiating, 130–131
full-service insurance
agencies, 102
health insurance,
109–115
artist group coverage,
109–110, 112–113,
115
cost factors, 111–112
hospitalization plan,
113–114
and performing art
unions, 112
questions to ask, 114
and state regulations,
110
types of plans, 113
life, 102
performance bonds, 102,
108–109, 130
personal insurance
auto, 102, 106
commercial policy,
103
disability insurance,
103
and fine art, 102–103
health, 91, 102, 103
health savings
account (HSA), 103
homeowners, 102–103
life insurance, 102,
103–104
mysterious
disappearance,
102–103
personal liability
insurance, 102
professional

business auto, 102
commercial general
liability, 102, 105
inland marine, 106
professional liability
insurance (PLI), 102,
107, 130–131, 132
subcontractors and,
104, 105, 150–151
workers'
compensation, 102,
104–105, 130–131
Wiegman on, 192
intangible rights, 136, 143
integrity, right of, 136, 138,
147, 199
interactive artwork, 9–10,
206
International Sculpture
Center (ISC), 151
internet art, 3
interview method, 19, 61
investment programs, 92
invitational, 18
IRAs (individual
retirement accounts), 92
irrevocable letter of credit,
108–109
IRS, 77, 88, 104

J

Jacob, Mary Jane, vii–ix
Jacobs, Jane, 171
Janacek, Lenore, 113
Jankowiak, James, 170
Johnson, Tonika, 180–181
joint authorship, 144
JW Flynn, 108

K

Kagan, Janet, 67, 81–82
Kapoor, Anish, 9
Kaspari, Brad, 134
Kelley v. Chicago Park
District (2007), 142
Kemper, Guy, 122, 134,
187, 190, 196, 198, 200,
202, 208

Keynote (Apple), 38
Kickstarter, 170
Kiefer, Kurt, 8, 67
King County's 4Culture
program, 162
Kings Country Art
Commission, 130
Kirkland, Larry, 184, 187,
190, 193, 196, 198, 202,
208
knowledgeable
negotiation, 119
Kresge Foundation, 177, 178
Krivanek, B. J., 69

L

labor and materials bonds,
130
labor costs, 72
Laker, Anne, 176
landscape art, 201
Lanzone, Dale, 142
legal advice, 63–64, 73,
120, 122
legislation
AB 753 (indemnity), 132
Affordable Care Act,
91, 109
CETA (Comprehensive
Employment and
Training Act), 2
Copyright Act, 136, 137
copyright laws, 135–136,
137–138, 143–144
Copyright Term
Extension, 137
political support for art
and, 5–6
Visual Artists Rights
Act (VARA), 133,
134, 136, 138, 139,
140–142, 145–147,
199–201
Leicester, Andrew, 145
letter of interest, 44–47,
52–54, 56, 57–58, 193
liability, 102, 104–105,
130–131, 132

licenses, 136–137, 143, 145
life insurance, 102,
 103–104
lighting costs, 76
limited liability companies
 (LLCs), 104–105, 133
Lin, Maya, 87
Lippard, Lucy, 19, 70
listservs, 192
living wage, 25, 70–71,
 85–86, 87, 88, 96,
 190–192, 195–198
Local Initiatives Support
 Corporation (LISC),
 177–178
local opportunities,
 159–160
location, 26
location-defining art, vii,
 ix, xi, 9–11
Logan Square
 Neighborhood
 Association (LSNA), 178
long-term savings, xi, 92
Lord Cultural Resources,
 15
Lovell, Vivien, 2
Lowe, Rick, 161
Lurie Garden, 9

M
Mackie, Jack, 69, 134,
 184–185, 188, 190–191,
 193, 196, 198, 200–201,
 202, 205–206, 208
Macon Art Alliance
 (MAA), 172–173
Maiki, Aisling, 166–167
Maintenance Art, 166
maintenance bonds, 130
"making of" videos, 161
making the leap
 act locally, 159–160
 artists-in-residence
 and calls for artists,
 50
 conceptual artists,
 166

embedded artists, 2,
 165–167
residencies, 167–169
Stone Street Co-op &
 Residency, 168–169
ZK/U Berlin, 168
creative placemaking
 and "artwashing,"
 172–173
Big Car, Indianapolis,
 174–176
consequences and
 responsibilities,
 172–174, 176, 184,
 186, 195, 203
defined by NEA, 172
funding, 177–178
neighborhoods in
 need, 176–177,
 180–181
and public
 engagement, 176
Sollod on, 207
urban planning
 approach, 171–172
Dixie Friend Gay's story,
 162–163
experiment with
 material samples,
 161–162
inspirations and
 influences, 159
making a difference
 96 Acres project, 181
 Englewood Rising
 Billboard Project,
 180–181
 self-initiated service
 projects, 179, 187
 Transnational Trolley
 Project, 179–180
murals, 169–171
no experience required,
 164–165
self-educate, 160–161, 163
show up, 160
voices of experience on,
 187–189

volunteer opportunities,
 170
Mancillas, Aida, 185–186,
 188, 191, 203, 208
Mandel, Mike, 20, 134
Manifesto for Maintenance
 Art 1969! (Ukeles), 166
Manton, Jill, 8, 9, 29–31, 67
Marsh, Shauta, 174
materials, experimenting
 with, 161–162
materials cost, 75
McAleavey, Marc, 175
media package, 192–193
mediation, 123
medical insurance, 91, 102,
 103. see also insurance
medium as inspiration,
 184–185
mental health care, 113
mentorships, 165
#MeToo movement, xi
Metris Arts Consulting, 15
Metro Nashville Arts
 Commission, 35
microresidencies, 166
Microsoft Excel, 38–39, 95
Microsoft PowerPoint,
 38, 83
Microsoft Word, 37, 41
Mill Hill neighborhood,
 173
Millenium Park, 9–11
Miotto, Stephen, 154, 155,
 162
Miotto Mosaic Art
 Studios, 154, 162
mock-up, 42
model agreement, 120,
 126, 132, 133, 137, 144
model maker, 72
Modica, Lee, 58, 67
monster.com, 99
"Monumental Lies"
 (Reveal podcast), 174
monuments, xi, 2
Moore, Julia Muney, 5–6,
 67, 134

moral rights, 136, 138–140, 141–142, 146–147
Morse, Nora Naranjo, 173–174
Mosaika Art and Design, 152
Mural Arts Philadelphia, 169–170
murals, 169–171
Museum of Contemporary Art, Chicago, 161

N

National Association of Teachers of Singing, 110
National Endowment for the Arts, 181
National Endowment for the Arts (NEA), 109, 115, 172
National Sculpture Society, 110
Neighborhood Arts Program (CETA), 2
neighborhood projects, xii, 2, 173, 174, 176–177, 178, 180–181
networked commons, 3
New Deal, 8
New Media Arts, 3
New Urbanism, 172
New York Artists Equity, 110
New York Circle of Translators, 110
Nike, 185
nonexclusive license, 136, 145
nonprofit mural organizations, 169–170
nonprofits, xi, 1, 175–176, 177, 181
Norfolk Arts, 8, 164
North Carolina Arts Council, 71
NOW Art LA, 15
Numbe Whageh, 174
NUVO Newsweekly, 174

O

Office of Cultural Affairs, Dallas, 166
Oldenburg, Claes, 192
Oñate, Juan de, 173–174
One Percent for the Arts Program, 165
online "making of" videos, 161
open calls, 18, 193
opportunities, 97, 170, 179
oral agreements, 118
Orbitz, 74
Organization of Independent Artists, 110
overhead, 76–77
ownership, and VARA, 146

P

paint shops, 171
painters, 150
"PAN Year-in-Review and Database," 159
Patronicity, 170
Paul, Christiane, 3
payment schedule, 127, 157–158
payments, 79
Payne, Brian, 175
PDAs (personal digital assistant), 3, 4
pedestal art, 2
per diem, 74
Percent for Art Collaborative, 81
percent-for-art programs, xi, xii, 1, 10, 28, 159, 160, 165, 169, 177
performance bonds, 102, 108–109, 130
performing art unions, 112
"permission wall," 170
permits, 64, 76
persistency, 21–22, 28, 204
personal auto insurance, 106
personal liability insurance, 102

personal property insurance, 102
photographers, 73, 144–145, 188
Photoshop, 37–38, 40, 41, 72, 193
Picasso, Pablo, 87, 200
Pillar Group Risk Management, 101
place ethic, 70
Plensa, Jaume, 9, 161
"plunk" art, 205, 206
police, off-duty, 76
political activism, 207
political issues, xi, 5–6, 8, 180, 205, 207
portfolios, 21–22, 38, 41–43, 55–56, 59
Portland Street Art Alliance, 170
power, in contract negotiation, 118–119
PowerPoint (Microsoft), 38, 83
prequalified artist opportunities, 17, 18, 164, 192
presentation of proposal, 82–83
presentations, 83
Priceline, 74
Pritzker Music Pavilion, 9
private funding, xi, 1, 10, 177
procedure, 61
productivity, 96
professional liability insurance (PLI), 102, 107, 130–131, 132
profitability, 96
project description, 24, 48–49
project managers, 18, 24, 28–29, 47, 63–65, 69, 71, 95
Project Row Houses, 161
proof of approval, 63–64
property damage, 105

proposals, 97–98. *see also* RFP (request for proposals)
fee, 61, 70–71, 96, 195–198
finalist, 19, 20, 32, 39, 42, 57, 61–62, 65–67, 80–81, 97–98
format and content, 65–66
learning process of, 184, 187
and letter of interest, 46–47
maximizing value of commissions, 93–94
requirements, sample, 50
RFQ example, 48–52
writing tips, 65–66
Public Address, 191, 208
public art. *see also* voices of experience
20th century initiatives, vi–viii, 8, 11, 123–124, 169
accessibility, 5, 7, 8, 9, 177, 186
bureaucratic aspects, 29, 64, 186, 202
collaborative aspect, 12, 124, 127, 132, 143–144, 186–187, 194, 197, 202, 204, 207, 208
as a "community living room," 206
consequences and responsibilities of, 172–174, 176, 184, 186, 195, 203
cultural factors, xi, 6, 7–8, 166, 172, 173–174
as economic asset, 5, 6, 7, 9, 10
and economic revitalization, 5, 8, 169, 172, 176, 178

effectiveness of, 10, 11
five reasons it matters, 6–7
getting started. *see* making the leap
irrelevance, perceived, 205
market, 93
meaningfulness of, 206
new artist advice, 20, 44, 164–165
and place ethic, 70
program managers, 29–31
programs, motivation, 7–9
social factors, xi, 2, 4, 6, 7, 176, 180–181, 195
studio art and, 13, 183–187, 203
as symbol of civic enlightenment, 5
Public Art for Black Wall Street Gardens, 45–46
Public Art Network, 18, 20, 21, 97, 159
Public Art Network Advisory Council, 6–7
Public Art Resource Center, 15
Public Art Review, 12, 97, 151
public domain, contracts
public health, 7
public service spending, 5–6
Public Works of Art Projects (PWAP), 8
PublicArtist.org, 15, 206
Public:Art:Space (Lovell), 3
Pueblo nation, 173–174
Pulliam Trust, 175, 176
purchase orders, 124–125

Q

quality control, 127
QuickBooks, 38, 95
Quicken, 95

R

Radioactive—Stories from Beyond the Wall, 181
"recognized stature," works of, 139, 141, 147
references, 43
registries, 17–18, 164, 192, 194
regulations, 64
Reicks, Sam, 74
rejection, 21, 28, 183, 193
relationship-building, in negotiations, 119
renters insurance, 102
residencies, 2, 5, 165, 166–167
Resident Association of Greater Englewood, 180
responsibility, duration of, 147
resumes, 26i, 31, 41, 93–94
Reveal (podcast), 174
revitalization, 5, 8, 169, 172, 176, 178
RFP (request for proposals), 19–21, 26, 32, 37, 46, 58, 68
RFQ (request for qualifications), 19, 21, 26, 37, 45, 46, 47, 58, 68, 122–123, 162–163, 165
RFQ, example of, 48–52
rights. *see* artist's rights; copyright
risk of loss, 131
risk transfer, 131
Riverside Sculpture Project, 48–52
Rodriguez, Marilyn Ines, 134
Rolon, Carlos, 170
Rolstad, Koryn, 134
Rose Kennedy Greenway Conservancy, 164
Rosenberg, Gigi, 177
Ross, John, 69
Ross's Landing, 69
Rowland Design, 39